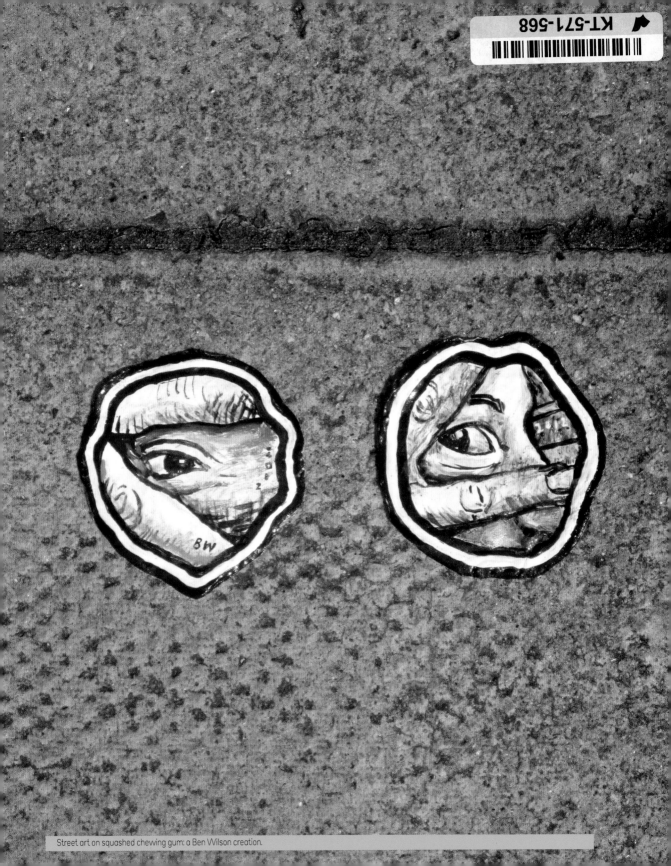

Street art on squashed chewing gum: a Ben Wilson creation.

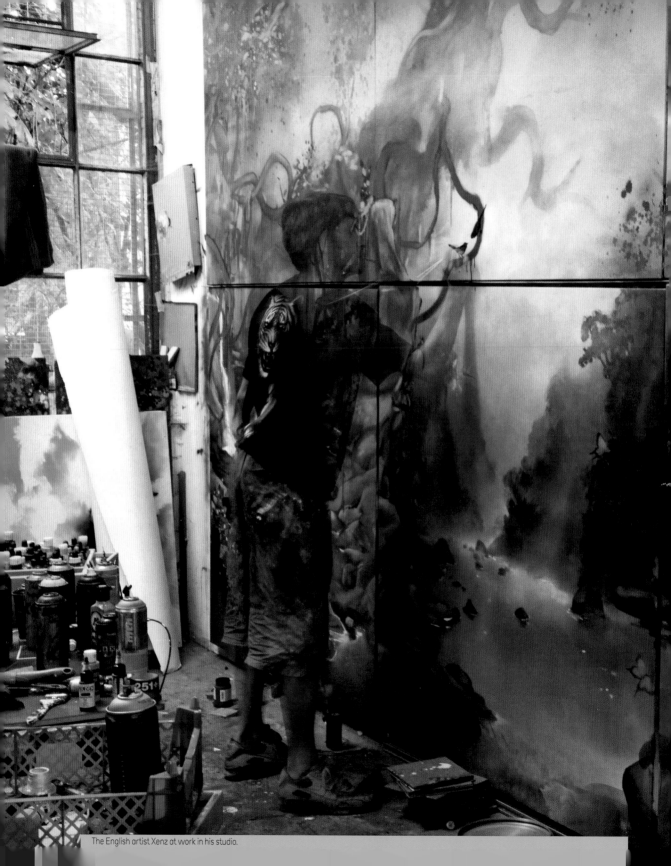

The English artist Xenz at work in his studio.

Eine, one of the masters of street typography, has transformed his hands into works of art.

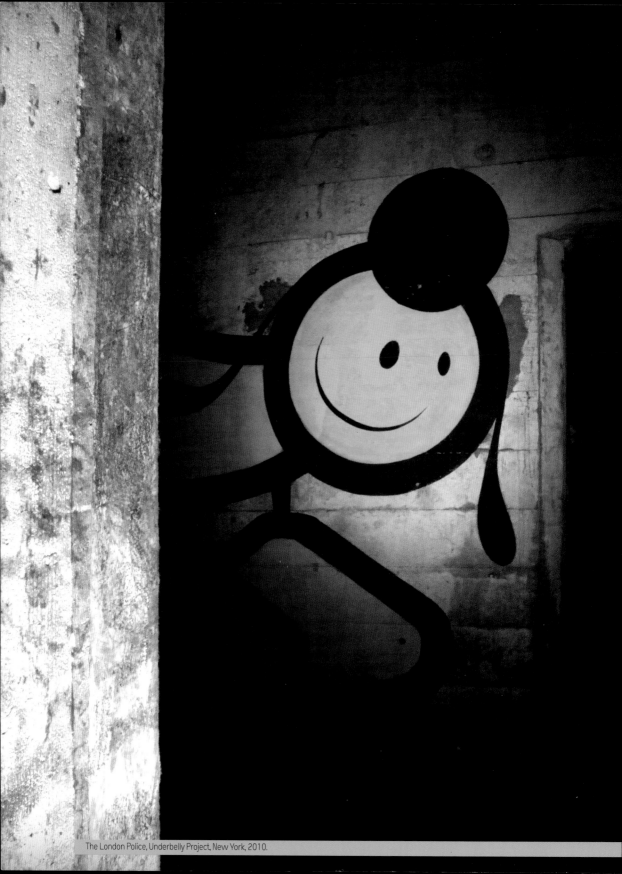

The London Police, Underbelly Project, New York, 2010.

Delta, *TkTkTk*, 2012 (detail). Acrylic on wood with string, 4 ft. × 4 ft. × 4 in. (122 × 122 × 10 cm).

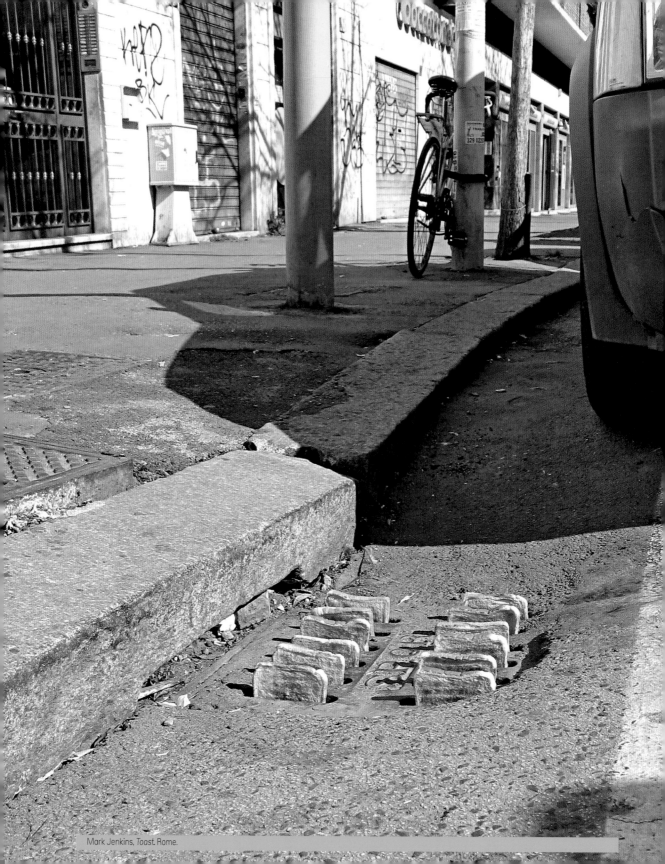

Mark Jenkins, *Toast*. Rome.

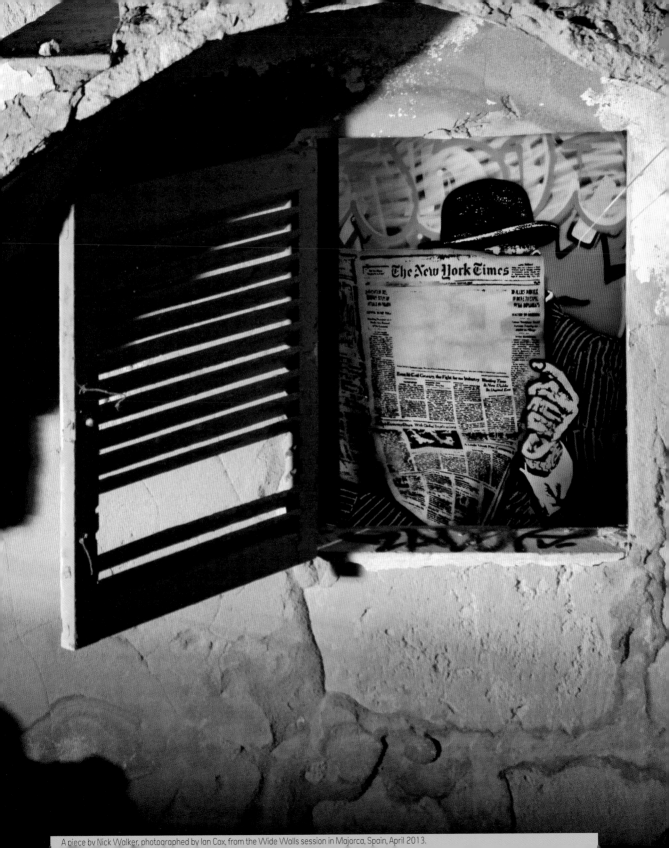

A piece by Nick Walker, photographed by Ian Cox, from the Wide Walls session in Majorca, Spain, April 2013.

Clet Abraham, Milan.

SERIES EDITED BY ÉLISABETH COUTURIER

JÉROME CATZ

talk about
street art

Flammarion

CONTENTS

PREFACE

Abandon hope, all ye who enter here. The legendary sentence engraved on the gate of Hell in Dante's *Divine Comedy* is a suitable warning for street art, a discipline that plays by its own rules. As a young teenager, I remember standing awestruck in front of a huge Bragon-the-bat fresco on one of the walls of the Galeries Lafayette store in Grenoble, around 1985, and the immense feeling of sadness when I discovered, a few days later, a cream-colored rectangle where what I saw as an artwork used to be. A few years later, I took part in nocturnal graffiti and tag expeditions as an observer/chauffeur/archivist. I had persuaded my parents to let my friends paint the family Volkswagen in its entirety. It was a budding passion, an exciting environment, an amateur interest that gave me a taste for adventure. Later, as a professional snowboarder, I traveled all over the world, organizing expeditions and exploring. Nothing pleased me more than the discovery of an as yet unknown destination, relaying this to others and sharing the exhilaration of those moments. This kind of career is as short as it is intense. After a decade of touring the world repeatedly, I settled in Grenoble, my native city, which I adore.

The end of one life and the beginning of another: in 2003, I decided to open a cultural community space with the aim of introducing artists to board culture, related to the world of skateboarding. Yet artists working in this field have been making a connection with street art since Craig Stecyk III's first creations on the West Coast of the U.S. Familiar with the designs decorating snowboards and skateboards, I immediately caught onto the links between these two worlds. I plunged in head first, became an exhibition curator, and organized ten or so hangings a year to present the works produced in each of these fields. And so I met a great number of participants, all of whom were more or less connected by the same network, the same passion, and even the same sense of commitment. One event led to another: in short, I skimmed the specialized blogs, hunted down new works, befriended numerous artists. Every day I became a little more involved in this ultra-creative tribe.

There is an incredible diversity in the field, from the results of Banksy's merciless humor or Blu's animated films to the increasingly monumental frescoes that cover huge surfaces. Each writing style is singular and means I cannot wait to see how the artist's work will develop and, of course, to discover others. A combination of physical and ideological commitment, of technical skill and spontaneous expression—everything comes together and makes sense. For me, there is no doubt that this is one of the greatest artistic movements that has ever existed, because of its strength, its capacity for continual renewal, and its geographical spread. Hats off, because this is an exercise that demands an extraordinary amount of investment, courage, and energy. It's a real revolution, which, I am sure, is only just beginning. Rich and moving to the extent that it is impossible to grasp it in its entirety, street art is everywhere, under everyone's gaze. From North to South, East to West, it is no longer possible to escape it, and so much the better.

Thinking back, my knowledge simply grew over time. Even if my vision of street art is sharper today than that of the simple passerby, I like to come across it by surprise on a street corner. Just as children walk with their eyes to the ground, looking for the slightest object to pick up, I scrutinize the unexpected on walls, from top to bottom. I am not alone. Anyone even the slightest bit interested remembers the pleasure of discovering a new work. I prefer the direct visual aggression of a huge tag made with an extinguisher on a building gable to the illuminated logo of a fast food chain or a large poster extolling a product. A veritable everyday initiation to art, works exhibited in this way continue to grow. References to art history multiply, the authors gain in recognition, and the street has become an excellent place for communication. Every day, new people invest the city with a conviction and a vision that depends as much on strategy as on performance. It is difficult to understand the profound motivation of those who choose to express themselves outdoors. But looking is like tasting: the gaze becomes accustomed, sharpens, and its ability to analyze evolves. New, banal, interesting, dire, great— many adjectives describe the designs that blossom every day. Some people need their three daily coffees; as for me, I need my three new works, and if the street does not satisfy me, the Internet informs me of the craziest and most far-off creations. It's a global treasure hunt!

The real winner is the street, that public space par excellence that has started to come back to life, re-humanize itself, and speak out again. The artists could not hope for a better exhibition space: it's open 24/7 and constantly piques our curiosity—which you know kills the cat!

JÉROME CATZ

WHAT IS STREET ART?

WHAT DOES IT LOOK LIKE?

Street art does not try to blend into its surroundings; on the contrary, its ultimate goal is to be seen. As the name indicates, its arena is the street: billboards, buildings, and other unexpected but prominent places.

Everything starts with the tag, a signature painted with a spray can or drawn with a thick-paint marker pen called a Posca. Comprising a series of more or less legible letters, drawn in black or in a color that contrasts with the background it is written on, the graffiti tag, from the smallest to the largest, generally appears within sight of passersby. One tag always attracts another.

It can draw you into a strange journey, full of surprising dips and turns. A small tag on a windowsill intrigues you but, already, you identify three others a few feet on. You start to follow them and you leave the main road and take a side street. A few patently handmade stickers appear on the road signs you encounter and, after a parking meter, a poster attracts your attention. Pasted onto the wall, it bears no message: this face looking at you offers you nothing, no slogan, no abuse, just a black-and-white, poor-quality photocopy. It is probably the work of an inventive character. On the fence protecting the worksite on the other side of the road, you spot the same image but this time embellished with the word "OBEY." You cross the street to make sure and you realize that it is placed next to a series of other tags. Further away, you notice a new poster, this time representing a cat. Judging by the size and the way the paper is cut around the drawing's outline, it is also handmade. The design is remarkable, with a whole series of little lines and shadings. Three colors jump out at you: black, white, and brown. You suddenly want to take the picture home with you, but it's no use, the paper is stuck fast and tears testify to previous unsuccessful attempts—probably by the person who tagged the drawing. This

Block letters made with spray paint thanks to the ladder giving access to the roof of this Parisian building: Sonic was here in 2012.

tag is not unfamiliar to you: you have already seen it several times on neighboring walls and parking meters, and you are beginning to decipher it well. You realize that the cat is made from a stencil, not in three spray colors, as you first thought but in five: what a feat!

The poster of a face with the OBEY slogan made you cross the street, but when you turn around to compare it with the first one you notice on the back wall of the building opposite, near the roof, a name in

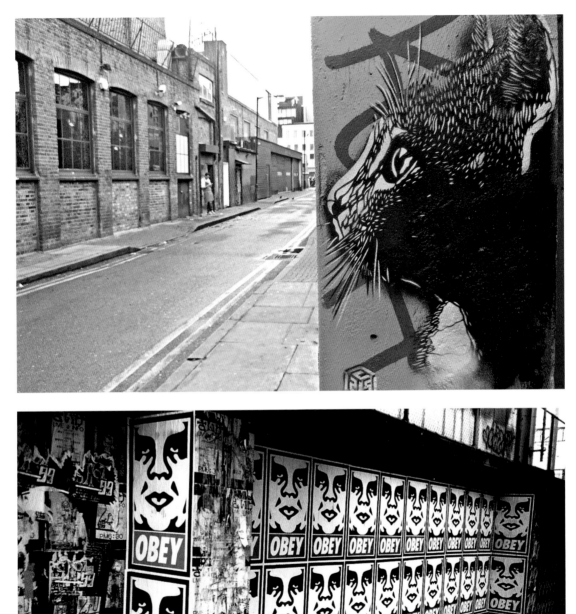

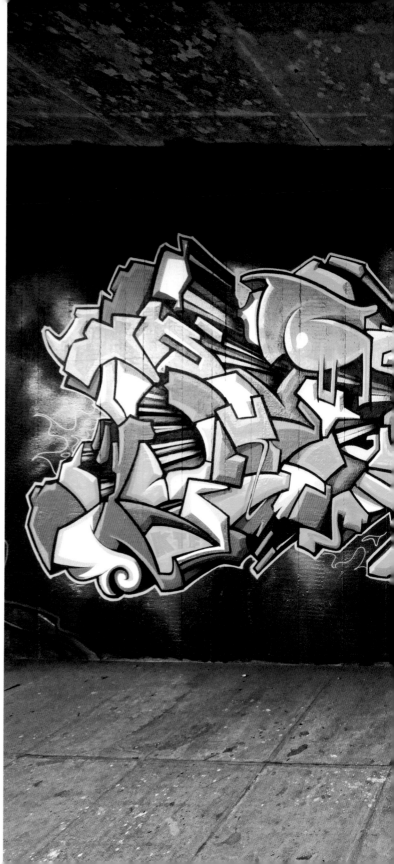

enormous, blue, square letters in black out-
line: SCENE2, written in a panoramic way,
like the most illegal of billboards. The cat
appears again further on, this time drawn
directly onto the large plank of unvarnished
wood that blocks the entrance of a restau-
rant under construction, and you notice that
the artist—because it can only be someone
with training—has used the natural color
of the wood for brown, while adding some
white to create another version of the
same stencil. Then the street divides into
two, and the same tag that has guided you
from the start makes you take the road on
the right. Now you notice two small, black
rats drawn in stencil running along the bot-
tom of a wall. Further along, you arrive in
front of a large billboard concealing a
derelict enclosure intended for the con-
struction of a ten-story building. Completely
tagged and decorated with spray paint, this
surface is covered in abstract drawings in
one or two colors that seem to have been
painted in haste. The one that stretches
over at least nineteen feet (six meters) turns
out to be a series of very legible letters that
are too large to be deciphered close up. And
your little tag is still there, in the middle of
this huge fresco. Inside this derelict enclo-
sure, a piece of sheet metal held on by only
one nail acts as a door. You can't resist
having a look inside, and you discover a
vacant lot. The sparse vegetation gives a
glimpse of the back wall, and the colors of
the graffiti covering it intrigue you. Before
you even ask yourself if it is sensible to
enter, here you are in the middle of this

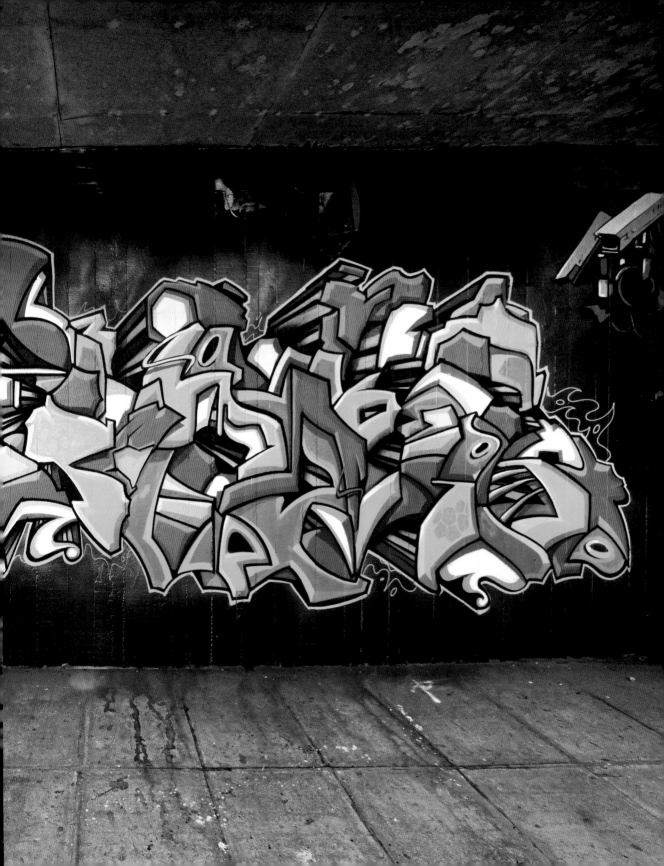

patch of land, surrounded by surfaces adorned with gaudy designs. Every last square inch has been painted using spray cans: abstract forms mix with cartoon characters and, there again, you spot tags placed like signatures for each of these "artworks" that touch each other without overlapping. Some forms are rounded; others are as thin as blades, ending in pointed arrowheads. The people who painted these designs apparently took their time: drawing a thirteen-foot- (four-meter-) tall figure with his baseball cap and oversized B-Boy chain must have needed scaffolding, unless that huge pile of crates served as a ladder. You regret not having brought your camera. You vow you will come back and immortalize these frescoes that are beginning to speak to you. But, as you leave, you suddenly find yourself face to face with an immobile figure, sitting on the ground, with his back pressed against the billboard and his hands in the pockets of his sweatshirt. It is impossible to see his face under the hood that almost entirely conceals it. He seems to be sleeping. You move closer to see if everything is ok (his position cannot be very comfortable) and the closer you get, the more his worn clothes suggest he is a hobo. When he doesn't reply to your "are you ok?" you lean over and, oh the surprise! It is a dummy made from old clothes and unmatched shoes that someone had fun stuffing with plastic bags, held together with tape. Impressively realistic!

PAGES 18–19
Wild-style graffiti made by Deamze in Bristol in 2013.

FACING PAGE
Real or fake hobo? Mark Jenkins keeps us guessing, even those who know his work. The illusion is perfect.

This time you leave the place with relief, but you quite enjoyed that little frisson. However, more surprises lie in wait: three delivery trucks, once white, are now embellished with a kind of dripping blob, somewhere between a drawing and a letter in the shape of a bubble. Still looking for the cat you liked so much, you walk on: the tags thin out, but the sight of a paper stencil pasted onto a billboard confirms your direction. Your laces are undone and, when you bend down to tie them, your gaze is attracted to a surprising patch of color in the middle of the sidewalk. You wonder what crazy guy could have painted this microscopic landscape on an old piece of squashed gum. Judging by the technique, it can't possibly be a child. A bit further on, you stop in a diner to wolf down a sandwich: the waiter offers you a Street Art Special and explains that you are in the middle of the graffiti artist district. When you tell him about the cat stencil, he replies that the author, C215, happens to be showing in a nearby gallery: "Second on the left, you can't miss it: there is an Invader on the building's corner." Without daring to ask what an Invader is, you walk toward the suggested address only to discover your cat in the window of a rather private-looking gallery. And, indeed, an 11 × 7 inch (30 × 20 cm) mosaic, stuck to the building's corner thirteen feet (four meters) off the ground, reminds you of a video game from your childhood: Space Invaders. Everything becomes clear: you have just discovered another side to street art and you enter the gallery. Once inside, you are given information that allows you to piece together the puzzle forming in your mind. Quickly, you retrace your steps, determined to ask the owner of the restaurant under construction to exchange his tagged wooden plank for a new, more solid, less sodden board. And if he refuses, you imagine yourself buying a good handsaw. The area should be quiet at night, don't you think?

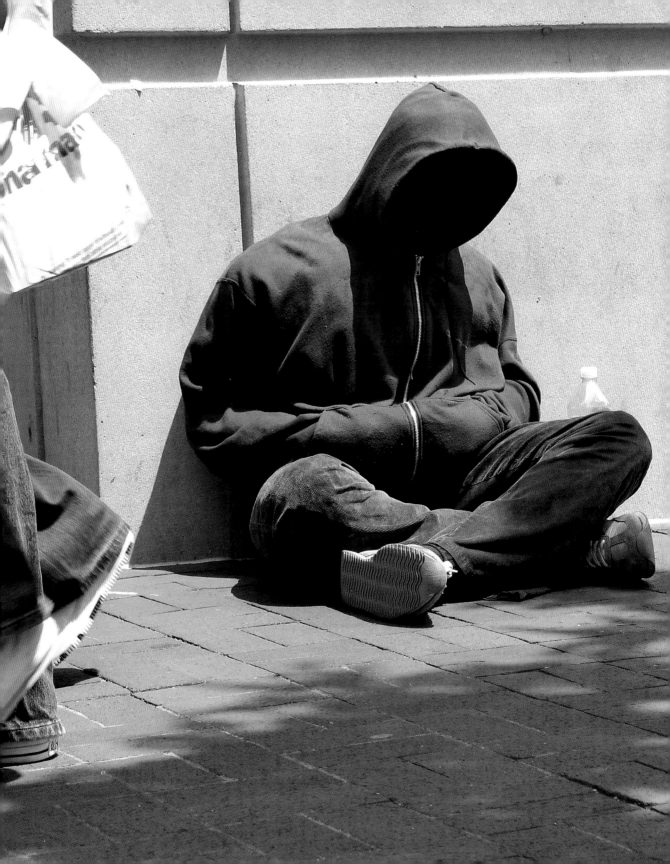

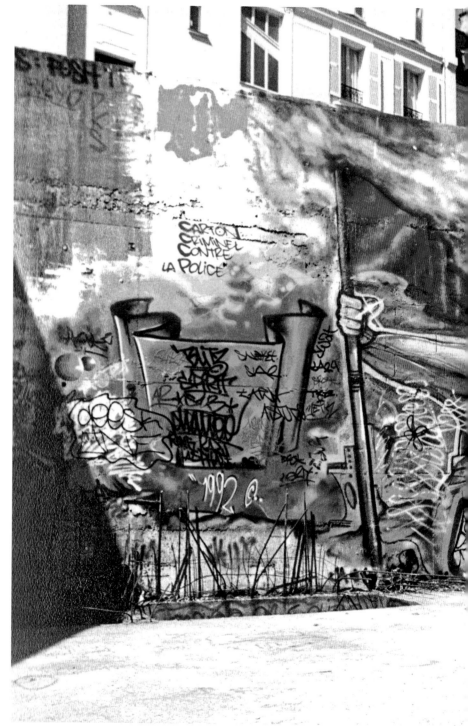

At the end of the 1980s, the Force Alpha collective was one of the most active in France. *Carton Criminel Contre la Police* (Criminal Mural Against the Police) was painted on a site in the Mouton-Duvernet district in the 14th arrondissement of Paris.

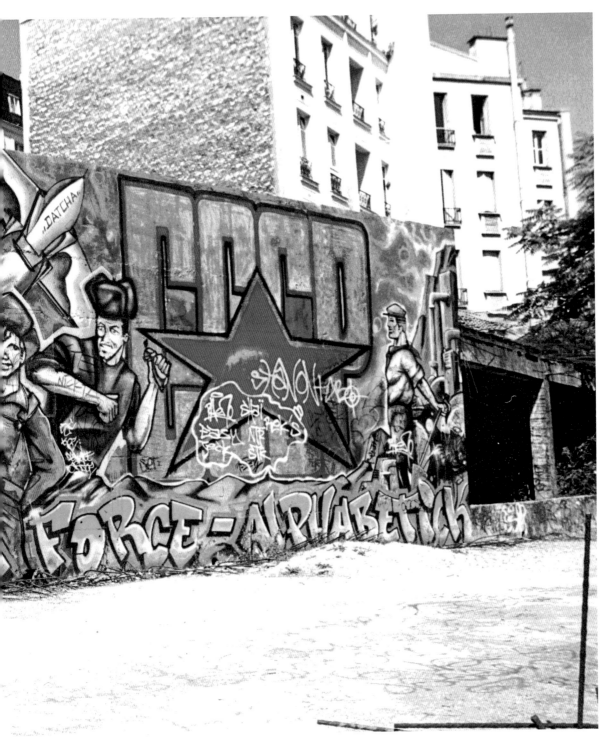

WHEN DID IT START?

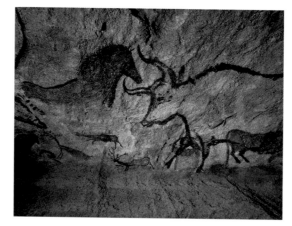

The origins of art lie in wall painting, as can be seen in the caves at Lascaux.

Wall drawing is a practice that has existed since time immemorial. Illegal graffiti takes us back in time to the earliest years of human history, to the prehistoric caves where the very first traces of wall paintings can be found. But street art as an artistic movement is a recent phenomenon. It mostly emerged in New York at the beginning of the 1970s.

Although other American cities such as Los Angeles and Philadelphia experienced a kind of convulsive expression at the same time, the city of New York proved to be the ideal place for this feverish outburst that consisted of using public spaces as a backdrop and exhibition space. Ruined by the industrial recession, public utility services such as the Big Apple's police and maintenance departments were operating on rock-bottom budgets while hundreds of unemployed youths were on the lookout for ways to kill time.

The first taggers identified themselves in and around their own districts by associating their own names with streets: they left their mark with signatures such as "Taki 183" (for 183rd Street), "Julio 204" (for 204th Street), "Eel 159", "Joe 136", etc. But New York also offered another fantastic prop: its public transport network. With over sixty-five thousand subway cars traveling every day across the city, the graffiti artists found a new way to make their work public. By documenting their feats with spectacular and original pictures, the photographers Jon Naar and Jack Stewart at the beginning of the 1970s, then Martha Cooper and Henry Chalfant at the end of the same decade, contributed to the myth of New York as the center of the graffiti world, even if artists such as Cool Earl or Cornbread had been doing graffiti in Philadelphia since 1967.

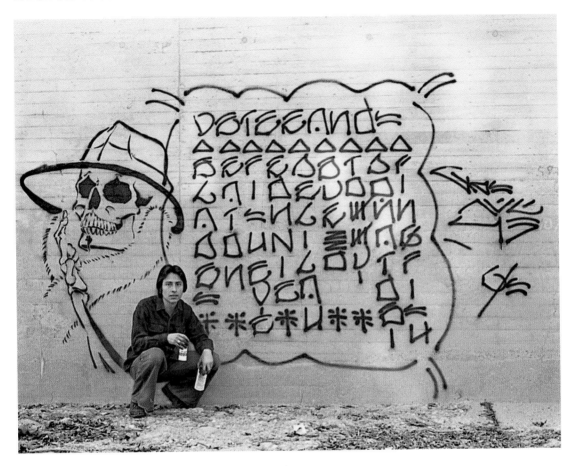

The West Coast also played an important role. It quickly earned a place for itself in the history of street art. The first groups to leave their mark on the walls were of Mexican origin, with cholo-style lettering, toward the end of the 1940s.

This reinterpretation of gothic lettering originally used in official documents such as birth certificates and press headlines was employed as early as 1969 by the calligrapher artist Chaz Bojórquez, whose work was shown the following year at a local artistic institution, the Mechicano Art Center in East Los Angeles. At this time, the Californian coast noticeably shifted away from the image of a laid-back, hippy lifestyle toward a tougher, more urban culture. In Los Angeles, the appearance of the first

In 1975, graffiti was only just beginning, but letters and stencils were already being painted to perfection by Chaz Bojórquez. Arroyo Seco River, Los Angeles.

tags was due to the gangs and the battles that tore them apart. The conflicts between the Crips and the Bloods left countless slogans tagged respectively in blue and red on the walls of certain districts. In addition, a new urban sport appeared: skateboarding left the skate pools and ramps, and poured into the street, in a movement called "street skateboarding." Skaters and taggers frequented the same places, were the same age, and listened to the same punk or hip-hop music. Street culture occupied city centers and disaffected areas alike. Among the cult works that laid the movement's foundations were the film *Wild Style* by Charlie Ahearn and the documentary film *Style Wars* by Tony Silver, both of

which came out in 1983, as well as *Beat Street* produced the following year by Stan Lathan. The first fanzine also appeared in 1983, the New York magazine *IGTimes* (International Graffiti Times) edited by David Schmidlapp in collaboration with the graffiti artists Phase 2 and distributed in authorized circles. In 1987, *Ghetto Art Magazine* (an important publication) was launched for its first six issues, before taking the name *Can Control*. It is also important to mention the publication, from 1989 onward, of *Fat Cap*, *Under Covers*, *Hype*, and *Crazy Kings* in the U.S., and *Xylene* in Canada.

Where there is art, even if it is illegal, there is also a market: this one emerged in the United States in 1973 with the Razor Gallery in New York, which organized the first exhibition devoted entirely to graffiti art, curated by Hugo Martinez, the founder of one of the first New York crews, the United Graffiti Artists (UGA). Other specialized galleries followed suit, such as Fashion Moda in 1978 and the Fun Gallery in 1981.

Street culture started to develop in Europe at the beginning of the new decade, following the example of the United States, and in particular New York. The discipline appeared almost simultaneously in most countries outside of the Soviet Union (until 1989), with a stronger spurt in Anglophone territories or countries where English was spoken fluently, such as Scandinavia, Germany, and the Netherlands. Even if street art already existed in France in the middle of the 1960s in the form of Ernest Pignon-Ernest's wall-and-paper stencils, or with Gérard Zlotykamien's silhouettes spray-painted on building-site hoardings, it was one of New York's graffiti stars, Futura 2000, who introduced the street spirit by executing graffiti live during the The Clash's

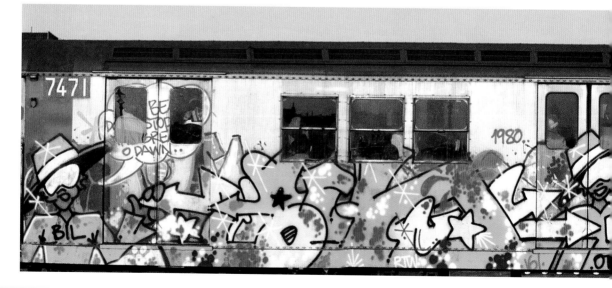

European tour. Another channel of communication between the United States and Europe was Philippe Lehman, better known as Bando. During one of his regular trips to New York, in the studio of the photographer and journalist Henry Chalfant, he met the artist Ber 167 from the TDS crew, who taught him graffiti. The very first crews that formed in France from 1983 onwards were the BBC (Bad Boys Crew), the PCP (Paris City Painters), the CTK (Crime Times Kingz), and the Force Alpha. At the same time in England, the London crew The Chrome Angelz (TCA) became one of the most active of the time, thanks to Mode 2 in particular, an exceptionally gifted designer of the figures that accompany frescoed lettering. In 1983 the Boijmans Van Beuningen Museum in Rotterdam organized the first exhibition of the movement in Europe, *New York Graffiti*, which showed the artists Dondi, Seen, Blade, Futura 2000, Crash, and Quik, while the Yaki Kornblit Gallery in Amsterdam presented the New York graffiti writers. The influences circulated in every direction: Bando met the TCA in London at the beginning of 1985, and the two teams began visiting each other regularly.

Bilrock and Revolt worked together to make this panel piece on a New York subway car in 1980.

The Dutch crew USA (United Street Artists), with Shoe, Yan, and Jaz, provoked an encounter with the Parisians by painting graffiti on the banks of the river Seine, a meeting that quickly transformed into an invitation to Amsterdam, where other artists such as Delta, Gasp, and Angel were present and made themselves known to Bando and his circle. The first names of Swiss writers such as Dare or Toast rapidly appeared, the Germans Can 2 and Shark started to make a name for themselves beyond their country's frontiers, and stencil artists began working in almost all the big European countries. When he came to France in 1986 to take photos and meet artists for his future book *Spray Can Art*, Henry Chalfant noted the vitality of the French scene. He defined the latter as deriving from a more aesthetic and technically accomplished lineage than that of New York. He also observed the influence of Japanese cartoons and the world of science fiction that had not yet appeared in the United States. The French scene of the time is particularly well documented by the Paris Tonkar collection, a compilation of the best tags and graffiti from 1986 to 1991.

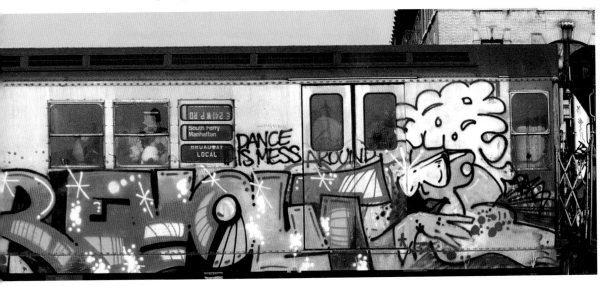

Before the wave of tags that appeared in the 1970s in New York, the Bloods and Crips gangs were already marking their territory with large numbers of tags in the deprived suburbs of Los Angeles.

The 1990s marked the beginning of a particularly vandalistic era, where the only thing that counted was the placement and number of tags. TCG (The Crime Gang) became a specialist of this practice. Its mission was to steal spray cans and paint markers and then to cover the largest number of surfaces, beginning with the Parisian metro. When it joined with the DRC, the NTM crew was born. After the metro lines, the stations were taken over. When the Louvre station was entirely vandalized on the night of April 30, 1991, an unprecedented wave of repression began, and the authorities did not hesitate to imprison graffiti artists. Since then, boundaries have been set up to distinguish two types of individuals and two modus operandi: the vandals, who find it more and more difficult to express themselves, and the others, who take over vacant lots or places where their interventions are tolerated, even authorized.

While at the end of 1992 the Groninger Museum in Groninger (Netherlands) presented the successful exhibition *Coming from the Subway: New York Graffiti Art*, the beginning of the 1990s saw the birth of the first events devoted solely to graffiti. They took place in industrial warehouses, more or less provided by the local authorities. **The best example of this is the city of Wiesbaden, twenty-five miles (forty kilometers) from Frankfurt in Germany, where the abandoned slaughterhouses became an almost-legal graffiti capital.**

A few years later, to block local authorities' attempts to rehabilitate the site, the artists came together and created the first international event worthy of the name, the Wall Street Meeting, from 1997 to 2001, when the buildings were finally destroyed by the city. In reaction to the disappearance of this mythical place, and bolstered by an event that had brought together the scene's major participants, the organizers decided to create the Meeting of Styles, a rally touring around Europe and the world. **This was the end of the graffiti movement's first period: canvas works began to be sold in art galleries, and institutions prepared retrospective exhibitions. Did this mean it would step into line? Not exactly.**

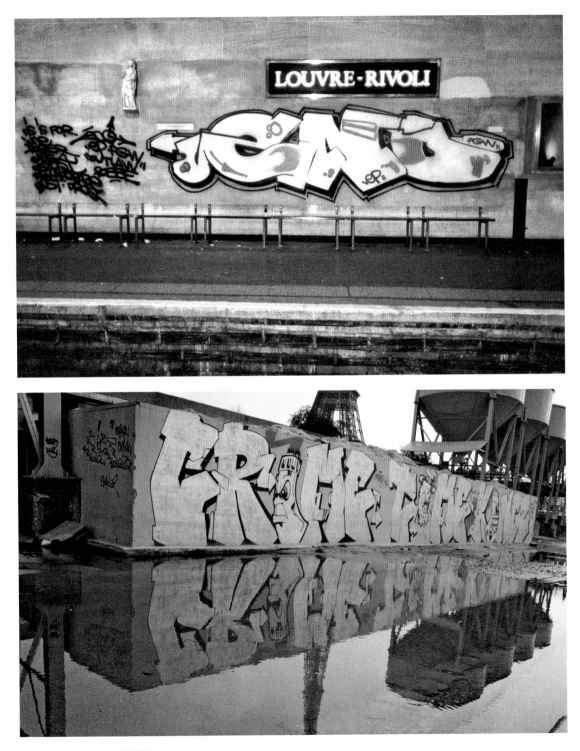

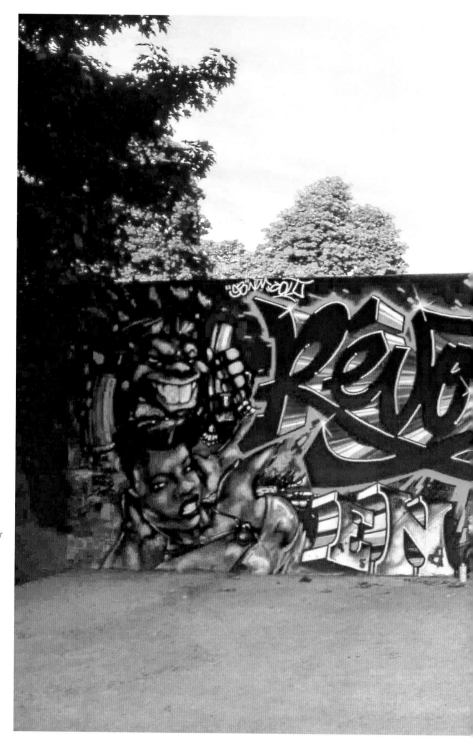

Mode 2, summer 1989, in front of one of his frescoes. The French artist Colt painted the lettering of "Révolution" and "Direct". The NTM crew was already active. Choisy-le-Roi, France.

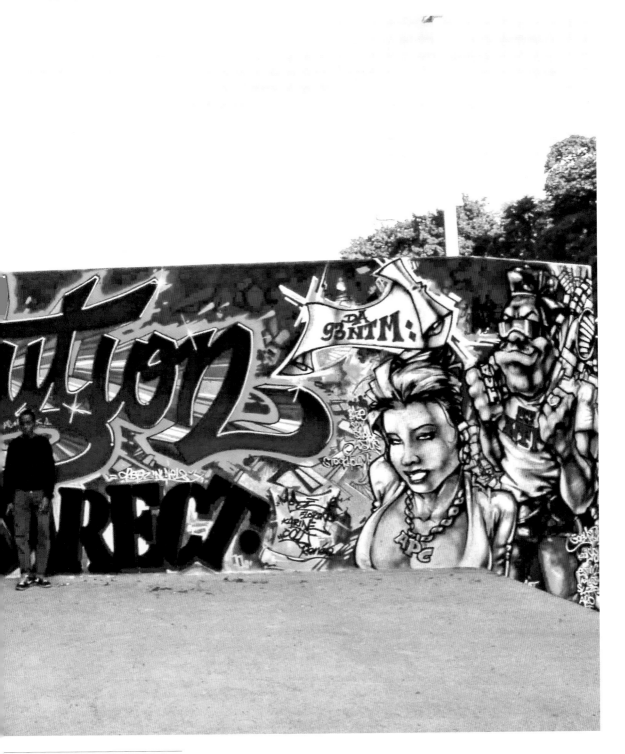

AN EPHEMERAL ART

Street art does not guarantee its authors a ticket to eternal glory. Far from it: essentially ephemeral, and generally illegal, the practice is a risky one. A collage can be torn off or a stencil stolen, and, with time, a graffiti drawing is rubbed out or covered by a "colleague's" design.

Originally, street art benefitted from the element of surprise: no one stood up to bar its way. If every time a tag was made, someone had immediately made it disappear, graffiti would never have grown on such a scale. Fortunately, the institutions reacted sufficiently slowly to allow for the movement to attain a certain level of maturity. When, in 1986, the MTA (Metropolitan Transportation Authority) of New York decided to prevent any subway car with graffiti from circulating, it committed itself to a tough battle that it ended up winning three years later with the withdrawal of the last tagged subway car from the tracks. In New York, as in many other cities around the world, local authorities started rallying seriously against tags and wall graffiti in 1995, to the point of establishing the Anti-Graffiti Task Force, a veritable special unit charged with the mission of eliminating the traces of these illegal acts by all means.

Since the beginning of the 2000s, specialized companies have been set up in every major city. There is no shortage of ideas for countering what the law considers to be a degradation of public spaces: in France, for example, the city of Lyon offers anti-graffiti insurance to joint-ownership properties in the city center. The creation of these coercive measures obviously does not discourage the street artists, who are more conscious than ever of the ephemeral character of their practice.

To get around this state of affairs, they have developed new, more resistant techniques such as glass or metal engraving, which appeared at the beginning of the 2000s, or even the use of homemade inks that are particularly difficult to eliminate. They also choose to work in places deemed inaccessible: the roofs and upper walls of buildings have thus become a prime target for graffiti writers and sticker artists capable of working in large format. But the best way of keeping track of these increasingly ephemeral graphic feats remains the creation of an archive. Photographs and videos allow artists to show their work, particularly on the Internet via social networks, with the hope of emerging from the constant flow of new urban creations posted online every day. It is a dangerous game: specialized blogs and other distribution channels on the Web also help the police arrest artists who have signed their works. Nevertheless, it is the best way for street art "professionals" to circulate and acquire a certain notoriety. What would remain of the early 1970s if a few visionaries had not played the role of amateur curator? This was the case with the photographer Jack Stewart, who invited taggers to leave their mark at his home, on the bathroom door. Moreover, in 2009 he published the book *Graffiti Kings*, showing his photos of the subway taken between 1970 and 1974. As for Hugo Martinez, the founder of UGA, in 1972 he organized the first exhibition devoted to tags at the City College of New York. Among the first writers, Ale One and

Flint had the idea early on of preserving the tags and graffiti created by their peers through photography. Jon Naar, in 1973, was the first professional photographer to seriously document the work of street artists in New York. A few years later, Martha Cooper and Henry Chalfant followed in his footsteps. Without them, the history of tags and graffiti would not be as well known. Another happy owner of rare pictures is the English photographer Keith Baugh: to the great joy of artists and passionate admirers of street art, he published his treasures accumulated during two trips to New York in 1973 and 1975.

Today books on the movement have increased, with volumes specializing in different techniques or artists, or on the movement's emblematic cities. Graffiti's ephemeral character has motivated the need to list lost or still visible "masterpieces," so much so that it is now possible to acquire an almost exhaustive knowledge of them.

FACING PAGE,
TOP AND BOTTOM

The graffiti artist Katre repaints over the fresco he had previously made with his partner Seth. Gentilly, France, 2009.

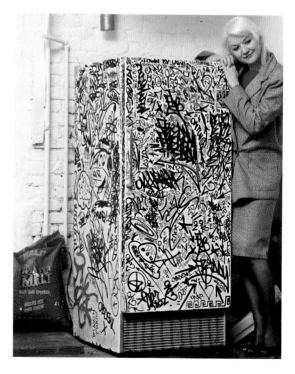

Patti Astor and her fridge in the Fun Gallery—one of the rare traces of the tags made in this mythical New York location between 1981 and 1985.

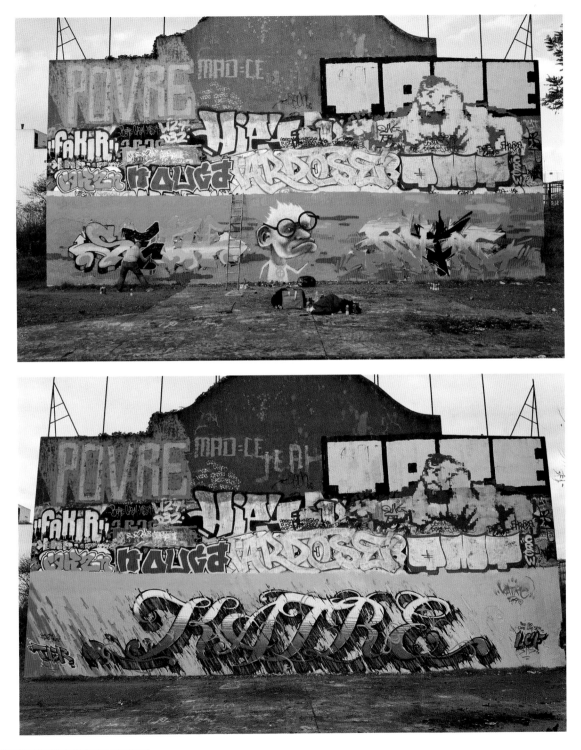

A STATE OF MIND

Practicing street art is about having an effect on your—and other people's—environment. The first artists started out by wanting to leave their mark. Most taggers who occupy the streets seek the recognition of their peers—a subtle game between anonymity and potential notoriety later revealed within the center of a group. These street artists earn their spurs the hard way, and step onto this rough path without any particular goal in mind. The only signal they send out is "I exist and this is what I know how to do." Others, on the contrary, want to leave a message, to create an awareness concerning certain social issues.

To exist in the eyes of his friends, and thus exist in the world, could be a way of describing the tagger's initial aim. From this, it is only a small step to reading all of these tags as revealing signs of a generation of youths who are trying to find their place. Some choose this direction as a way of being heard. Could street art be both a fashion and a cry for help? And can taggers be considered artists? According to one of the founding fathers of European graffiti, Mode 2, the creator's qualities can be deciphered in the tag by the letters' originality, the graphic skill, and the mastering of gesture that gives the lettering its dynamism. What about the other means of expression or intervention that bear no relation to the tag apart from the fact that they occupy the same backdrop? These are an easier way to obtain a place in the great galaxy of contemporary art.

But street art, like punk rock, requires above all a rebellious state of mind. Alongside their existence, some express what they believe should be changed about the world—poverty, anonymity, violence, politics, etc. They use the public sphere as a place of popular expression, accessible to everyone. So many street artists—including stencil, sticker, and graffiti artists—spend a considerable amount of time on their work and put their talent to serving a cause. They hold on to the hope that their message, thanks to its strength and poetry, will be understood by passersby. They consider the street as a continuation of their studio, reaffirming the insinuated: "I exist, I am physically here, I am showing it, and I am free to say what I think."

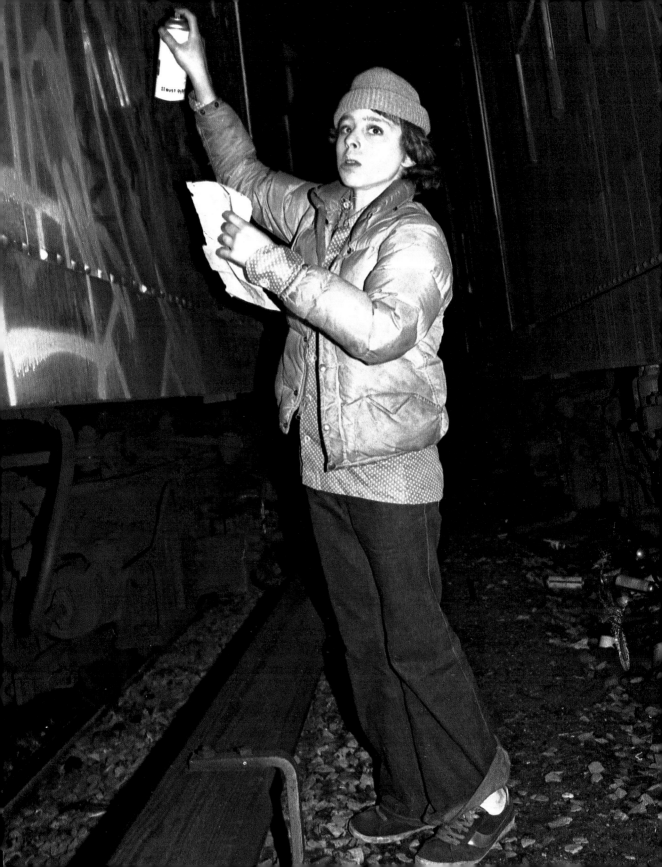

But practicing street art is also about breaking the rules, with the consequences we are aware of. Fear is an essential factor for understanding the phenomenon. When do we feel most alive, if it isn't when we place ourselves in danger? All the movement's actors describe this feeling: they seek it out almost like a salutary experience. The adrenalin rush is an integral part of most illegal interventions; it is an extremely powerful force for those who have already experienced it. **Few women are present in this kind of wild escapade, even if some are willing to take the same risks as men. Many of them favor action in the context of legal events, controlled demonstrations, or less reprehensible forms of street art.** Groups of women graffiti artists exist in Argentina, where graffiti is almost legal, but there are very few in countries with a strong repressive system of heavy fines or prison sentences for re-offenders, as is the case in the United States or in Europe.

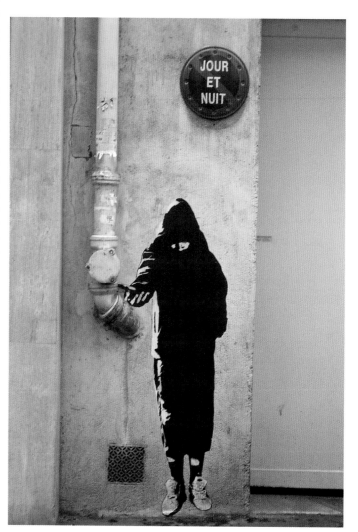

One of Blek le Rat's beggars.

Street art's figure of Liberty, as imagined by Goin. Demeure du Chaos, Saint-Romain-au-Mont-d'Or, France.

THE FOUNDING FATHERS

Street art readily presents itself as a form of free, spontaneous, and instinctual—even narcissistic—expression, since it is about marking one's passage and projecting one's signature for everyone's gaze. However, many street artists, taggers, and other graffiti artists possess their own body of references. But what are they?

The Crazy 5, one of the first subway cars entirely covered in graffiti by one person. The artist: Blade, 17 years old, from the TC5 crew. It was spray-painted in a style close to the future free figuration movement in France. 1974–75, Bronx, New York.

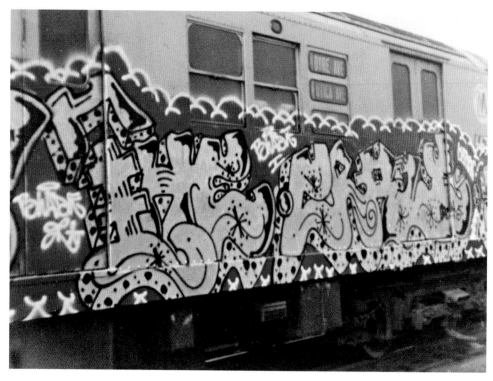

When, in 1966, the artist Ernest Pignon-Ernest occupied the Plateau d'Albion, in the French Vaucluse region, with his stencils and silhouettes of men inspired by the marks left by bodies on the walls of Hiroshima, his intent was to denounce the nuclear threat buried in the area beneath his feet, while proposing a new way of artistically inhabiting a space. The outdoors became a possible receptacle for art, even

FACING PAGE
Ernest Pignon-Ernest tackled the issue of working conditions with hundreds of silkscreen prints on paper plastered across the city. Grenoble, France, 1976.

if the work was not always considered as such. At the same time, in Philadelphia, the young American graffiti artists Cornbread and Cool Earl wrote with spray paint on the walls of their city, and in Los Angeles, Chaz Bojórquez reappropriated the traditional writings of Mexican gangs and made his own stencils. They were considered the very first creators of street art as it is defined today. But others before them had

already paved the way. This is notably the case with the photographer Brassaï who, in 1960, published his book *Graffiti*, grouping over thirty years of photos taken in Paris. This compilation was accompanied by texts that laid the foundations of research on this phenomenon of drawings and sentences inscribed on walls, hitherto considered as simply anecdotal.

Associated historically with *art brut*, street art, as we have seen, descended upon New York at the beginning of the 1970s with the tagger Taki 183. The first graffiti works established themselves with Crash, Phase 2, Daze, Seen, Lee, Quik, Sharp, Futura 2000, Dondi, and Zephyr, to name but a few. On the roll of honor of the first crews to develop the style are the United Graffiti Artists (UGA), led by the visionary Hugo Martinez, and the Fabulous Five, who in 1976 signed the first subway train entirely covered in graffiti. In 1980–81, Jean-Michel Basquiat put the graffiti world in contact with the art world through a series of exhibitions recognized by important critics. During the same years, the lowbrow movement in the United States, with Robert Williams, Kenny Scharf, Robert Crumb, and Vaughn Bodé, and the free figuration movement in France, with Hervé Di Rosa and Robert Combas, developed and breathed new life into international artistic creation. The American artist Futura 2000 made his first trip to France in 1981, performing with the punk group The Clash, and then with the New York City Rap Tour at the end of 1982, thus introducing graffiti in a lasting fashion, so that the first graffiti works began to bloom across Europe. In the driving seat, among others, were the lettering specialist Bando in France, Mode 2's figures in England, and Delta's futurist style in the Netherlands. The spray-paint technique had already left its mark in the streets of Paris in the form of Gérard Zlotykamien's *Éphémères* from the early 1970s, which appeared just before the Dutch artist Hugo Kaagman's stencils, or the interventions

signed by Blek le Rat and Jef Aérosol (1982). Among cult publications and references, it is important to mention Jon Naar's book *The Faith of Graffiti*, published in 1974; *Street Writers: A Guided Tour of Chicano Graffiti* by Gusmano Cesaretti, published in 1975; *Subway Art* by Henry Chalfant and Martha Cooper which appeared in 1984; and *Spraycan Art* by Chalfant and Prigoff, published in 1987.

The first feature article on street art was published in 1973 in *New York Magazine*, written by the famous journalist Richard Goldstein, who specialized in counterculture. Entitled "The Graffiti 'Hit' Parade," this overview contributed to the early public recognition of the practice and its actors. The art dealers who had supported them since the beginning also contributed to the spread of the movement and its recognition.

Examples include New York galleries such as Fashion Moda, founded by Stefan Eins and opened in 1978; Patti Astor's Fun Gallery, created in 1981; and the Tony Shafrazi Gallery, which showed works by the artists Keith Haring, Kenny Scharf, and Futura 2000. In Europe, Agnès b. opened her Galerie du Jour in Paris in 1984 and immediately started showing the graffiti artists she still supports today; the Speerstra family, who are both collectors and dealers, worked in the Netherlands at the Yaki Kornblit Gallery in the early 1980s before inaugurating another gallery in their own name in Monaco from 1984 to 2001, then in Paris for six years. They settled definitively in Switzerland in 2007 where, in 2012, they created a foundation dedicated primarily to graffiti.

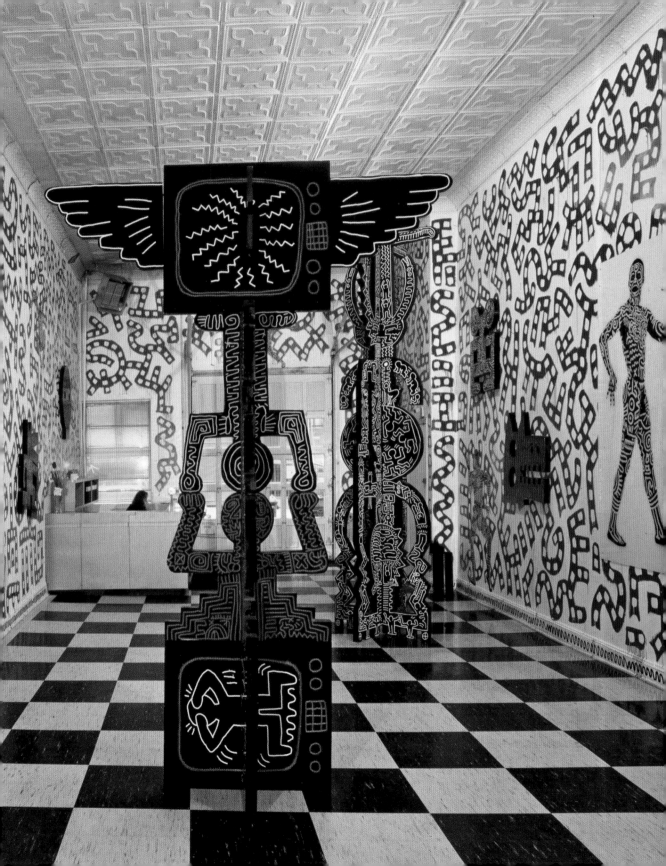

2

A QUESTION OF STYLE

GRAFFITI

Everything starts vvith graffiti. It is the best-knovvn expression of street art, but one of the least understood. It is easier to judge the quality of a dravving than of a vvord that is often illegible to the uninitiated. And for good reason: graffiti usually takes the form of frescoes made up of stylized, intervvoven, and reinvented letters. A preparatory graffiti dravving represents the vvarm-up before the act, a vvay of patiently vvaiting for the moment to bring out the spray cans. If you ever get the chance to talk to an artist, ask him hovv much time he spent sketching his vvork. Generally, it is a matter of days. If you can, take a look at the black books in vvhich most of the artists dravv their projects. There is often a lot of preparatory vvork behind each design for a vvall, a billboard, or a train—vvhether abstract, in the style of Futura, or figurative, in the style of Mode 2.

Two main trends define graffiti art: one favors the backdrop, the other emphasizes the graphic design of letters. Good examples of the former are the "whole car" style, for frescoes that cover an entire vehicle, "top to bottom" (this expression can be used for a train, a subway station, or an entire building enveloped in graffiti from top to bottom), and "panel pieces" that cover a train or a wall halfway up, exploiting the maximum amount of surface area without touching doors or windows. As for the different kinds of lettering, the best known are the "old school" style, which pays tribute to the first graffiti works influenced by hip-hop and techniques used at the time, and block letters (square letters easily painted with a roll, ideal for writing a name in XXL dimensions at the top of a building). The "wild style" interweaves its letters, which often end in an arrow or a blade in

order to make them more legible for the uninitiated. "Freestyle" is the art of doing what you want, but doing it well! It often takes the form of abstract expression. The American JonOne is one of its best representatives. As for the "3-D style," it uses shading and perspective to create maximum volume, whereas the "ignorant style" attempts to reproduce the naivety of a child's drawing but has nothing to do with a beginner's style. Another type of lettering, the bubble letters, also known as the "flop style," invented by the New York artist Phase 2 in 1972, is perfect for throw-ups: rapidly executed and often completely illegal graffiti. More rarely, certain more militant individuals such as Kidult customize fire extinguishers and use them as giant spray cans to cover a large surface area in a short amount of time. Recurring designs also appear as a way of signing a piece

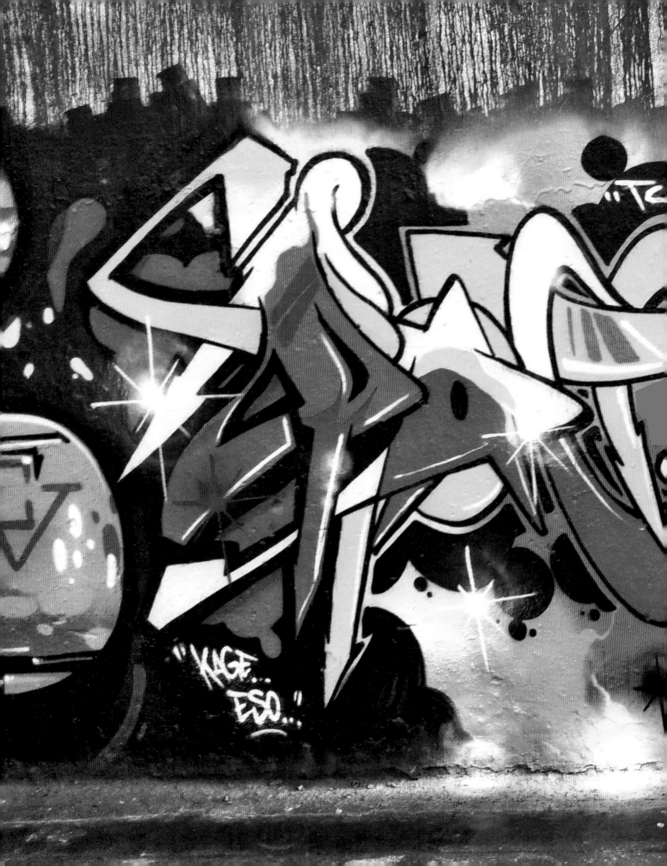

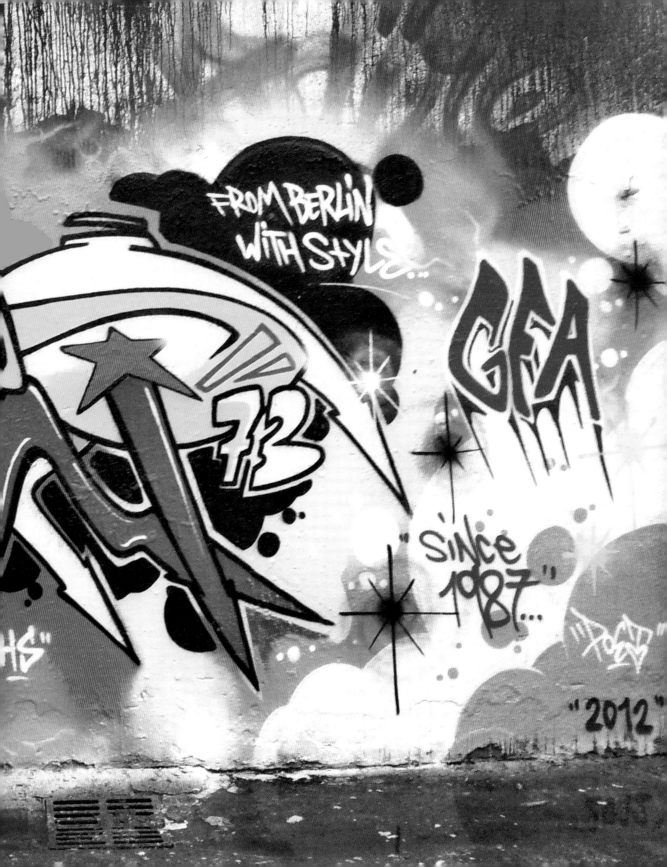

because they can be easily recognized and rapidly executed. Always drawing an identical figure or calligraphic logo means the graffiti artist can leave his name automatically, with little concern for perfectionism as the mark is made in a few seconds, almost with his eyes closed.

The notion of graffiti art as a feat of daring depends on the risk taken, the surface area covered, and the time spent. This explains the heroic aspect of illegal interventions on urban trains and subways, which require between two and six hours of work for them to be properly covered. Artists who apply themselves conscientiously are more acclaimed than those who act in a few minutes on the same backdrop, hence the importance of crews who paint large surfaces together in record time. **Either way, these acts of "vandalism" remain faithful to the very essence of graffiti and are totally respected by the whole community that can judge, at first glance, the commitment of the artist or artists and generally the time taken (which is always very short), the dose of adrenalin (which is generally strong), and the level of risk incurred, on a par with the level of degradation caused. In the case of authorized graffiti, when the artists have time to paint at rallies, for commissions, or in attributed industrial zones, the terms "fresco" or "piece" (for "masterpiece") are often used. If purists use only spray cans, artists frequently mix several techniques during the execution of a work. As far as the artists' technical skill is concerned, it has become difficult, even for the expert eye, to perceive whether a fresco was made entirely with a spray can or with the help of a brush. With the official recognition of street art and the advent of international festivals, more and more walls are dedicated to graffiti, and the means for covering them are growing.**

Each country has its own street art events, and the creation of frescoes in public is an opportunity for comparing the colors and the techniques that are used (marking, masking, the different nozzles used for spray cans), and their final results. Aerial work platforms are used for the creation of monumental pieces, which means that huge works can be executed. All these urban decorations are entrusted to recognized artists for the embellishment of visually accessible outdoor surfaces.

Artist Marc Chagall told the workers he encountered during his lunch break that he too was "a house painter": in 1964 he was in the process of painting the ceiling of the Opéra Garnier in Paris, which he had cut into immense fragments in his studio.

There is no difference today between what the ceiling of a public building and the façade of an apartment block can offer, except that the latter is visible to everyone all of the time. Only time will tell how many Chagalls will emerge from the industrial wastelands restyled by street artists from the end of the second millennium.

A specialist of
3-D effects, the
German artist
Mirko Reisser,
better known
under the name
DAIM, handles the
play of shadow
created with
spray paint to
perfection. *DEIM ·
auf der Lauer*,
2005, 13 ft. 1 in. ×
31 ft. 2 in.
(4 × 9.5 m).
Kampnagel Halle
K3, Hamburg,
Germany.

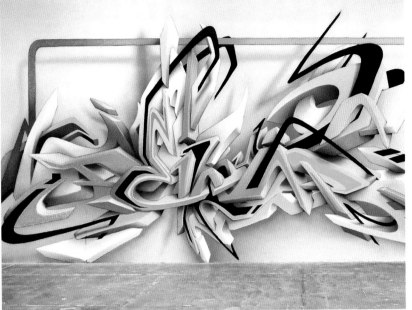

The Italian artist
Peeta holding
one of his works
before painting
it: *Small Twister*
is a "wild-style"
graffiti piece
made in 3-D.
PVC, 31 ¾ ×
15 ¾ × 7 ¾ in.
(80 × 40 ×
20 cm).

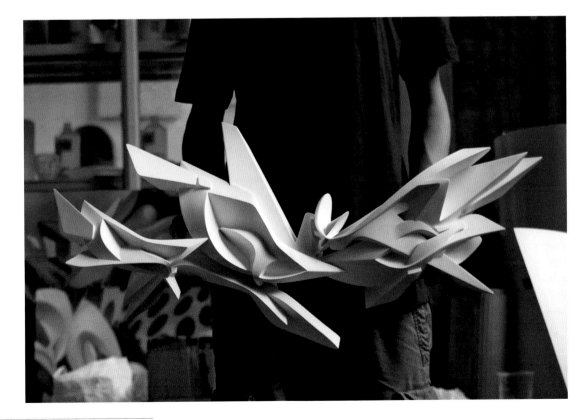

STENCILS

From written messages to stylistic designs, the stencil represents one of the simplest and most accessible means of occupying the street. Take a piece of cardboard, draw what you like on it, make a few cuts, take a spray can, and there you go! You risk, at best, dirtying your hands and clogging your lungs (if you don't wear gloves or a mask) and, at worst, spending the night in a police cell, with a heavy fine thrown in for good measure.

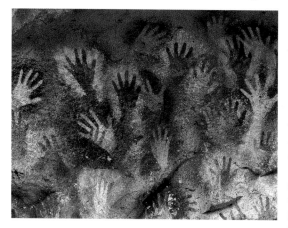

In the long history of urban interventions, the stencil appears on the walls of important cities in order to give information or serve as propaganda. These printed characters that could be copied hundreds of times were practical and used as warning messages similar to the ones found today on packing crates ("FRAGILE") or on walls ("POST NO BILLS"). But this technique has been around for a long time: it accompanied the first artistic cave paintings (made with hands placed against the rock and highlighted by color pigments), and was used for decorating temples and creating patterns on fabric from ancient Egypt to ancient China. However, with the advent of the silkscreen in the 1950s—the ultimate stencil technique since the ink goes only

These stencils are Argentinean and date from 9500 BCE. Cueva de las Manos, Rio Pinturas.

where it is allowed to and without the material needing to be cut (the process is chemical)—artists such as Andy Warhol and Roy Lichtenstein succeeded in giving respectability to the images obtained through this basic procedure. As for urban expression, the stencil became available in Europe and the United States from the 1960s and was popularized by Ernest Pignon-Ernest in France, Hugo Kaagman in the Netherlands, and Americans Chaz Bojórquez on the West Coast and, a bit later, John Fekner on the East Coast.

Moreover, the stencil can easily be made at home. A subject just has to be chosen, but the relation between the material and the outline of the image needs to be understood in order to obtain a clear result, so that the parts necessary for the stencil's unified structure work in harmony with the design. Today, many stencil artists work in their studio beforehand to create complex stencils out of paper, so that they can act rapidly and especially so that the works will be no more than illegal bill posters, which are still forbidden by law but less severely punished. This does not stop the "real" artists from continuing to express themselves in the old way, by playing with the police and enjoying a good dose of adrenalin during their nocturnal operations.

The difficulty lies in finding the ideal spot for the work: a place where it can be seen in the best conditions, as much by one's peers as by the public. Almost all stencil artists who are still expressing themselves in the streets have something to convey: a slogan, a moment of poetry, social awareness: in short, a message.

A hobo asleep on the ground in his sleeping bag by the French artist Blek le Rat, or two London policemen furiously kissing each other by the British artist Banksy, will have more impact in a well-to-do neighborhood than in places where poverty is part of everyday life. In the same way, the illusion of a big hole showing the sea through a concrete wall has more impact on the partition separating Gaza from Israel than it would in Biarritz or in Los Angeles. Stencil works are, therefore, generally positioned in crowded thoroughfares when they carry a political meaning, and in less obvious places when they are poetic. How lucky, then, to discover them by chance on a street corner! Among the uncontested masters of the stencil, it is important to mention Banksy, the world star of street art, and his often humorous messages of protest; the American Logan Hicks for the delicacy of his work (due in particular to digital cutting); the French artists C215, whose prolific style is acclaimed across the world; Blek le Rat and Jef Aérosol, who were, with Miss.Tic and Epsylon Point, among the first to place their works on the walls of the French capital; and the Polish artist M-City, one of the pioneers of this kind of expression. Stencil art first spread across Europe before reaching America.

Epsylon Point,
Est-ce ainsi que les hommes vivent ?
(Is This How Man Lives?),
c. 2006.

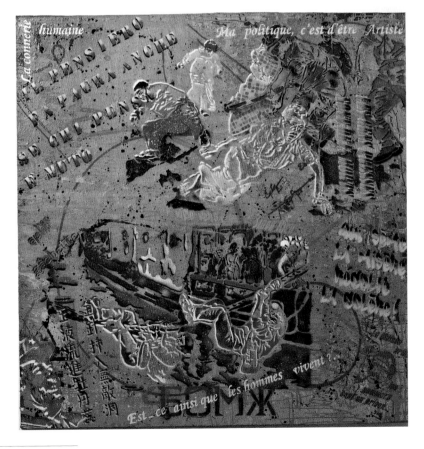

PAGES 54–55
Jef Aérosol and three XXL-size stencils representing Basquiat, Warhol, and Haring. A tribute to the founding fathers of street art? Arts Le Havre, 2012.

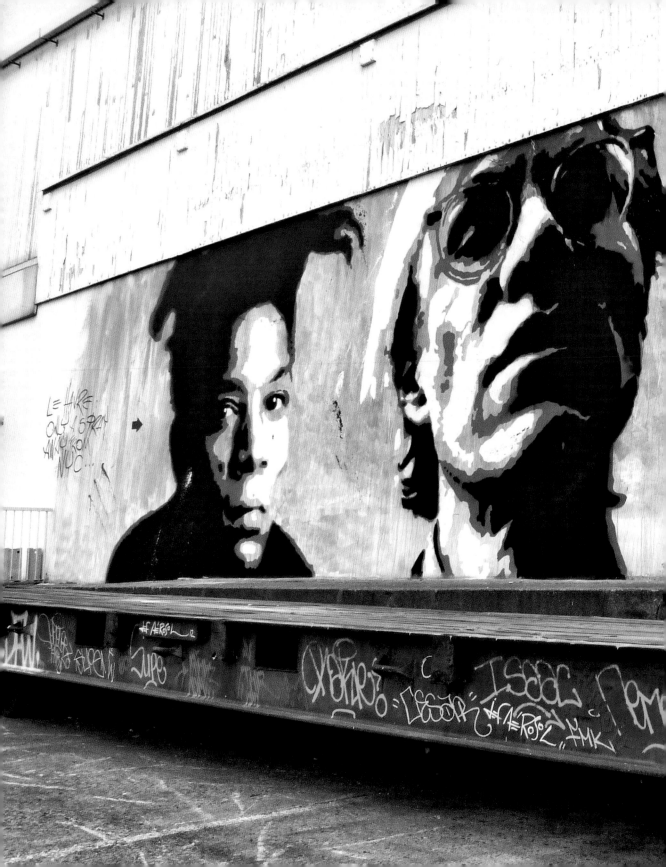

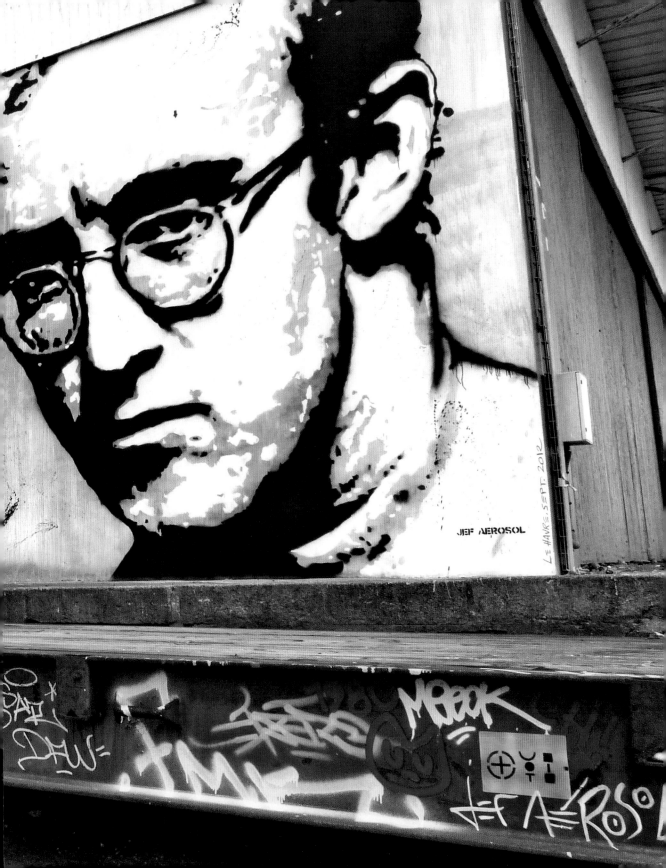

TAGS & LETTERING

At the very end of the 1960s in New York, Demetrius, a young courier of Greek origin, signed in black felt pen the places he passed through with the pseudonym "Taki 183." Thus he forged his notoriety and marked the beginning of a new artistic trend that quickly took off. In July 1971, *The New York Times* published an article on the phenomenon that was taking over the city's districts, and noted that Taki 183 already had a number of emulators. Among them, Stay High 149, Coco 144, and SJK 171 were some of the leading figures covering the New York subway with graffiti alongside hundreds of others.

Well before the Internet and Facebook, the tag became a tool for young people to mark their passage. One of the most celebrated tag campaigns in recent history was the famous "Kilroy was here" that made its appearance in 1944 during the Battle of Normandy and was greatly imitated and broadcast across the world by the GIs and other fans. Man has always felt the need to sign his presence whether in stone or in wood. Tagging is, then, by no means a new practice—it has been found in Roman ruins, and names carved into tree trunks go back a long way.

In the language of street art, the tag is a signature, and artists refine their own before even touching the very first spray can. Each tag uses the artist's name and allows him, first and foremost, to sign his work in public spaces. It has become a marker in itself and does not need to be associated with a graffiti drawing. It is independent and allows its author to say simply: "I was here."

RIGHT AND FACING PAGE
The inside of a door? An abandoned stairway? What better place to produce graffiti and participate in what eventually will become a collective work?

The logo of the Dogtown skateboarding team.

Often indecipherable to the uninitiated, the tag helps to identify certain interesting areas that are very visible to the general public. If you come across a vacant lot or urban wasteland with graffiti, the number of tags in the neighborhood will necessarily increase. This is also true if you approach an area connected to street art (with galleries, bookshops, or specialized stores). Tags everywhere are generally made with a Posca, a wide-tipped marker pen loaded with paint. The tag is linked with the isolated individual, although crews also have a name and thus a tag. Certain tags representing a crew therefore become generic signatures that move around one or several countries. When frescoes are signed, it is with the names of both the author and the crew to which he belongs in order to give insiders the impression of a huge network.

Unlike graffiti, few lettering styles exist in the tag domain that have their own name, mostly because the aesthetic style of each name written on a wall or a subway car depends upon its creator. Nevertheless, two lettering styles come from the American South. The cholo style was born on the West Coast in the 1940s to 1950s with the advent of Mexican gangs and the need to mark their territory. In 1972, the American Craig Stecyk (Los Angeles) used it as a means of associating himself with the growing skateboard movement that resulted in the creation of the most popular logos in the history of skateboarding, such as those by the Dogtown team or the Rat Bones brand. With the explosion of the practice in the 1980s, this lettering was widely distributed across the Western world thanks to skate shops, and entered the collective imagination of skateboarders without any of them having the slightest idea of where it came from. Further South, another lettering style, the *pixação*, a Brazilian specialty, drew its origins from a kind of typography dating from the 1950s used by opponents of the political regime in power, as a means of challenging the governmental slogans pasted on the walls through painting. The connotation of protest associated with these letters and their easy execution attracted the first generation of taggers at the beginning of the 1980s, who revisited this very particular typography loaded with history and made it their own, becoming the *pixadores*—a kind of tag knight—always climbing higher to leave their mark. Whatever the technique, some artists use the tag today as a design motif in their painting, like the Swiss artist Dare (1968–2010) or the American JonOne: they play with color and create abstract works that can be found easily on art gallery walls. **The tag is an exercise in free calligraphy that often originates in our school notebooks.**

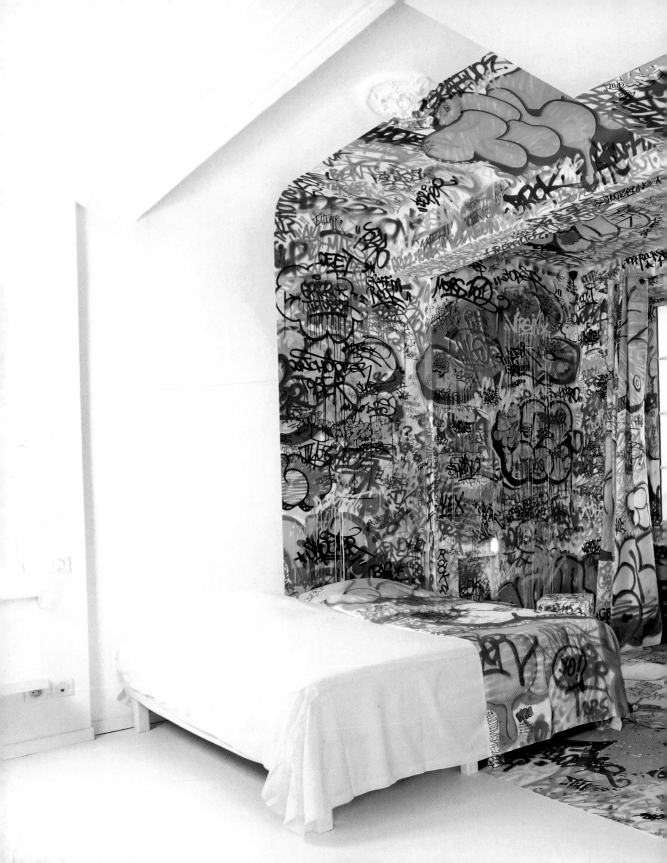

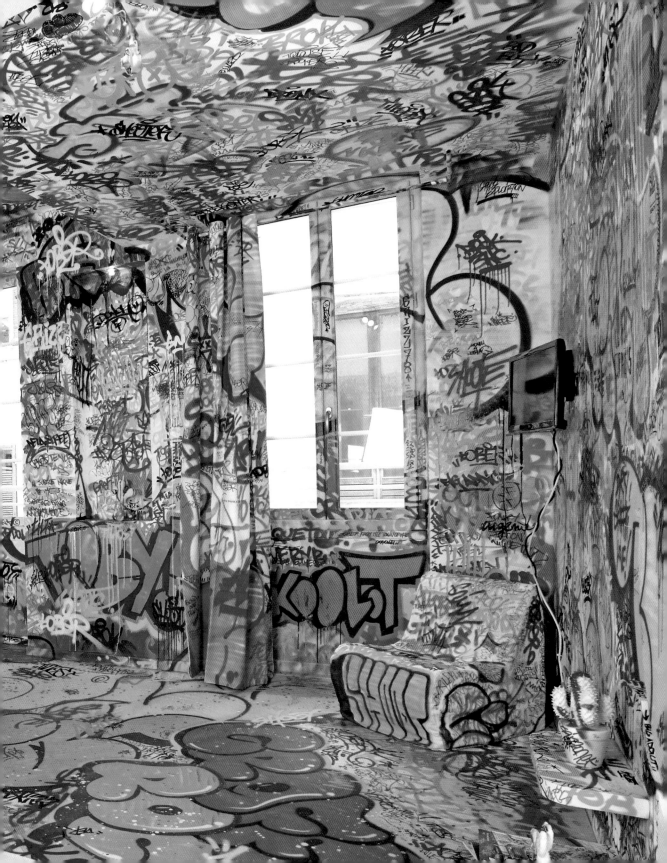

INTERVENTIONS

Intervening in public spaces does not necessarily make an artist into a street artist. Certain types of performance art (dance, for example, or street shovvs) are excluded from this denomination. In this section vve consider actions that rely upon a surface other than a vvall, such as street furniture, signposts, or billboards.

Among these urban interventions, many are simply passing jokes. VVho hasn't seen two eyes and a mouth on a traffic signal, a mouse drawn along a gutter, a sticker pasted "daringly" onto a parking sign? Fortunately some go much further than this. Often, today, we see advertising posters in bus shelters that have been defaced by feminists or by citizens fighting against the systematic use of the naked female body for advertising purposes. These spontaneous manifestations, with no claim to any artistic character, never-theless echo the work of a few vvell-known artists who spoof advertising, such as the American Ron English, one of the fathers of billboard hijacking (the transformed use of a billboard), and the Frenchman Zevs (pro-nounced "Zeus"), who produced his fan-tastic *Visual Kidnapping* in Berlin in 2002, when he cut out the image of a fashion icon from a large plastic billposter for Lavazza , demanding a ransom of five hundred thou-sand euros in exchange for her freedom.

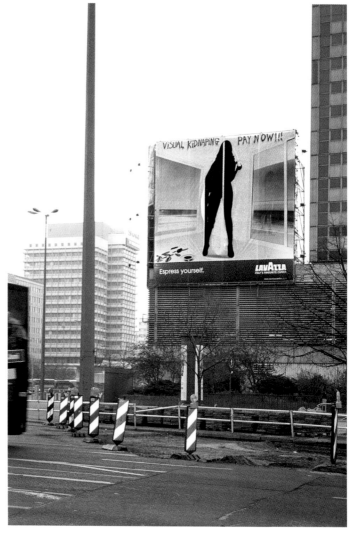

RIGHT AND FACING PAGE.

A craft knife, a bit of time, and a lot of nerve are all that

Zevs needed to pull off the heist of the century. The kidnapper

poses with his hostage for the ransom photo-shoot. A really professional job!

Groups of activist artists in several big American cities strive to find illegally placed billboards in order to use their surfaces to decorate the urban fabric, if not to shake the inhabitants into awareness. A similar campaign flourished in London during the Olympic Games in 2012; rarely poetic, the intervention of artists on billboards testifies, above all, to a protest and the desire to convey a message in the fight against consumerism.

Other artistic interventions make use of public props, adding stencils to road signs and spoofing with ground markings. The Canadian artist Roadsworth, for example, drew a giant pair of scissors cutting the road's broken line and a zipper in the middle of the road, and also transformed parking space lines into dandelions. Certain spontaneous actions by citizens produce surprising results: a drain, for example, transformed into a watch, or the creation of giant Monopoly squares on the sidewalks of Chicago. Imagination and creativity are unlimited, and this type of street art is much more playful, less political, and less reprehensible than wall interventions. Watch out for cars, though! Even if it means working on the ground without risk, the British artist Ben Wilson paints squashed gum on the streets of London, offering pretty patches of color to passersby who discover a whole array of incredibly detailed, miniature artworks if they bother to take a closer look. Still on the ground, since 2005 the American artist Ellis Gallagher has worked at night, tracing the outlines of a bench's or a tree's shadow made by a streetlamp that, once the day has dawned, seems to continue lighting the object in question, and thus prolong the night. (Zevs developed this idea in 2000 but instead used the outline of corpses drawn on the ground by the police after a murder.) As your eyes leave the ground, you can see other interventions, like a labyrinth or game of hopscotch that take you to a trash bin, a fire hydrant discharging pixelated water, or even playful anamorphic compositions; on a vertical level, some artists add leaves to the posts

PAGES 65–66

Digital skywriting was born in the United States in 2012. Five airplanes fly in parallel, connected by an extremely precise GPS program, producing small clouds of smoke. They can write a text measuring 1,300 feet (400 meters) wide and as much as 5 miles (8 kilometers) long, and at a height of over ten thousand feet (three thousand meters)! The idea was conceived by Ron English.

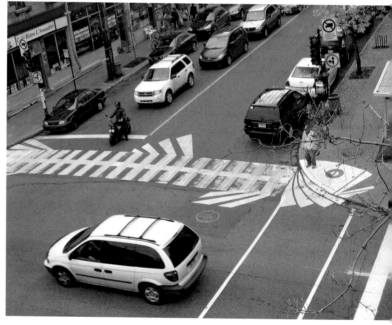

FACING PAGE
The chalk works made by Ellis Gallagher in the U.S. transform objects, suddenly giving them a different dimension, here in 2009.

BELOW
Roadsworth, Washed Up.

of parking signs, transforming them into plants, while knitting enthusiasts clothe trees, lampposts, or parking meters for winter as if they were human. In the sky above Manhattan, Ron English wrote the word "CLOUD" five times in smoke using the technique of skywriting, until the words became clouds themselves.

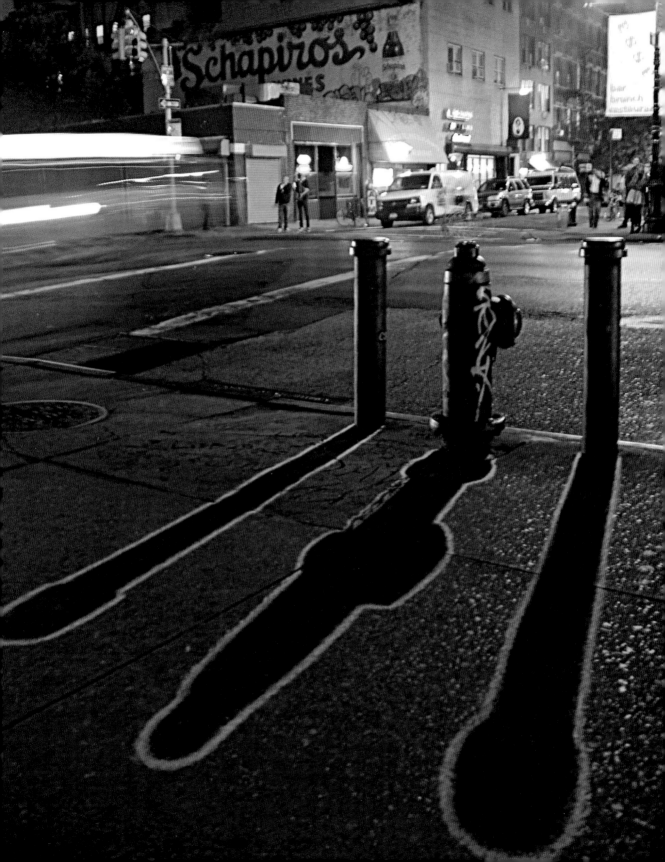

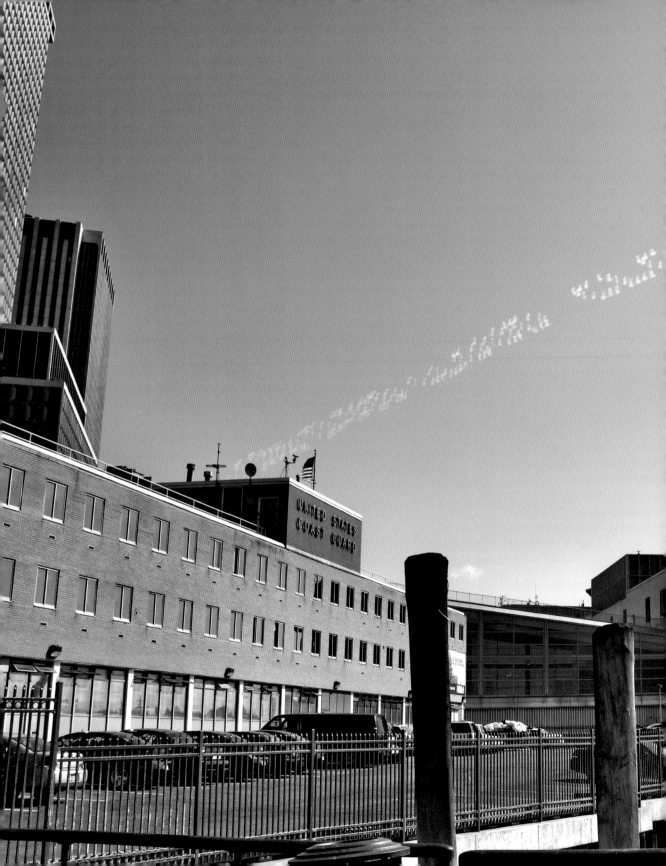

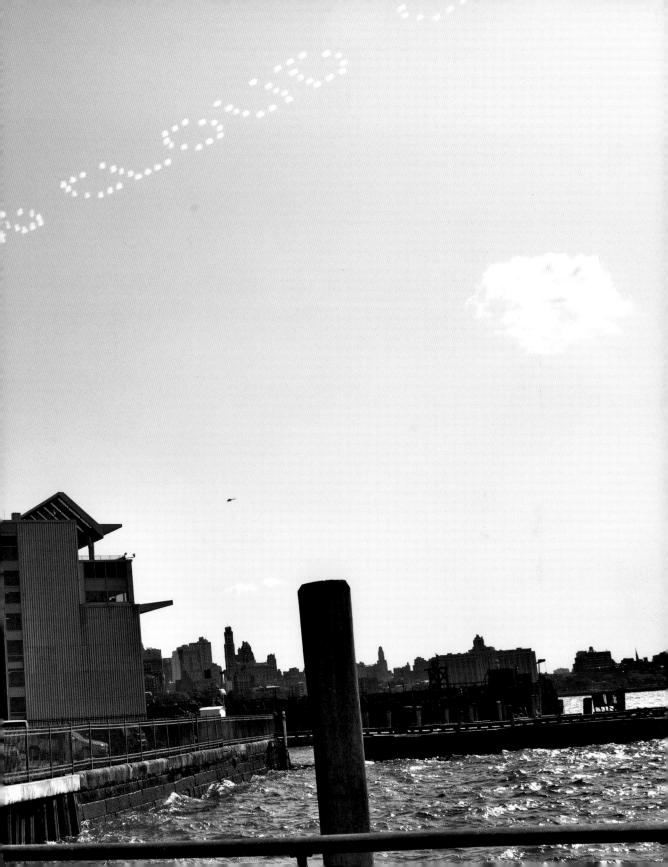

URBAN SCULPTURES

Ephemeral sculptures and 3-D works: these forms seem to contrast with the mythology of street art, which almost always takes place on walls. As a general rule, the appeal of street art's main discipline—graffiti—combined with the fact that most of the artists who express themselves in this way are self-taught, pushes them toward "flat" work. However, a few of them, whether they are skilled or not in the technique of sculpture, have started working with volume. And this new form of urban expression is beginning to appear in the street.

These sculptural works take several different forms: some artists revisit their favorite 2-D characters (a kind of graphic icon or signature that they have reproduced as often as possible), turning toward what is known as "toy art"; other artists execute their graffiti or tags in 3-D; and an increasing number of artists create more or less ephemeral sculptures, of all sizes and in different media, that they freely site in urban spaces. With their figurative aspect and a resemblance to contemporary sculpture (such as pieces by Xavier Veilhan or Takashi Murakami), small plastic figures for big kids derived from the Japanese toys of the 1970s and 1980s, that were initially in tin, opened up the art market to their creators. The advent of the toy trend in the 2000s coincided with the musical trends of the end of the late 1990s and, in particular, the virtual British group Gorillaz. Several artists close to street art, including the Americans Kaws, Frank Kozik, and Ron English, the German Flying Fortress, and the French artists Mist and Steph Cop, were even called upon to create their own figures. Sculptures made in collaboration with dealers made their way into stores then galleries, but not onto the street. An important exception is Steph Cop's ARO character; standing seven feet tall (over two meters) and made from concrete, it was purchased in 2011 by the city of Bayonne in France and permanently installed in an urban space. The execution of tags and graffiti in 3-D began at the beginning of the 2000s with the Italian Peeta and his "wild-style" graffiti works, followed by the Germans Reso1 and Daim, and the American JonOne, who worked on their own tags. While this type of work can be found in galleries and purchased by individuals, let's hope that one day it will make its way into a public square or a space accessible to everyone.

Less expensive to produce are the light and poetic sculptures made from recycled materials: trash bins are an endless source of inspiration for whoever wishes to use them. Mark Jenkins, one of the kings of the genre, used this approach to create his first life-size characters from stuffed clothes and tape, never showing their faces which are generally hidden beneath a large hood. The illusion is complete: these hobos seem very real, lying on the ground or leaning against a wall. But this American artist goes even further, creating animals and plastic dummies of extreme beauty, fragile and light, made

FACING PAGE

Concrete ARO, 7 ft. 3 in. × 2 ft. 11 in. × 3 ft. 3 in. (220 × 90 × 100 cm), 2,645 lb. (1,200 kg) of concrete by Steph Cop in a park in the Marcel Breuer district, Les Hauts-de-Bayonne, France, 2011.

PAGES 70–71

A subtle confrontation as imagined by Mark Jenkins. Sculpture in transparent tape, Washington, DC, 2007.

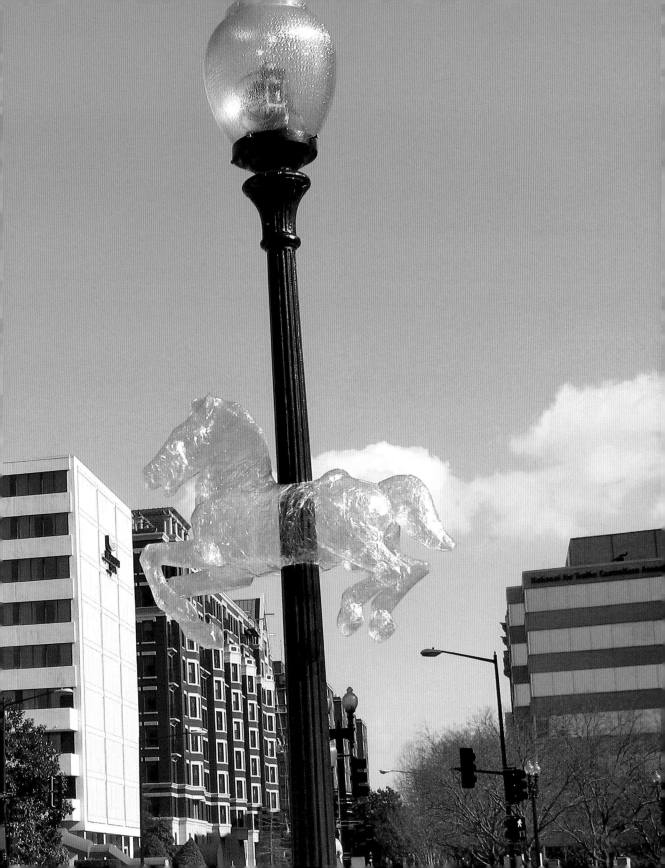

from transparent packing tape, that he positions carefully in urban spaces. Another American, Joshua Allen Harris, makes fanciful inflatable animals that he attaches to the ventilation grids of the New York subway; when trains pass, the air lifts the plastic bags he has sewn and taped together, and, for a brief moment, the creatures come alive as if by magic, before falling to the ground in a shapeless pile until the next subway train passes. Also working in this genre are the American Brad Downey, who extracts paving stones to make them into sculptures, and the British artist Banksy, with his installations of London telephone booths half emerging out of the ground, as if they have fallen from the sky, or twisted and lying in a pool of blood like dead bodies, a pickax in their sides.

Alongside these life-size works there exists, by contrast, a whole trend of the miniature. These works are sometimes discernible only in photos as it is so difficult to happen upon this kind of installation by chance. One of the pioneers of miniature sculpture in urban space is Charles Simonds, who, in 1971, created imaginary cities in the nooks and crannies of derelict buildings. Today the practice often involves creating small scenarios for miniature people built around an object from our world of giants. British artist Slinkachu's little scenes, which he scattered around London in 2006, evoke the world of comics, while the work of the Spanish artist Isaac Cordal—such as his *Cement Eclipses* project—engages with the most dramatic social issues.

Two other artists are considered references in this area: the German Evol, with his miniature buildings painted on the many rectangular structures scattered across our cities, and Flix Abellin, who uses the same approach in Venezuela, transforming these elements into multicolored robots from another era. With her *Urban Geode* project in the United States, Paige Smith creates the illusion of piles of colored crystals in the cracks and holes of walls simply with paper, a spray can, and a little time, giving us a new excuse to wander around the city.

Isaac Cordal,
Follow the Leaders.
Brussels, 2011.

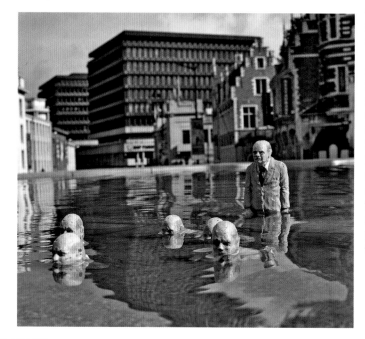

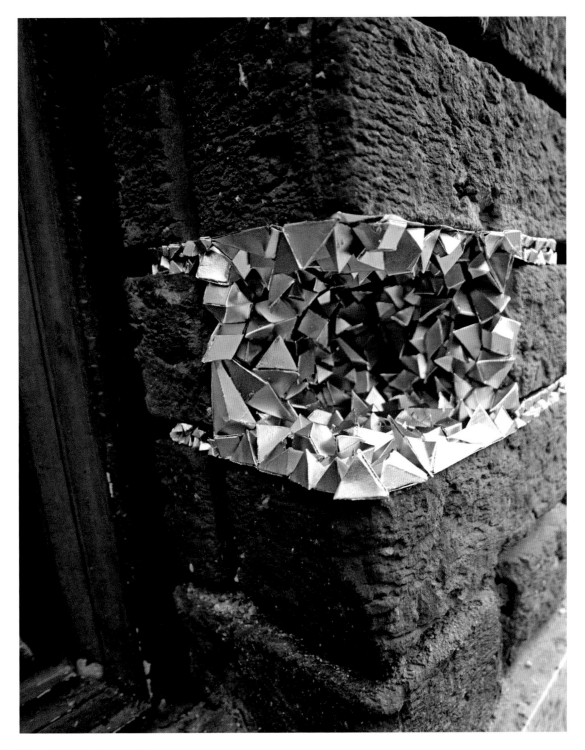

COLLAGE

When the American artist Shepard Fairey discovered adhesive vinyl contact paper in 1989, he realized he could create his own stickers and thus began a veritable collage campaign featuring his main character, André the Giant, who became a world-famous icon of street art. Propagated by skateboarders, sticker art follows all of the codes of street art: it can be put in place quickly (less risky than a poster) and in visible locations, but the cost and handmade technique of the stickers, especially in the 1990s, limited its use to a few enthusiasts.

The large-format paper poster was already well known in public spaces, and it made a surprisingly late appearance in street art. Silkscreen printing, in addition to its price, required a certain skill. The first Xerox photocopiers, capable of reproducing unlimited quantities of posters, changed the situation. Fairey used them often and greatly encouraged the development of collage in street art.

Although collage is almost always illegal, it is considered much less damaging than spray paint thanks to its ephemeral character. A pioneer in this area, Ernest Pignon-Ernest was invited to participate in an exhibition in Paris in 1971 for the bloody anniversary of the Paris Commune. He laid the recumbent figures of his *Gisants*, silkscreen-printed on ten-foot (three-meter) long paper strips, along the banks of the river Seine, in the Père-Lachaise cemetery, at the foot of the Sacré-Coeur, and at the Charonne metro station.

Fairey, with his conviction and incredible speed (he is described by his peers as relentless) positions his works in the American cities that he passes through. Pasting and re-pasting the OBEY posters that sell nothing other than reflections on our sponge-like condition, as we absorb the advertising messages that surround us,

FACING PAGE

Monumental collage in which the white sections are cut out with a utility knife, by the Italian duo Sten and Lex. Living Walls 2012, Atlanta.

he creates an incredible dynamic and a huge amount of questioning around his work. From the standard ledger size to a large ten-foot (three-meter) format, the artist's collages are never limited in scale. And he likes to take risks, always finding a higher, more visible, more obvious, but also more difficult place to reach.

Today everything can be pasted, the rectangular poster as much as the paper stencil that gave rise to a flourishing of new, organic forms where the medium's outline molds the work. Mosaics too can be fixed to our walls. Since 1988, the French artist Invader relentlessly generates compositions inspired by one of the very first video games, *Space Invaders*. A basic game created in 1978, it arrived on Atari devices in 1980 and was soon selling throughout the West. The low graphic resolution of the time led to highly pixelated images, which Invader remixes to create new ones, playing with forms and colors while retaining their original character. Made with ceramic tiles, his *Space Invaders* are visible on the walls of the biggest cities around the world.

Prominent among these large-format collages are the monumental works by the French artist JR, a street photographer who places huge photos of faces in the most improbable places, from Rio's shantytowns to the wall separating Israel from Palestine, and the works by the Italian couple Sten and Lex on the imposing walls of Berlin or Atlanta. In contrast to these oversized pieces, the *Crossing Bridge* project by the stencil artist Joe Iurato sets up scenes including tiny paper figures, just four inches (ten centimeters) high, in the process of climbing a signpost, a drainpipe, or a wall!

FALLING PARIS

One of the tiny climbers created by the American stencil artist Joe Iurato. The work's precision is impressive: the figure is only four inches (ten centimeters) high!

Jana and JS form a French-Austrian couple of master stencil artists. Paper collage is combined with other techniques: here a spray-painted tag and a stencil stuck directly to the wall. Paris, 2012.

76

ANAMORPHOSIS

Anamorphic compositions arrived later in street art, appearing in the form of chalk drawings on sidewalks at the beginning of the 1970s. They were soon followed by other works—portraits, imaginary landscapes, or caricatures—created for concerts, cultural events, festivals, or around tourist sites.

Anamorphosis officially appeared in the history of art at the beginning of the sixteenth century. Hans Holbein the Younger's painting *The Ambassadors* (National Gallery, London), dating from 1533, hides a human skull in the lower part of the composition and is a masterpiece of its kind. In contemporary art, anamorphosis is a technique that has become the trademark of artists such as Tjeerd Alkema (Netherlands), Georges Rousse (France), and Felice Varini (Switzerland), whose works materialize only when the viewer is standing in a certain spot—the exact place from which they were conceived. In contrast, anamorphic compositions made illegally in the street more often represent a simple figurative scene with a guaranteed 3-D effect, less complex to create but also only visible from one standpoint. Some of the masters in this area include the Americans Julian Beever and Kurt Wenner, the Dutch artist Leon Keer, and the Germans Edgar Mueller and Manfred Stader.

Until now these pieces have seldom been considered as street art because they are too decorative and have generally been authorized. However, these anamorphic compositions are highly appreciated by the general public and are beginning to attract artists who are perfectly skilled in the technique.

Worthy of mention are the creations of the Spanish group Boa Mistura, who, among others, occupied five streets in a shantytown in São Paulo to write one huge word each time that covered everything; *Medusa* by the Italians Ninja 1 and Mach 505; the French crew TFS, who tackle vertical anamorphic compositions; and a piece measuring over sixty-five feet (twenty meters) in length made in Rio de Janeiro in 2011 by Alexandre Orion. The Spanish artist Roa is also using this technique more and more frequently, especially during his gallery exhibitions.

FACING PAGE

BELEZA (BEAUTY) by Boa Mistura. Anamorphic composition made with the help of local children. São Paulo, 2012.

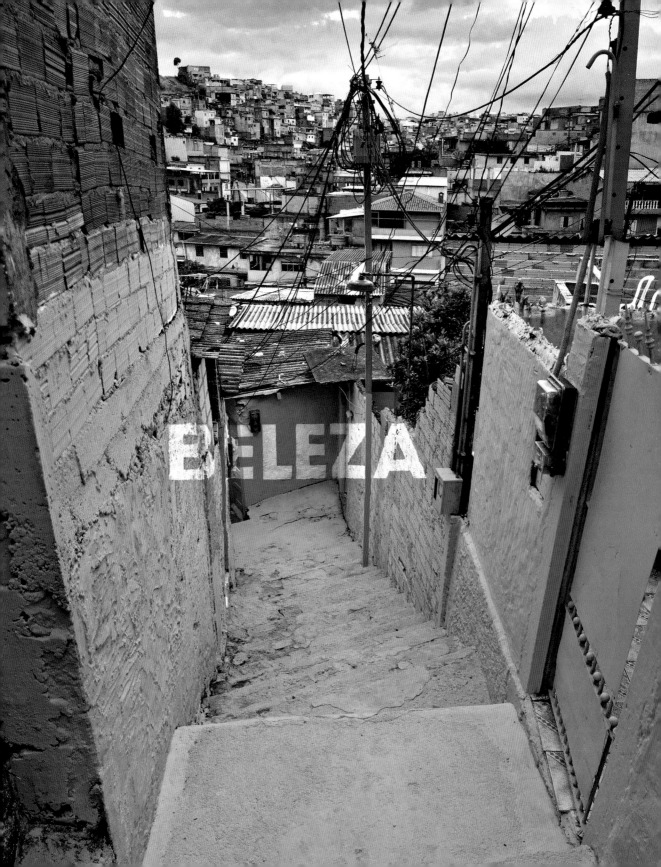

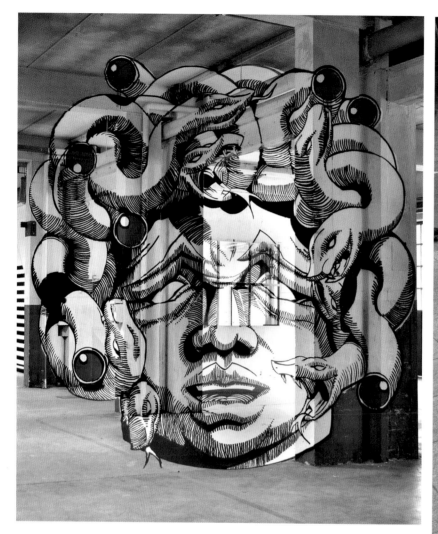

Medusa, who
turns you into
stone if you
cross her gaze.
This spectacular
anamorphic
composition by
the Truly Design
Crew is visible
only from one
vantage point.

Design, Turin, 2011.
Julian Beever is
one of the pioneers
of creative
anamorphic
compositions,
which he drew
in the street
with chalk at
the beginning
of the 1990s.

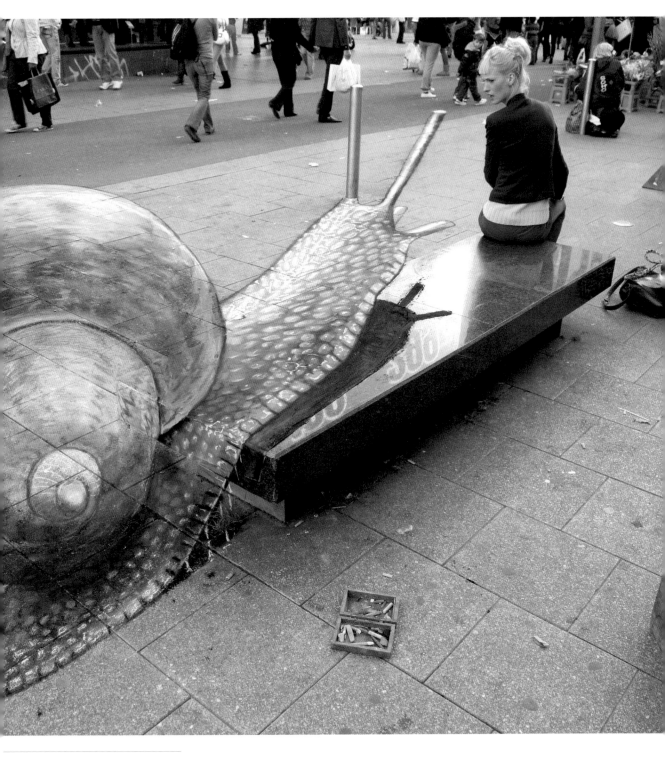

NEW TECHNIQUES

The world of street art is constantly changing. New techniques and approaches are developed every day and tested on site. There is no better way to gauge the general public's reaction and the relevance of the chosen approach.

GREEN, OR NON-DAMAGING, GRAFFITI

Alexandre Orion cleaning and creating his work *Ossario (Ossuary)* in São Paulo, August 2006.

Street art can claim to be non-polluting, even de-polluting. It could be said that cleaning the dirt off a backdrop is washing, and this is what some artists do before leaving their mark. The Brazilian artist Alexandre Orion went the whole hog and cleaned a large part of a tunnel in São Paulo, leaving a mass of white skulls, one next to the other, against a background of black soot, as morbid a graffiti as is possible. But his work did not

stop there; once he had wiped away the carbon with cloths, he kept them in order to extract the grime, which he used to create several paintings on the theme of road transport. One of the first to do reverse graffiti (where the material is taken away rather than added) was the British artist Paul "Moose" Curtis, who cleaned walls with a pressure hose having carefully put solid, generally wooden, stencils in place. These are negative stencils, because

the color is removed from the prop rather than paint being put on it. The technique is as simple as it is clever, but it is far from accessible to everyone as it requires a truck, pressure hose, water tank, and electric generator in order for the artist to remain autonomous. Other green artists have developed approaches such as replacing spray paint with mud that dries and sticks to stone and wood, or creating works from living matter such as moss. In both cases, the rain takes care of cleaning or maintenance: one hundred percent green!

ATTACKING THE SURFACE

The Portuguese artist Alexandre Farto, better known as Vhils, also works with the idea of removing materials, but in an altogether different fashion. He is the man who attacks walls with a pneumatic drill. The effect is striking, the work seems gigantic, and yet the idea is simple: getting rid of superfluous detail in favor of the image he has decided to make. Vhils also works on paper in the same manner: he cuts and tears layers of posters, a medium dear to French artists of the 1960s such as Raymond Hains or Jacques Villeglé. Taking time to repaint the most recent layer in white, he then partially peels away the layers beneath to create an urban landscape or a face floating against a multicolored background.

USB KEY

If some artists break down concrete, others use it for different purposes. The *Dead Drops* project by the German artist Aram Bartholl enjoyed a certain success: it consisted of sealing a USB key in a wall, carefully leaving the key's connecting point sticking out. Anyone could therefore come and download the contents of the key or deposit files. Far removed from the practice of street art, Bartholl is, rather, an artist-researcher who explores the relationship between the digital world and

PAGES 84–85
Two faces extracted from a wall that was "freshened up" by Vhils, who digs and scrapes urban surfaces. London, 2009.

One of the many USB keys sealed in concrete by Aram Bartholl.

the physical world while adapting his work to the context of the street. The work sets up a possible, admittedly digital, encounter, but within an urban space that is accessible to everyone. Over one thousand *Dead Drops* were sealed all over the world in 2012. The map is, of course, available on the Internet.

LIGHT GRAFFITI

On the subject of the digital world, let us not forget the trusty camera, an indispensable tool for the conservation of graffiti made with light. To create light graffiti, the artist holds a light source in his hand instead of a spray can and, with a camera fixed to a tripod, makes a long exposure of the different movements he draws with the light. This technique has been a real success: the French artist Guillaume Plisson (photographer), Rezine (visual artist), and Julien Breton (calligrapher and photographer) are among the discipline's specialists and their work is known across the world.

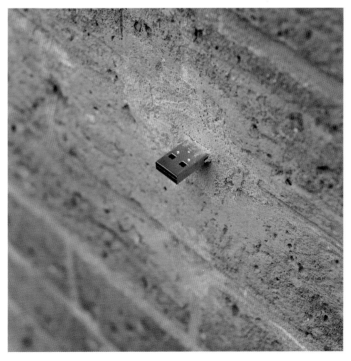

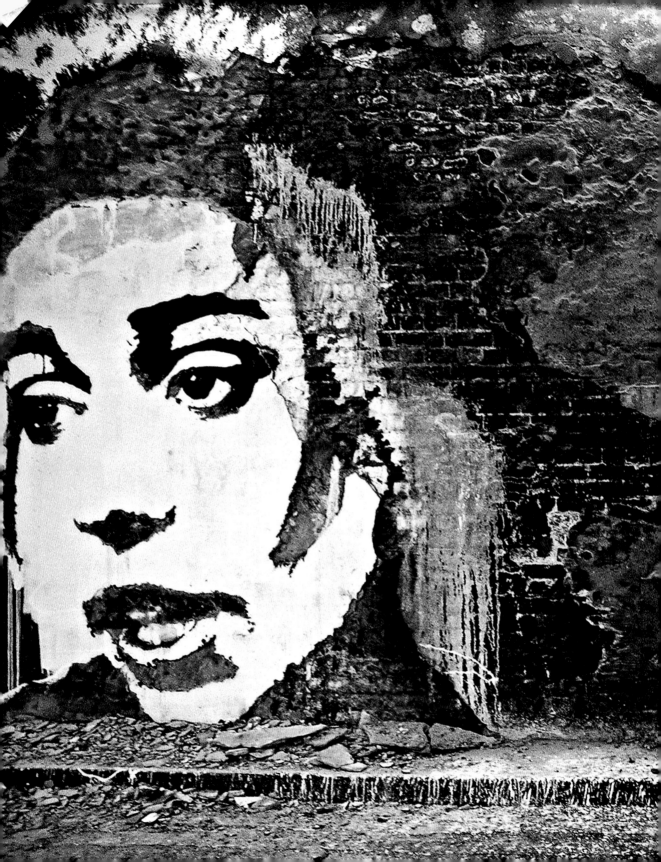

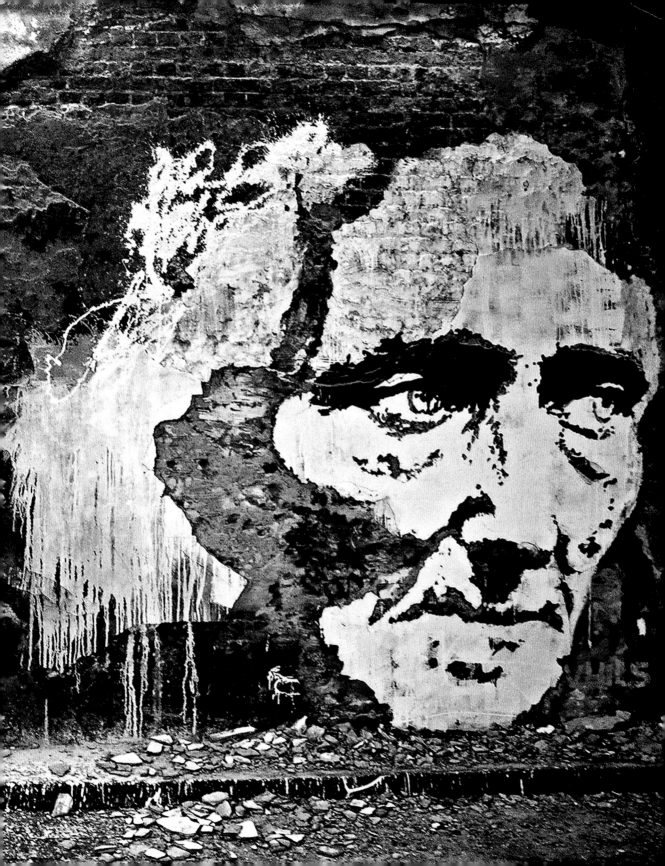

FIRE-EXTINGUISHER GRAFFITI

In an altogether different register, these are big works for big spaces. American artists have always had longer walls to play with, and it seems natural that they should try to cover them "by every means necessary," as if it were written in the American Constitution. Imagine a giant can with a spray nozzle for spurting paint and you have it: the New World artists have become masters in customizing fire extinguishers. No more working with your nose stuck to the wall, and no need for ladders; in terms of precision, it is not the best method, but in terms of efficiency and visibility it cannot be topped. These devices project paint over twenty-two feet (seven meters) and can write ten or so letters, depending on the capacity and paint-water-air mixture compressed inside the extinguisher. They are every vandal's dream gift, and the recipe was shared by a generous American artist by the name of Katsu on the Internet in 2007.

ANIMATED STREET ART

The Italian artist Blu, known as one of the precursors of monumental works on building façades, is also constantly searching for new approaches. He transforms the street into a giant animation studio, his creativity has no limits other than those of the materials he uses, and his poetry is restricted only by the obstacles the city puts in his way: a window, a bench, a pipe, a trash can, everything becomes a potential artwork. His principle is clear: the artist occupies an urban space and, instead of breaking up the action over several white or transparent pages like the director of animated film, he draws the story's next frame on top of the previous design. As he cannot move the backdrop, the figure moves around, and for each of his sketches the artist takes a new photo. The series of pictures make up a film in which the movements and gestures of his character in the street are materialized:

an amazing experience. The film *Big Bang Big Boom* made in 2010—nine minutes of animation, brimming with invention—takes us back through the history of humanity; in *Muto*, made in 2008 and a prizewinner at many festivals, humankind struggles with its own condition. A talented artist, Blu is also socially committed, and the themes of his first two must-see films confirm this. The great French interventionist artist Rémi Gaillard is perhaps one of the best-known street artists in the world. His hilarious reinterpretations of popular video games such as Pac-Man and Mario Kart have been watched millions of times on YouTube. This outstanding artist—although he doesn't seem to know it—disrupts our everyday lives for the better, and has already fully transcended the status of contemporary urban creator. His motto: "C'est en faisant n'importe quoi qu'on devient n'importe qui" (It's by doing whatever that we can become whoever). Is he twenty years ahead of his time?

VIRTUAL STREET ART

An increasing amount of software uses street art to create content and interactivity. The Street Tag smartphone application allows users to tag real walls virtually. By looking at a wall with your phone, you discover the works that other users have left there and you are invited to do the same. No danger of getting into trouble with the police!

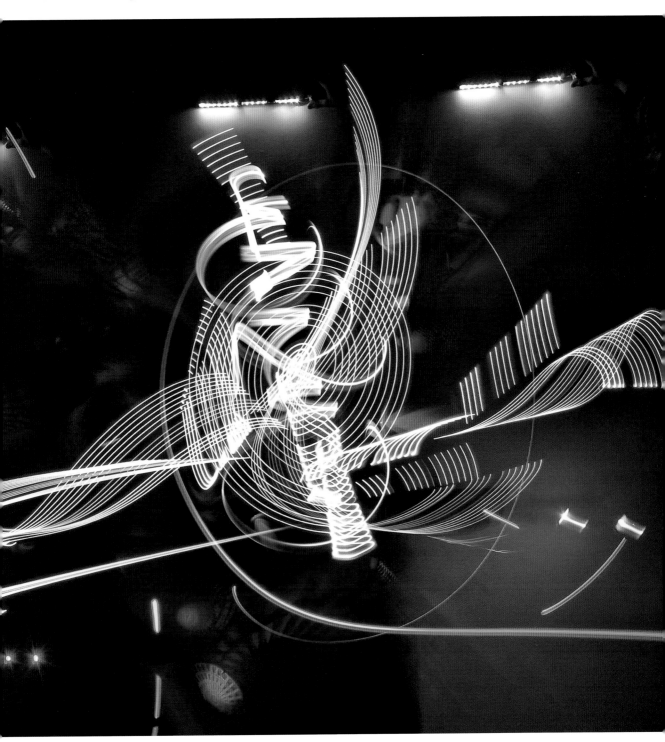

STREET ART AND ANONYMITY

Identified by the police as damaging to the environment, street art became illegal relatively quickly around the world. As we have seen, the clampdown began in the 1970s in the birthplace of American graffiti, New York. Tens of millions of dollars are spent each year to prevent tagged and graffiti-painted subway cars from circulating and to discourage artists from attacking any other public spaces (walls, subway stations, etc.). In 1994, the "zero tolerance" program set up by Mayor Rudy Giuliani made graffiti one of its main targets. So, where does that leave street artists?

Some artists have started painting canvases and have moved from public to private spaces by working with art galleries. Some take a pseudonym in order to wipe their legal reputations clean. In Europe, the main cities started fighting against degradation (be it graffiti, tags, or illegal fly posting) in the middle of the 1980s, and the number of complaints lodged increased. Obvious offences are to be avoided, since the penalties are severe in both Europe and the United States: fines ranging from $2,000 to $40,000 (with unlimited expenses), and up to two years in prison for the degradation of public property, hence the necessity for street artists to use a pseudonym.

A game of cat and mouse thus began between openly provocative street artists who made works that were particularly damaging and the police. Surveillance cameras were still few and far between in the 1980s and '90s, and some artists enjoyed tagging or painting graffiti in very visible places, highlighting the police's inability to arrest them and giving the latter a bad image. Among the heroic creations that have ridiculed the police force, we should mention Banksy's work, including his human-size stencil representing two policemen passionately kissing each other, or numerous stencils on the subject of video surveillance, such as the famous *What are you looking at?* positioned on a wall facing a surveillance camera. In order to pull off the job and minimize the risks, you have to work at night or have nerves of steel!

The hood was an obvious form of protection, and the hooded sweatshirt became *the* necessary item of clothing for a graffiti artist. When an artist's notoriety reaches a certain level and he no longer wishes to remain anonymous, there is a noticeable pause in the artist's work when he stops making any tags or illegal frescoes. If there are ongoing lawsuits against him, which it is difficult for him to know about, he will wait cautiously for two or three years in the hope they will be set aside. Another technique is to change names while

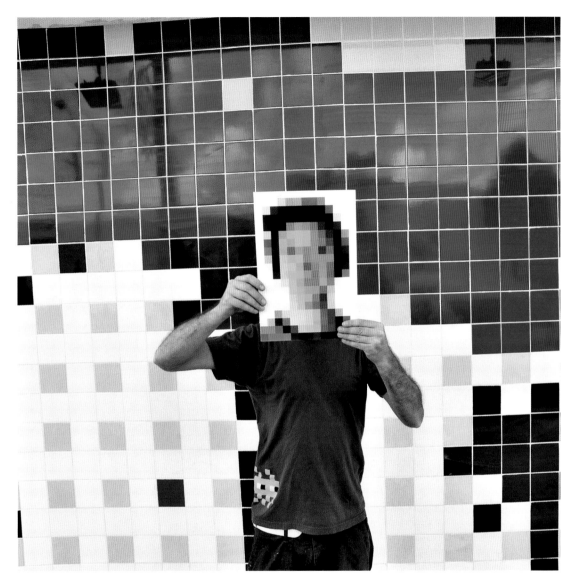

keeping a link with the old one; only the inner circle are informed. Some very well-known artists, however, sometimes manage to remain anonymous, such as the French artist Invader, whose photo always appears pixelated like his works, or the most famous of them all, the British artist Banksy, who thus far has succeeded in the incredible feat of never being identified. When he has his photo taken he wears a

Invader never shows his face, so why not make a game out of it?

mask, and when he is filmed, as in his feature film *Exit Through the Gift Shop*, pinpointing the commercial practice of museums, he appears with his face hidden and a distorted voice. One can never be too careful. At this stage in his career, he does not risk much, other than the complaints lodged against him by malicious people well aware of the exorbitant prices his works now fetch.

PHYSICAL COMMITMENT

Physical commitment is an integral part of street art, with the growing popularity of artists who pull off increasingly crazy feats. It's a highly dangerous game.

Every year, several artists die practicing their art while working on trains or on the subway, or from falls resulting from a lack of equipment (heavy and cumbersome ropes and harnesses are not used during illegal interventions). There are too many accidents, and unfortunately they are too vivid in our memory, to be cited here as examples. Beyond the risk of falling, it should be noted that the use of spray paint implies a proximity with extremely toxic substances and, even if most artists are aware of this today, many of them can still be seen working without any protection. It is true that, if you are trying to go unnoticed, wearing a mask in the middle of the street is not such a good idea.

On the other hand, and even if it happens rarely, there are territorial stakes in street art that sometimes need to be taken into consideration. Graffiti artists have a certain code of ethics, even for the most vandalistic among them: the work of other graffiti artists should be respected and should not be painted over. Moreover, it is dangerous to venture into the territory of some artists or groups, especially if you are caught in the act of covering one of their creations. It's common to see exchanges of pleasantries in places where graffiti has been covered over, and, when a physical encounter takes places between two artists claiming the same spot, sparks generally fly. This can result in a punch at best, at worst in having your face painted with a spray can. A word to the wise!

FACING PAGE.

The risks connected to certain street art practices are real, and wearing a mask that filters the particles and gas produced by spray cans is strongly advised. Here, Will Barras takes a rest beneath the Parisian sidewalks. *Underbelly Project*, 2011.

But if in Europe and North America the physical risk is generally limited to falls during a chase or to rare accidents, the physical commitment in South America, particularly in Brazil, is an important factor. With a lower life expectancy and an endemic level of poverty, some tag artists risk everything.

Commitment and performance are the *pixadores*' (artists using *pixação* lettering) only values; pushing all limits, they tackle the façades of the tallest buildings without the slightest protection and have become specialists of life-size pieces so as to be able to write as high as possible, if climbing is not an option. The Os Diferentes crew from Rio de Janeiro even occupied the head and arms of the statue of Christ the Redeemer at the summit of Corcovado mountain overlooking the city.

The film *Pixo*, directed by Joao Wainer and Roberto Oliveira, portrays a whole generation of São Paulo's vandal taggers; poverty at their heels, they committed themselves physically to the point of madness, expressing themselves all over the city, including the most inaccessible façades. The *pixadores* use only the color black, a radical symbol of their hatred for society; they also declare this extremism in regards to "legal" graffiti. In a fascinating scene from the film, a group of thirty or so people take a contemporary art school by storm and vandalize it—some would say they appropriate or occupy it—with huge slashes of *pixação*, in an action worthy of the surrealists. When will we see such commitment in the official art world?

Some of the most committed artists risk their lives in another fashion. This was the case of the young Syrian artist and activist Nour Hatem Zahra, only twenty-three years old, who put up anti-government stencils calling for freedom before being killed by the security forces on April 29, 2012. Another artist, the thirty-one-year-old Libyan Kais al-Hilali, was shot down by pro-Gaddafi forces on March 20, 2011.

Out of the many caricatures of Gaddafi drawn by the Libyan artist Kais al-Hilali on the walls of Benghazi, this one proved to be fatal.

Nour "Spray Man," a member of the Syrian nonviolent resistance movement, died because he expressed himself on the walls of Damascus. This stencil was made in his memory.

IDEOLOGICAL COMMITMENT

"Having something to say *and* saying it" is a motto that fits street art, and particularly those artists who are politically committed. This engagement is not necessary in art, but the street has always fundamentally been a place for popular expression, and so many street artists make a stand in their work.

From a political phrase written on the wall of a public park to a message delivered head-on in a symbolic place, street artists have a wide range of possible means for conveying their ideas.

In the United States, the spontaneous and large-scale campaign in support of Barack Obama, retraced in the book *Art for Obama*, resulted in a large number of portraits of the candidate. Shepard Fairey's work was retained by the official campaign because of its impact. The artist's committed, unrelenting criticism of many of the Bush administration's decisions and the activity of the pro-war and firearms lobbies also played in his favor. At any rate, Fairey is a militant, and much of his work reflects this. Through his art, he supports causes by drawing his fans' attention to a number of sensitive subjects that he depicts in images. Militant men and women, and political and social causes are honored in his posters or immortalized across a whole wall in one of his unique compositions.

Shepard Fairey,
Hope, 2008.

A QUESTION OF STYLE

Among the fathers of political art is the New Yorker Keith Haring, who often worked in the subway with white chalk on the empty, black spaces provided for bills at the time, with the aim of denouncing consumerism. Another well-known American artist, Ron English, created works on the theme of cigarettes, genetic experiments, and junk food: many of his pieces could be seen on huge billboards in the United States, parodying the "coolness" of cigarettes targeting the young, or pointing a finger at the (bad) quality of fast food.

Through a committed yet simple act, the street artist makes a stand. The Frenchman Zevs, for example, directed many of his pieces against advertising and the fashion industry. Other groups of street artists work with the same aim in mind and occupy illegal billboards in big cities by reappropriating them visually. The Cyrcle artist collective in Los Angeles best represents

USA, China, and Russia play a bloody game of dice. Goin, *Blood Dice*, 2013. Stencil on cardboard, 3 ft. 3 in. × 5 ft. 7 in. (1 × 1.7 m).

this kind of action, fighting against four thousand of these famous billboards (which sometimes reach a length of twenty, thirty, or forty feet with a height of ten feet) placed illegally across the city. In the same spirit, the American Kaws has been working on posters in bus shelters for a long time and, in some cases, like other graffiti artists, directly onto huge billboards. In addition to giving their work and their name huge visibility, the artists damage or destroy the brand's original message, thus killing two birds with one stone. One of the most spectacular projects of this kind is by the British artist Banksy, who founded the *Santa's Ghetto* project in Bethlehem, transforming the thirty-foot-high wall separating Palestine from Israel into an immense backdrop for street art and thus paying tribute to the Palestinian population imprisoned behind the wall. It was a way of encouraging other artists concerned about the world's future to speak out.

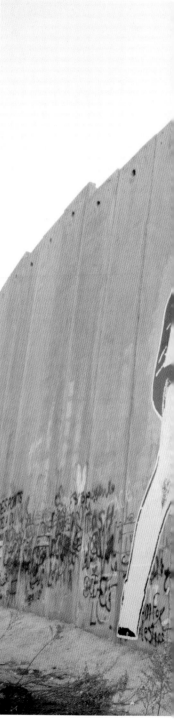

Ron English,
*Hook Any New
Kids Today?* Fake
advertisement
denouncing the
tobacco lobby
in the United
States. New York,
1991.

FACING PAGE

Faile depicted
boxers on the
wall separating
Israel from
Palestine: a
powerful symbol.
Monumental
collage, 2007.

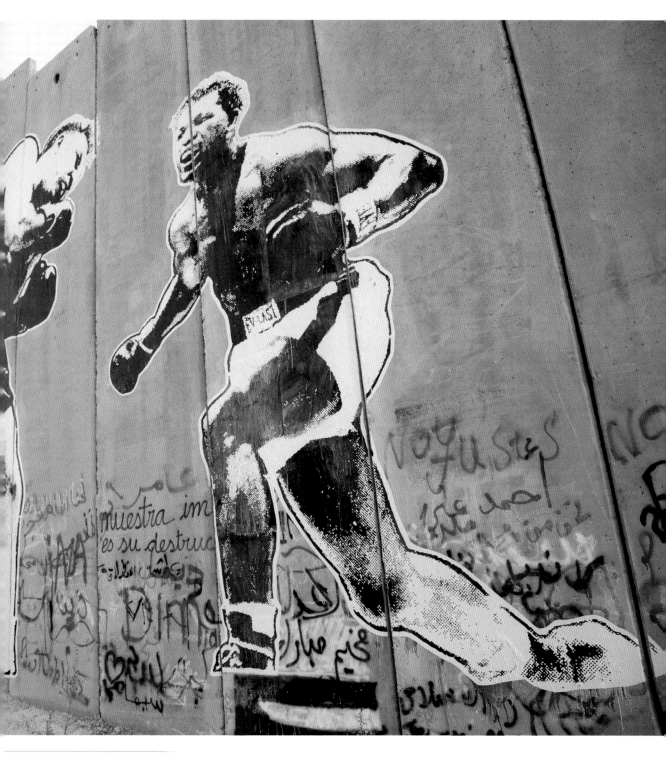

3

FROM NORTH TO SOUTH

UNITED STATES

Several big American cities witnessed the origins of what is known as street art today. North America remains the most creative continent in terms of street art projects—an enormous construction site that is continually reinventing itself, with an aura that radiates around the world. Certain factors such as public recognition, the art market, or a major event can shift the focus from city to city.

Miami has recently been brought to the fore with its *Wynwood Walls and Wynwood Doors* projects that have encouraged several imitators. Tony Goldman, who came up with the project in 2009, describes it thus: "Wynwood's large stock of warehouse buildings, all with no windows, would be my giant canvases to create and display the greatest street art ever seen in one place." The city's association with Art Basel Miami, the biggest contemporary art fair in the United States, has led to over forty artists creating gigantic and spectacular frescoes downtown.

The area contains work by such artists as Os Gêmeos, Invader, Kenny Scharf, Futura, Faile, Shepard Fairey, How 8 Nosm, Clare Rojas, The Date Farmers, Roa, Ron English, Jeff Soto, Logan Hicks, Phase 2, Coco 144, Gaia, Vhils, Swoon, and Barry McGee, among others. A genuine "street museum" now exists, to borrow the phrase of the former director of MOCA in Los Angeles, Jeffrey Deitch, a staunch supporter of the project. A specialist in street art, assisted by the curators Aaron Rose and Roger Gastman, he conceived the biggest ever museum exhibition on the subject in 2011: *Art in the Streets*. Its success with a new generation of visitors was proof, once again, of the movement's appeal to young people from all walks of life. Los Angeles and its surrounding suburbs have always enjoyed a strong relationship with skateboard culture, innovative graphic art, and street art, as shown in the exhibition *Beautiful Losers* organized by Aaron Rose and presented in 2005 at the Orange County Museum of Art. The first galleries of the City of Angels to show artists such as Keith Haring, Saber, and Raymond Pettibon were the Robert Berman Gallery, opened in 1979 and still active today, followed by the 01 Gallery a year later with artists including Chaz Bojórquez and Futura. The rise of street art and the purchasing power of Los Angeles collectors allowed for the emergence of other galleries, such as the Carmichael Gallery, LAB ART Gallery, and Subliminal Projects, Shepard Fairey's gallery. Many frescoes were authorized in the city, often near key sites such as the Merry Karnowsky Gallery. Elsewhere in California, San Francisco—the birthplace of underground art in the mid-1950s with the Beat Generation (Burroughs, Kerouac, and Ginsberg) and later the nerve center of alternative comic strips with the first fanzines such as *Mad*, *Help!*, and *Zap Comix*—also played a major role in the spread of street culture. Barry McGee, with his many signatures, of which the most famous is probably *Twist*, was one of the rare artists to succeed in creating a link between street art and contemporary art. **San Francisco's City Hall has stood behind the colors of graffiti art since the early 1970s by supporting projects in the Mission District, one of the style's key areas.**

Most of the important street artists have left their mark in the Mission, a veritable epicenter for the graphic expression of popular culture. The magazine *Juxtapoz*, founded in 1994, played an important role, as did the 24th Street Gallery and the Upper Playground fashion and art label, which gave urban art international distribution.

Since the history of street art was forged in New York, it is only natural that the city should play a special role, both as a symbol and as a popularizer of the practice. In terms of illegal graffiti, the subway and train protection systems and video surveillance got the better of spontaneous interventions, and only a few nostalgic, politically involved artists still work in this way. Their new arenas are in the suburbs, in districts far away from Brooklyn, Queens, or the Bronx, where there are still many more-or-less abandoned sites. In Manhattan, street art now appears only on facades or on authorized sites, and of course in art galleries. The most important galleries, such as the Tony Shafrazi Gallery, for example, which represents Keith Haring and Basquiat, as well as many independent establishments, fight for the presence of graffiti on the walls of the Big Apple. The Museum of American Graffiti was inaugurated in New York during the summer of 1989 on the private initiative of the American artist Martin Wong—an insatiable collector—his friend Peter Broda, and a Japanese investor. Shows included works by A-One, Chris "Daze" Ellis, Lady Pink, LA2, Lee Quiñones, John "Crash" Matos, and Sharp, to name a few.

Unfortunately, following the stock market crash of October 1989, the museum closed its doors after only two exhibitions. Four years later, Wong donated his collection, one of the biggest in the world, to the Museum of the City of New York. The Alleged Gallery, created in 1992 and directed for ten years by Aaron Rose (associate curator of *Art in the Street*), soon became a favorite place for street artists. Jeffery Deitch also played an important role, launching Deitch Projects in 1996 by associating a gallery with numerous experimental exhibitions and continuing until

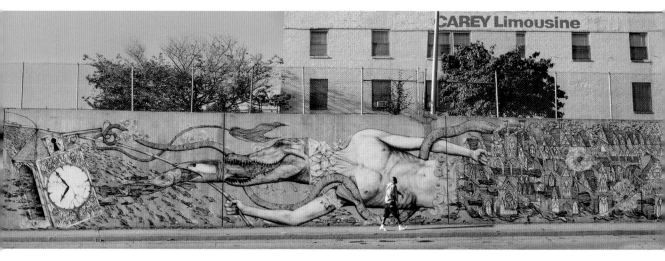

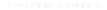

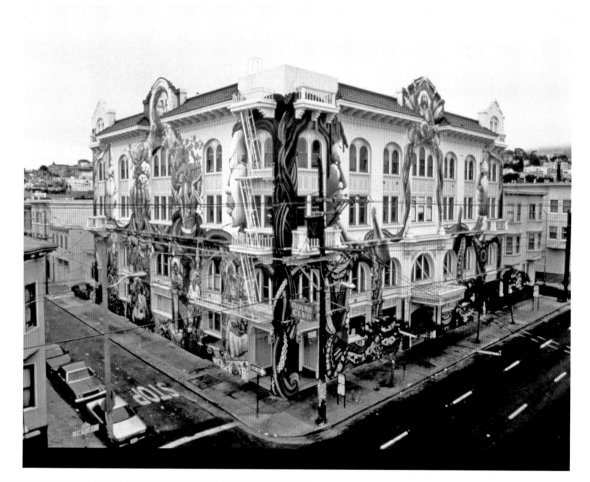

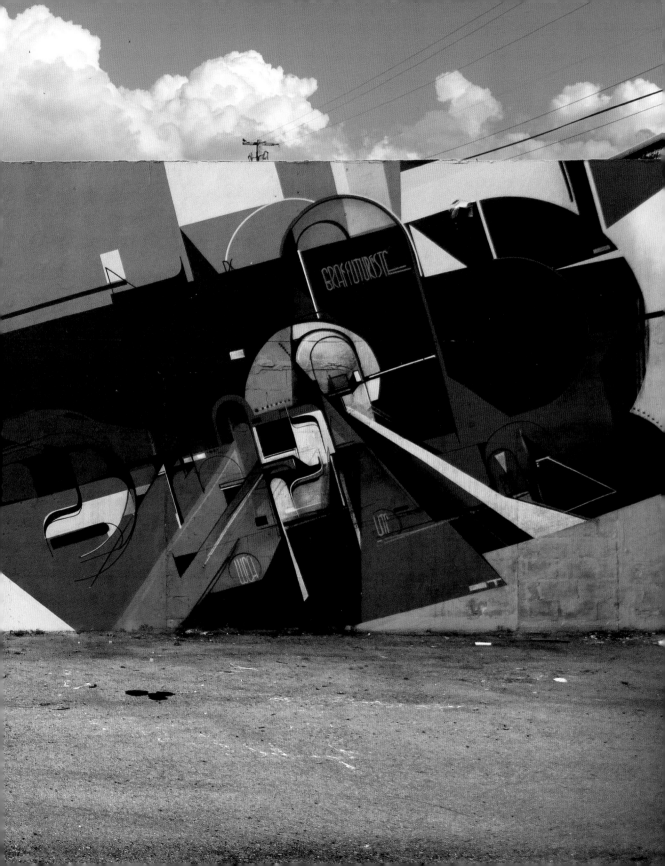

2010, when he was appointed to MOCA in Los Angeles. Other galleries, including Gallery 69, Brooklynite, Jonathan Levine, and Joshua Liner, represented many artists from the field. But today, for the most part, frescoes and tags are scattered across the city with no real coherence, on authorized walls and a few construction hoardings. Fortunately, the major works are compiled in two books, *Brooklyn Street Art* and *Street Art New York*, thanks to the work of the photographer Jaime Rojo, who has been documenting New York graffiti since 2001.

Because of its proximity to New York, Philadelphia was also involved in the first wave of tags in the 1970s. In reaction to the graffiti phenomenon, the city's mayor, Wilson Goode, initiated the Mural Arts Program in 1984 and asked the mural artist Jane Golden to act as a mediator. A large part of the artistic community became aware of their capacity to embellish their own districts and develop their techniques.

The mayor reorganized the event in 1996, and Jane Golden took advantage of the occasion to create a foundation in order to show, on an international level, the work that had already been achieved. Today, over three thousand frescoes are dispersed across all districts, earning Philadelphia the name of "Fresco City". The city also went on to organize a series of reintegration activities around street art for people in difficulty. This experience may have given Atlanta the idea for the Living Walls project, which was first held in August 2010. During this international gathering, graffiti artists were invited to make frescoes on site. They covered the walls over the course of the yearly event, moving further and further from the city center and spreading into the suburbs. Associated with five days of conferences and meetings, the Living Walls festival also takes place in the city of Albany, New York, following a very successful first edition in 2012.

Further north, Canada also has its own street art scene, and the artists of Toronto and Montreal keep in close touch with those of the East Coast of the United States, while those in Vancouver look to California. The biggest street art event in Canada is undoubtedly the Under Pressure festival, organized in Montreal since 1995 by Sterling Downey. For two incredible days, he single-handedly attracts a large part of the U.S. East Coast graffiti art scene by taking over one of the city's districts. Toronto also developed a pro-active community program around local street art with its StART project that aims to focus on specific, well-identified walls. As for the Canadian West Coast, street art expresses itself predominantly on the walls of Vancouver, in a more spontaneous manner.

PAGES 108–9

Beneath the surface of the Underbelly Project NY, New York, 2010. Only a few carefully chosen journalists were invited to descend into this underground lair.

FACING PAGE:

Under Pressure festival in Montreal, Canada, 2012.

FROM NORTH TO SOUTH

110

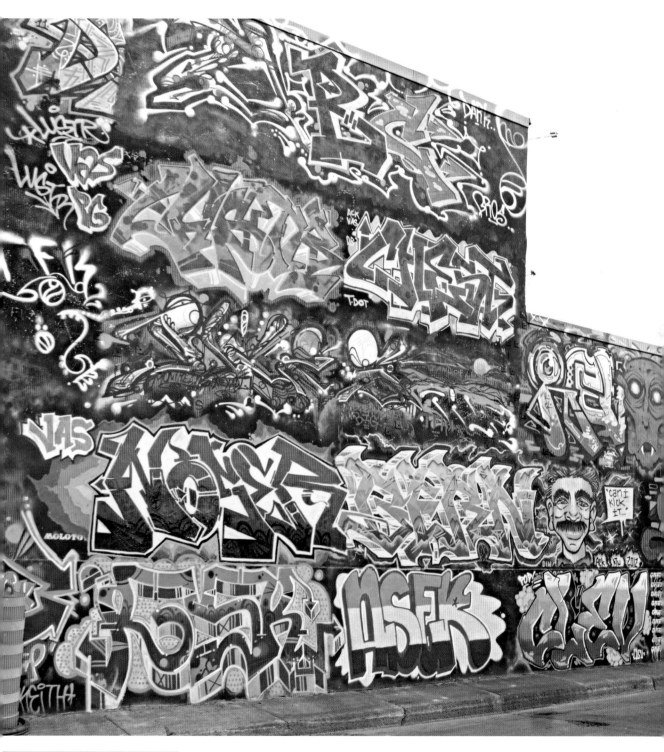

EUROPE

One event signaled the advent of street art in Europe: the New York City Rap Tour that, in 1982, presented the American hip-hop and graffiti scenes in Paris, and then in Berlin, before winding up in London. This memorable occasion showcased the best American graffiti artists and accelerated the presence of this movement in the European capitals.

Today, graffiti culture circulates in all European countries. The artists, regular users of low-cost flights, travel from one festival or event to another, throughout the year.

Thanks to the Internet and a few magazines such as *Graffiti Art Magazine* (French and English), *Graffiti Magazine* (German), and *Code Red* (Russian), graffiti art, which has become a cultural scene in its own right, has met with increasing success since the beginning of the 2000s with the younger generation, who are sensitive to the street artists' creative energy. Nothing, and nobody, seems to prevent them from getting together, sharing ideas, and developing or pushing back the technical limits of their art.

In the face of the scale of this phenomenon, local authorities tried to adapt: they offered sites and provided equipment. This form of expression is now part of the urban landscape, and works produced in consultation with local authorities are received favorably by the general public.

As a result, street art is becoming professionalized, and local politicians defer to the experts in the field, whether artists, gallery owners, auctioneers, or journalists. It is, indeed, impossible today for a politician to ignore the number of people visiting graffiti events, or the spontaneous interventions (i.e. illegal graffiti) that bloom every day in cities of more than fifty thousand inhabitants. When public authorities in Europe support the creation of a festival, they benefit from a sizeable economic gain. Their success means that the financial calculations are quickly made, which explains the growing number of actions stamped with the term "street art": yearly rallies, touring festivals, battles, and meetings that form a calendar of European events that is unique in the world. Scheduled from April to October, they take place from the Azores to the Czech Republic, from Denmark to Southern Italy. **Over seventy-five events take place every year in over fifteen different countries.** Among the famous rallies is the Meeting of Styles, which was created in Germany in 2001, and has developed considerably since. Another international meeting, the Kosmopolite festival, created in France in 2002 in Bagnolet, has now become the Kosmopolite Art Tour and moves around different countries. The Eurocultured street festival, born in 2004 in Manchester, also moves from one European city to another, from Dublin and Belfast to Bratislava (in Slovakia) and Aarhus

Snow White
and the poisoned
apple, revisited
and updated by
Speedy Graphito.
Kosmopolite
festival, Bagnolet,
France, 2012.

FROM NORTH TO SOUTH

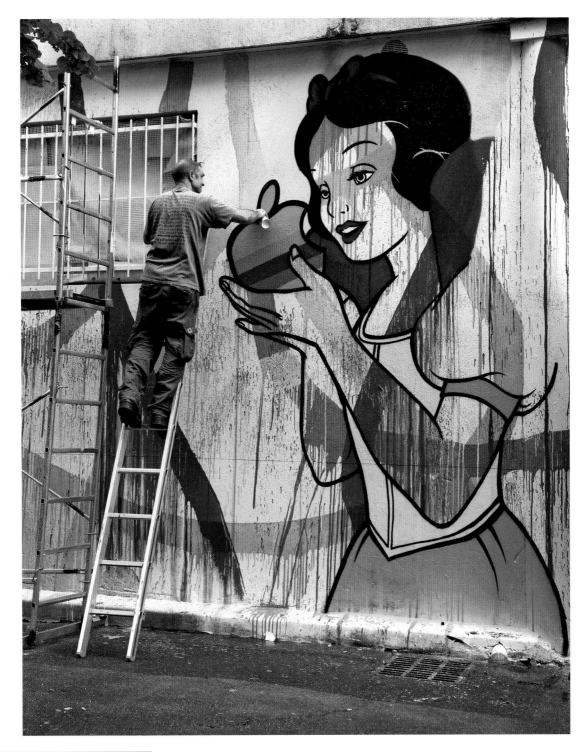

Aryz, passing
through London
in 2013: the
bowler hat is
a valuable clue
for images
circulating on the
Internet without
any references.

FACING PAGE

Work in
progress: first
the background,
then the outlines,
and finally the
finishing touches.
Ogre during
the Trailerpark
festival in
Copenhagen,
Denmark.

(in Denmark). It provides a fantastic opportunity to meet English, Polish, Hungarian, Czech, Spanish, French, Italian, Portuguese, Austrian, and German street artists. **Northern European countries are particularly active.** Top of the list is Norway, with its Nuart festival exclusively dedicated to street art, and the TJ Art Walk project in Oslo, a series of monumental works commemorating the two terrorist attacks of July 25, 2011, including work by Will Barras, Logan Hicks, Faile, and D*Face. With a far less developed scene than its neighbor, Sweden in 2012 authorized for the first time the creation of a fresco measuring three hundred feet (ninety meters) in the center of Stockholm, which did not prevent artists from expressing themselves freely and illegally across the country or during the Öland Roots reggae festival on the coast. Despite—or maybe even because of—the long winter months, street art has established itself in Finland, in Turku, thanks to the touring European project Eurocultured. With its famous Roskilde festival, Denmark hosts one of the most ambitious European events— gathering 100,000 people for four days— and probably one of the oldest, as it began in 1971. Free graffiti workshops are organized and numerous frescoes are created by the European avant-garde, including sush figures as Brondby (Denmark), and Zmogk (Russia). Copenhagen also boasts a great number of stencils, tags, and other collages, including those by the local artist Armsrock. The city's Trailerpark and Galore festivals are two important annual events that attract the very best of the European graffiti scene. For monumental works, one has to travel to the other side of the country, to Aarhus, where pieces by international artists such as Blu, Zevs, Espo, Os Gêmeos and Shepard Fairey can be seen.

As for Southern Europe (in addition to France, which, as we have seen, occupies a key place with its Kosmopolite festival), Spain also plays an important role. Barcelona alone welcomes three or four events every year, including the Poble Dub Sec and the OFFF festival. Tudela organizes Avant Garde Urbano, Zaragoza the Festival Asalto, and Huarte the Cantamañanas festival, to name but a few. There are many other events across Southern Europe, including the Wool festival in Portugal, True Skills in Milan, and Fame in the small town of Grottaglie, Italy. Further east, Turkey stands out with the Meeting of Allstars Graffiti Festival held there since 2009, as well as Austria with the Freakwave Festival in Bregenz, while Germany, considered a graffiti pioneer, hosts the Urban Syndromes graffiti meet-up that has been taking place in Dresden since 1999. Switzerland, Russia, Ukraine, Ireland, the Azores: street art is blowing up all over the continent.

Although institutions as important as the Grand Palais and the Fondation Cartier in Paris and Tate Modern in London devote official performance-exhibitions to street art, in Europe the vandalistic spirit still remains. It is essential for most street artists, and is supported by a few magazines and websites such as *On the Run*, *Metropolitan Press*, and *Swegraff*, which specializes in interventions on trains and other illegal actions with a taste of the forbidden. **The purists who follow this high-risk approach are always on the hunt for an adrenalin rush and extra recognition for their street name. They form a group of free spirits who, for a short reign of two to five years on average, make their own rules and are visible everywhere: in Madrid, Warsaw, Rome, and Berlin.**

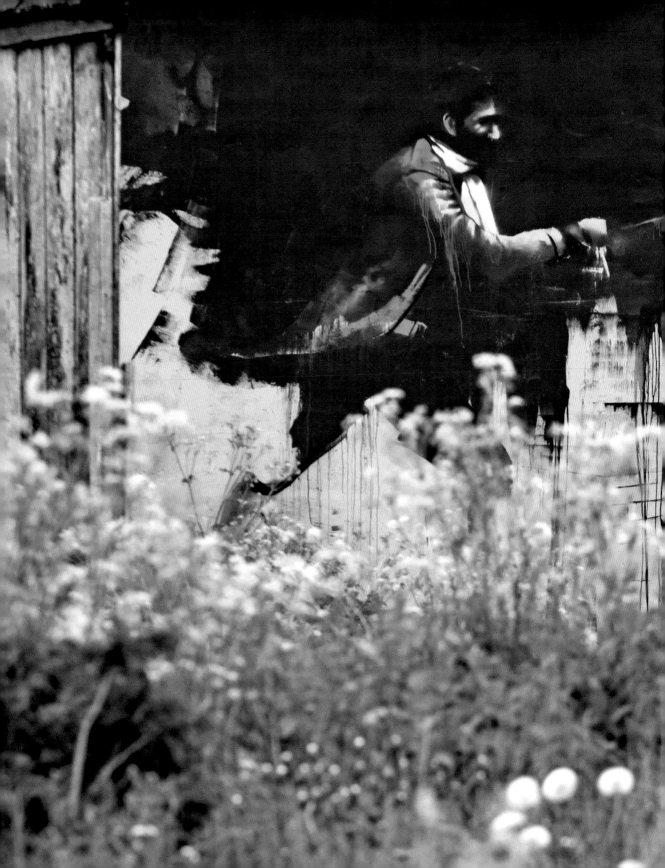

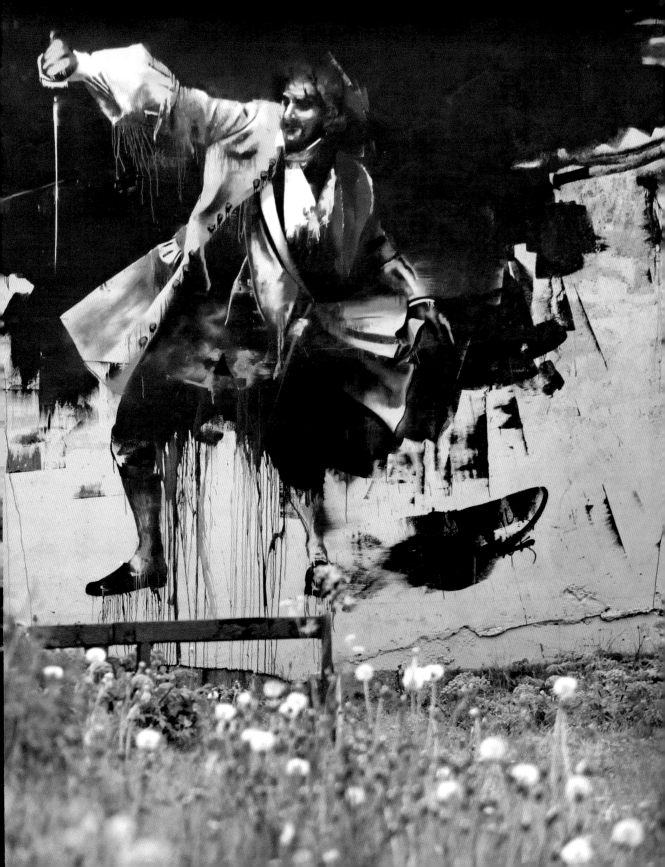

Stencil artists represent another important family of street artists in Europe.

Encouraged by the first generation of the 1970s and the 1980s—such artists as Epsylon Point, Jef Aérosol, Miss.Tic, and Blek le Rat—and stimulated by the success of Banksy, they are very active in most European countries. Generally endowed with a good knowledge of art history, these stencil artists create a visual identity specific to the streets of Europe. Some of them, whose works exist on the border of contemporary art, seek to leave less repetitive traces than the tag or graffiti in the city. Examples are the sentences created by the French artist Rero, the collages by the Berlin collective Mentalgassi, and the parodies produced by the Spaniard SpY. There is only one museum bringing together these creations, as joyful as they are unexpected: the Internet, with its hordes of blogs.

David Choe in front of his work during the Nuart festival, Stavanger, Norway, 2009.

ASIA AND AUSTRALIA

The graphic arts, closely associated with handicraft, have always existed in Asia. However, the political regimes in power, that often privilege traditional ways of life, restricted all spontaneous interventions in public spaces for many years, a situation that began to change only in the 2000s for a handful of fortunate countries. Since 2011, things have moved on: the Wall Lords event includes a graffiti and wall-painting competition reserved for Asian countries. Artists are selected from each big city and a final is held in one of the participating countries—an encouraging breakthrough.

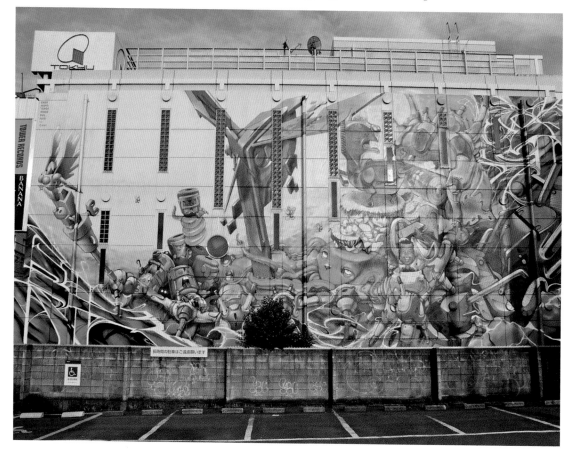

A collage
by Robbbb in
Beijing, 2012.

and pastes his stencils in around city. Ironically, China was the winner of the first edition of Wall Lords in 2008 and hosted the final of the 2012 edition, in which it came second, behind Thailand.

JAPAN

Japan is much more open to street art than China. A hotspot for the production of toy art, Japan has an avant-garde audience that is in touch with what is going on the other side of the Pacific. However, despite solid ties with the United States since the mid-1980s, the latest media technologies, and the manga tradition, Japanese street art has little international visibility. In spite of the number of collages, tags, and graffiti present in the cities, few official events exist, there are no real international stars, and only a few artists, such as Shiro, have careers abroad. Osaka hosted two editions of the Crazy Crimers event in 2010 and 2011, but in a private space, CASO (Contemporary Art Space Osaka), not outdoors.

INDONESIA, MALAYSIA, AND THAILAND

Unlike other Asian countries, Indonesia, Malaysia, and Thailand witnessed the rise of graffiti quite early. Despite possessing a cultural context more open to wall or outdoor painting, the street art scene, strictly speaking, began only in the early 2000s. With their strong link with the West, fed by tourism and a well-established surf culture, Indonesian youths, who are heavily influenced by the American and Australian scenes, quickly took over the walls of their major cities. The first mural frescoes made in Yogyakarta in 2000 symbolized the still recent history of revolution and the anti-colonialist liberation. Nevertheless, the first Street Art Festival, organized in Jakarta in December 2004, was virtually banned on the first day of the event, with numerous interventions by the police in charge of dispersing the

CHINA

By opening a space in Shanghai, the Parisian gallery owner Magda Danysz has contributed to this change. As she exhibited Western artists such as JR or Vhils, they used the opportunity to create works on authorized walls. However, illegal Chinese street art is almost totally inexistent. There are a few courageous graffiti crews but, despite a rapidly expanding art scene, particularly in Beijing, Shanghai, and Hong Kong, the free, anti-establishment spirit of street art remains banned from city centers. You have to go much further afield to find any political statement left intact. A solitary figure, the Beijing stencil artist Robbbb fits into the heritage of Europeans

The Nanashi crew in action in the Kitchijorgi district, Tokyo.

The Wrinkles of the City, one of the artist JR's projects, in Shanghai.

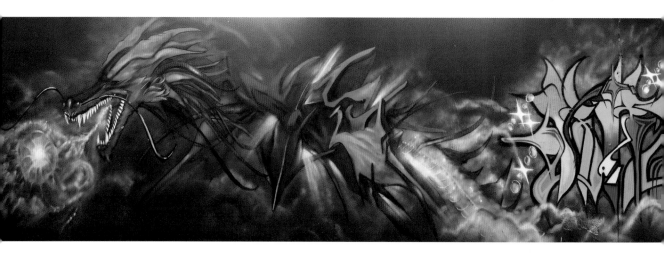

participating artists and organizers (even though they had permission to create three stages, only one could be made in the end). This has not prevented the appearance of political messages closely associated with street art on the capital's walls since 2010. Malaysia and Thailand have also developed a strong local scene, and their artists are beginning to travel abroad to take part in events.

LAOS AND BURMA

Artists from Laos and Burma represent the well-behaved (or bullied?) children of Asian street art, even if the new generation lacks no motivation to express themselves vigorously on their cities' walls. Generation Wave was created at the end of 2007 after the Saffron Revolution that protested against the military junta in power in Burma. Hundreds moved to Thailand in 2013 to learn to fight against the regime and to mobilize youth through political music and graffiti, which were mainly executed on university campuses. The slogan "CNG" (Change New Government) brought them fame, and it has become their trademark, not to say their tag. In 2009, the American artist Shepard Fairey greatly participated in raising the profile of the political leader Aung San Suu Kyi, imprisoned at the time, by making a portrait of her. The poster was distributed rapidly across the whole country, to be stuck on walls as a sign of support for the "Lady of Rangoon," winner of the Nobel Peace Prize in 1991.

FREEDOM TO LEAD

SUPPORT HUMAN RIGHTS

DEMOCRACY IN BURMA

LEFT

Aung San Suu Kyi made into an icon by Shepard Fairey.

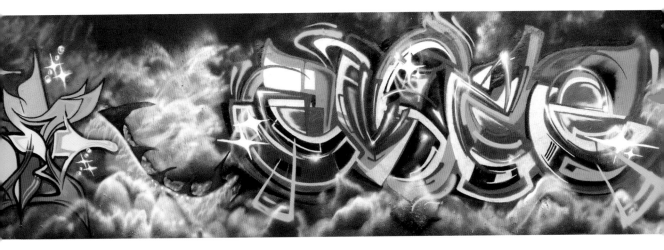

INDIA

India, with its castes, its taboos, and its complex culture, is not a very accessible country for street art. The few foreigners who have attempted work here have had to use specific strategies, such as JR, who pasted white posters during elections (any other posters would have led to punishment), on which the image revealed itself over time with the dust from the streets. The French artists C215 and Invader, working with stencils and mosaics respectively, succeeded in melting into the background and were able to work without being noticed, while managing the sensitivities of the different castes surrounding them.

TAIVVAN, SINGAPORE, AND HONG KONG

Three avant-garde countries: thanks to the different editions of Wall Lords, the Singapore and Hong Kong art fairs, and the presence of a large contingent of expatriates from all over the world concentrated within a particularly small area, street artists were able to develop faster in these three countries than elsewhere. They inscribe the history of Asian art on their walls, charged with the protest and upheaval of the recent past.

ABOVE

Generation
Wave's stencil
logo. The people
who placed this
stencil risked life

imprisonment
at the very least,
and yet it can
still be seen.

AUSTRALIA

Australia is one of the first street art nations, greatly inspired by the New York graffiti movement of the 1970s. An immense but sparsely populated country, culturally close to the United States but also very independent, Australia cultivates its autonomy, its artists, and its street art without much interaction with the rest of the world. The cities of Sydney, Brisbane, Adelaide, Perth, and Melbourne compete with each other. Even though they all possess their own artistic scenes, galleries, and press, Melbourne has the upper hand, benefiting from a good suburban train network, a strong urban character, and the country's second-largest population. All the artists gather here, each year, for Sweet Streets (formerly the Stencil Festival until 2009), which was created in 2004 and has produced over one thousand works on the city's walls (the city was awarded the title of Stencil Graffiti Capital as a result). Unlike in neighboring Asian countries, street art in Australia is not limited to graffiti and tags.

PAGES 130–31

The two Australian artists Rone and Meggs collaborated on the fresco *Order 8 Chaos*, Melbourne, Australia, 2012.

RIGHT

Australian artists are frequent travelers! Antony Lister used a visit to London to express his opinion on stencil art.

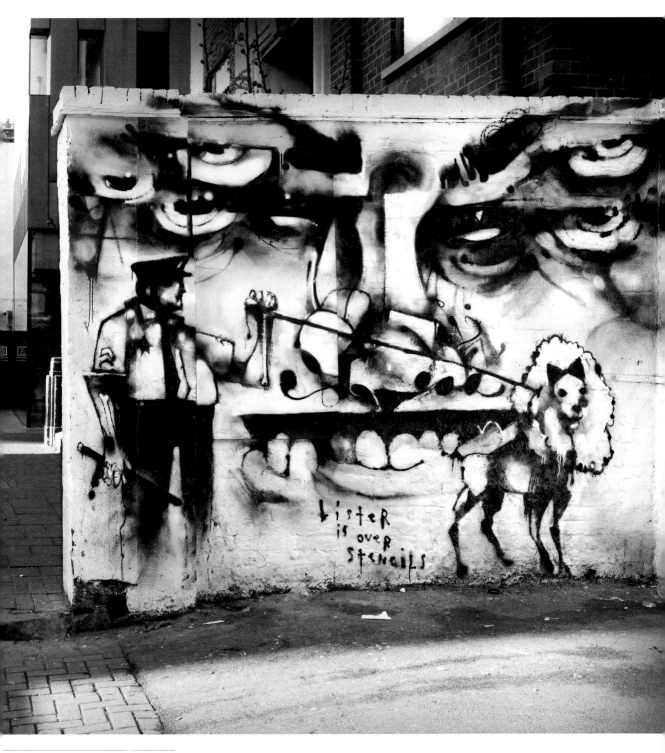

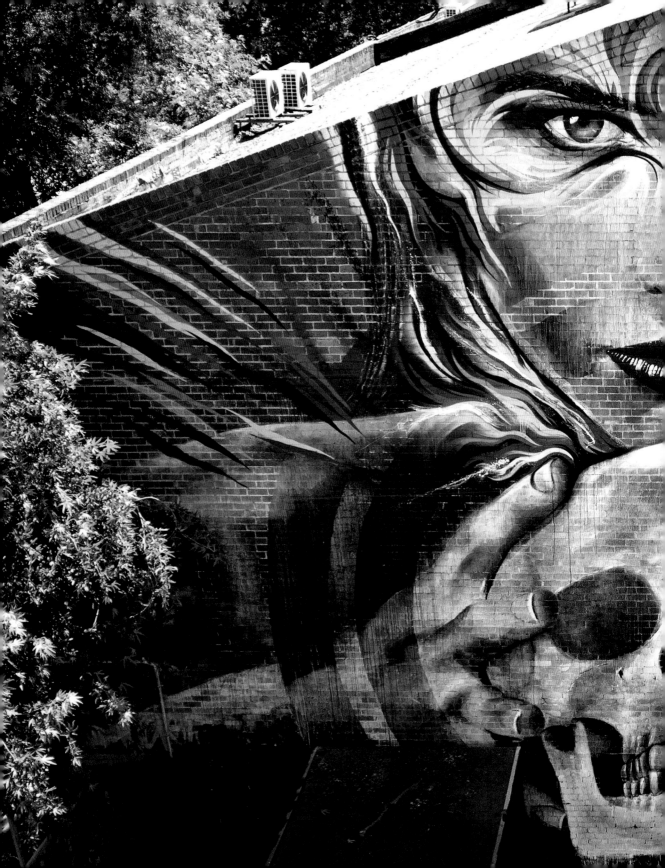

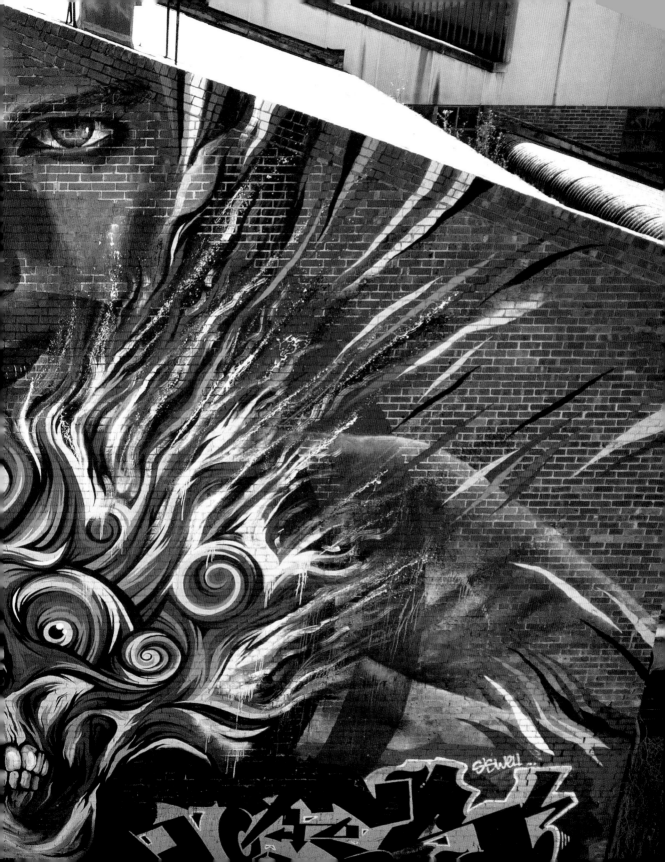

AFRICA AND THE MIDDLE EAST

Many of the fifty-four countries that make up the African continent are beginning to open up to the Western culture of street art, but have not yet made the link to the local graphic traditions visible in art, fabrics, and house walls. Different techniques of graffiti and stencil art are starting to make an appearance.

Since the beginning of the millenium, urban art has slowly found a place for itself in North Africa and the Middle East. In regions with little tolerance for these forms of expression in public spaces, creating tags and graffiti requires no small measure of courage.

Recognized artists such as the Frenchman C215, the Italian Blu in Morocco, the German Case in Egypt, and all of those who participated alongside Banksy in the Santa's Ghetto project on the wall between Israel and Palestine, have encouraged local artists to participate in this growing history. Spaces dedicated to street art have opened, including the David Bloch Gallery in Marrakech and the Art Lounge in Beirut, which collaborated on the publication of two books in Lebanon. The actions carried out around Tel Aviv by the artist Know Hope demonstrate the younger generation's interest in these cultures and the reality on the ground. In 2011, following the Arab Spring, the Kif Kif collective in Tunis was finally able to exist out in the open, whereas in January 2012 the Mad Graffiti Week in Egypt was an opportunity to pay tribute to the revolution while encouraging its expansion. The event was restaged four months later in Iran in support of the freedom of political prisoners. Surprisingly, an underground scene exists in Tehran, which has been visited by recognized street artists such as A1one and the duo Icy and Sot. In the surrounding countries, whether they are at war or under an authoritarian regime, street art, an extraordinary means of communication, remains a high-risk activity and may lead to a death sentence. In Syria, the history of graffiti goes back to 2008, but it was the words on the walls of Daraa, "the people want to topple the regime," written in early 2011 by a group of schoolchildren who were immediately arrested and tortured, that led to the first demonstrations in the area, which then spread across the country. In Damascus, the walls have become the civil war's second battlefield, and anti-government slogans are covered over as soon as possible by partisans of the established regime. Several artists have been arrested, imprisoned, or killed since the beginning of the uprising. Here, street art is a life-or-death commitment.

Sub-Saharan Africa remains virgin territory for street art. In all likelihood a new way of using the street as a place of expression will spring up there. For the time being, a few locally based individuals are changing things and slowly creating a body of graffiti and mural work.

PAGES 134–35
JR, *Women are Heroes!* Large format collage of women's faces in the town of Monrovia in Liberia, 2008.

FACING PAGE
A1one in the Apadana district of Tehran. Like the artist's name, this child must feel very alone. *A Rainy Day for the Son,* Iran, 2009.

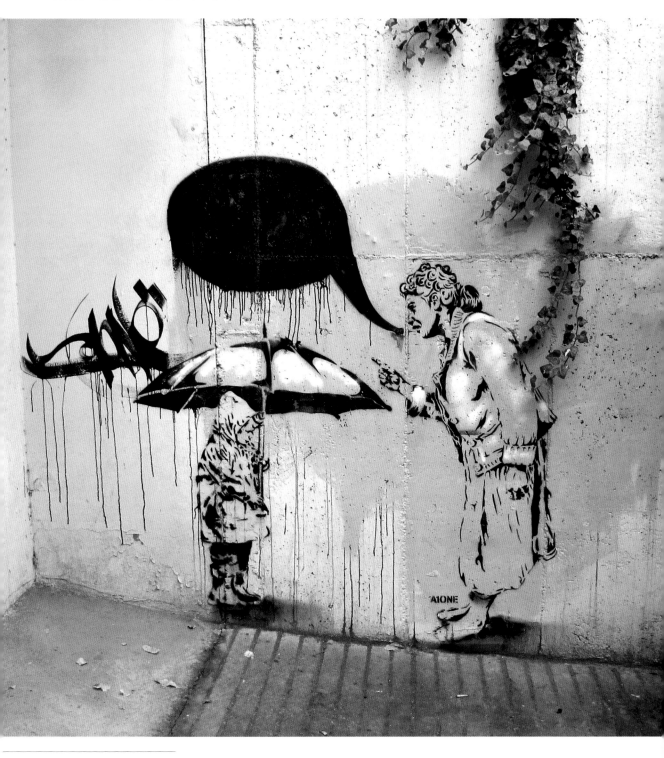

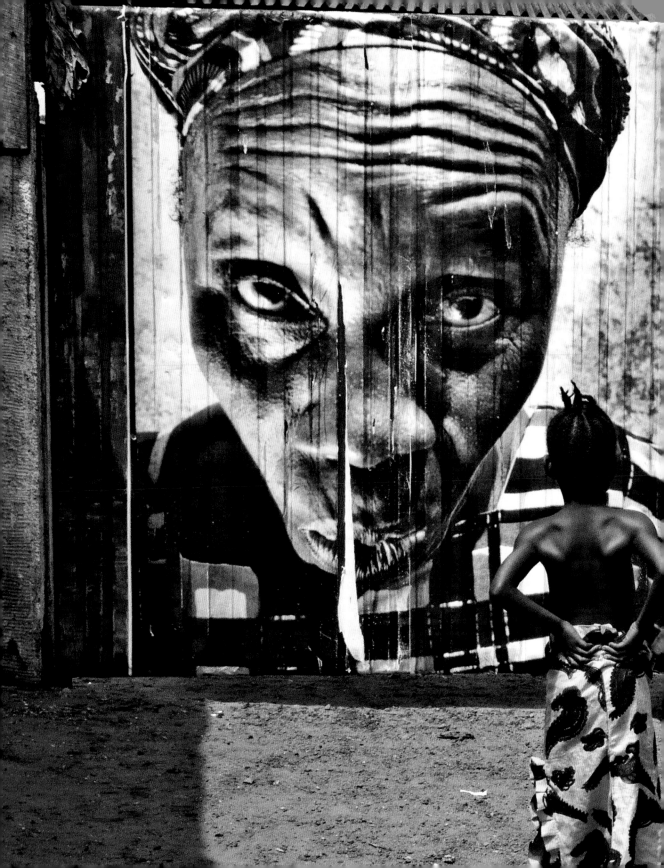

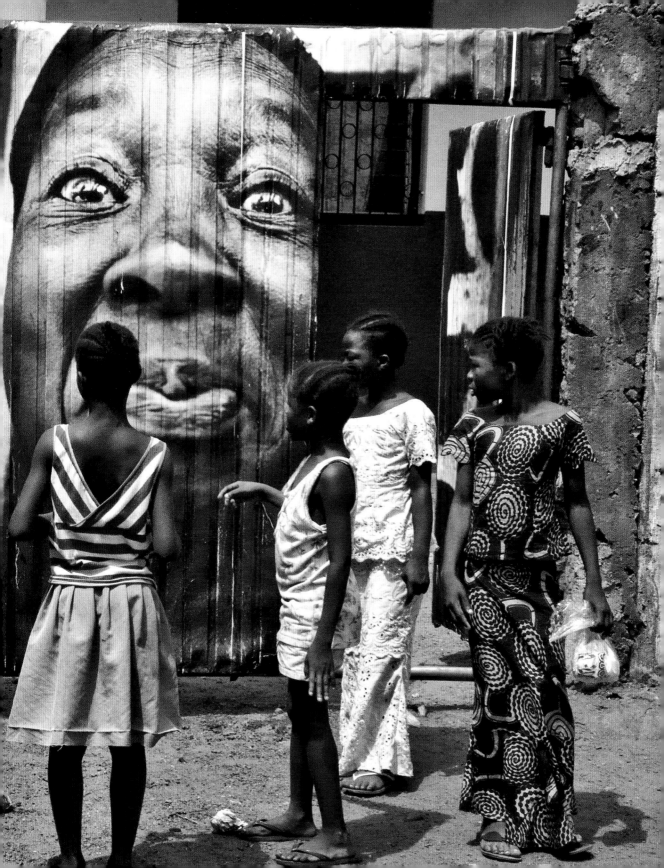

In Senegal, the annual Festigraff meeting in Dakar began in 2010 thanks to the local multidisciplinary artist Docta. The actions of the Superpose collective, with their DKR project, and the work of the artist 2Mgraff from the village of Nioro, 125 miles (200 kilometers) from the capital, have cemented the country's position among the most active in Africa. Further east, Banksy went to Timbuktu in Mali in 2008, and left a few beautiful works there dedicated to Africa, while the artist JR plastered huge photos of women for his project *Women are Heroes* in Liberia, Kenya, and Sierra Leone. Over the same period, the American David Choe left his mark in the Republic of Congo, the French artist Invader in Kenya, his fellow countryman Jace in Madagascar, and the Brazilian Zeh Palito in Zambia. In 2010

The Weight of an Empty Space, Tel Aviv, February 2013, by the Israeli artist Know Hope.

and 2011, the Wide Open Walls festival in Gambia provided an important platform for artists such as Bushdwellers (Gambia), Roa (Belgium), Know Hope (Israel), Remed (Spain), Tika (Switzerland), Freddy Sam and Selah (South Africa), and Best Ever (Great Britain). They produced works in the fourteen villages of Ballabu as part of the Conservation Project which, as its name implies, aims to preserve the villages and their population in this region, which formerly had little tourism.

We can conclude this brief overview with South Africa, where street art has been thriving since the end of apartheid. In this country with close cultural ties to the Western world, graffiti arrived very early under the influence of Holland and the United States. Cape Town is today the capital of street art, hosting platforms such as A Word of Art and several internationally recognized artists.

RIGHT
C215 in
Marrakech
in 2010.

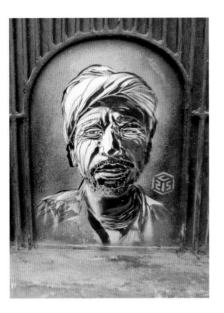

PAGES 138–39
The British
artist Lucy
McLauchlan in
Gambia, during
the Wide Open
Walls festival
in 2013.

BELOW
The Long Wait,
by the South
African artist
Faith 47,
Johannesburg,
2012.

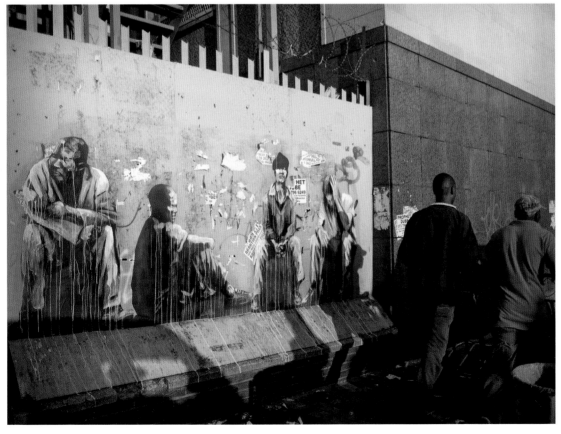

SOUTH AMERICA

Mexican mural frescoes from the 1920s, made after the revolution, embody the spirit of street art south of the United States. Everyday scenes, historical, politically charged narratives, and educational frescoes were some of the works imposed upon the population, and marked the beginning of an era when public spaces were officially open to expression. They gave a particular color to all the cities of South America, from Mexico City to Ushuaia. They shared one obvious trait: the massive use of color, beginning with the bright hues that covered the houses. Chosen freely by their owners, these colors bring a joyful atmosphere to those cities or districts that have managed to preserve this aesthetic.

Today, street art reaches across the whole continent. Mexico City remains the original city of mural frescoes, since the very first pieces date from the Mayan era. It is also very active in the field, hosting All City Canvas, one of the best international festivals, which takes place each year for one week in October. Nevertheless, Brazil has become the leading nation for street art south of the United States. The Brazilians' very particular style quickly became a trademark for the entire continent, and in its strength it rivals American or European creativity. We can be eternally grateful to the San Francisco artist Barry McGee for coming to São Paulo in 1993 and for helping the duo Os Gêmeos to emerge, becoming the most prolific figurehead of Brazilian street art.

As for tags, Brazil is still out in front with its *pixadores*, **who produce ten times as many as the American and European vandals combined. These artists are capable of covering an entire twenty-floor building in a single night, thanks to their very specific lettering that is visible everywhere, from São Paulo to Brasilia, from Copacabana to Florianópolis.**

Institutions have also chosen to focus on emerging cultural genres by supporting spectacular initiatives like the creation, in 2012, of the largest graffiti in the world: signed with a spay can by President Lula himself, it covers 120,000 square feet (37,000 square meters) and was made in the Iguaçu region.

Among the other leading South American countries, Chile plays an important role, producing a mix of poetry and protest. The influence of Pablo Neruda is still palpable in Valparaiso, the city of many colors that feels like an open-air museum, such is the extent of its wall paintings. The country's political history is still being written, and its many street art collectives, such as TDV and the Peka

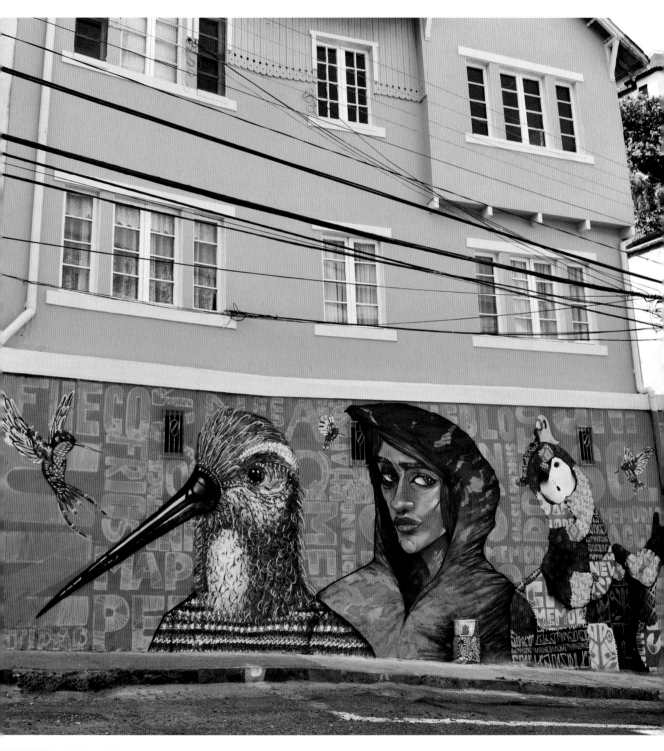

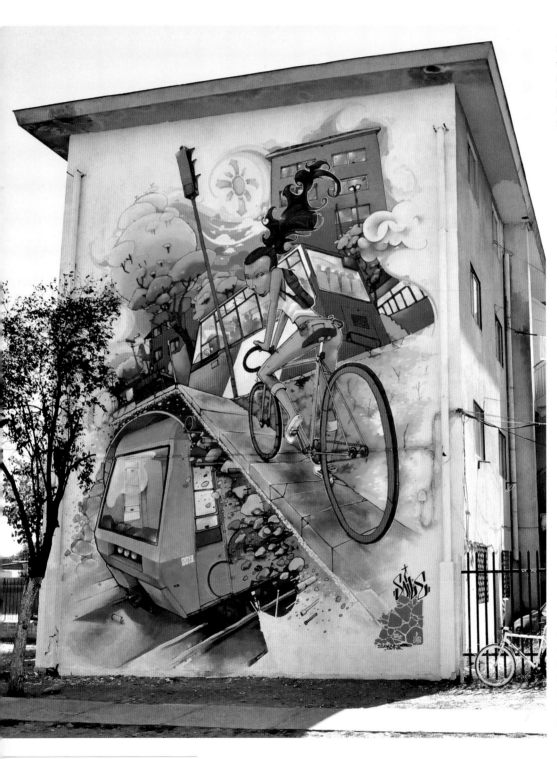

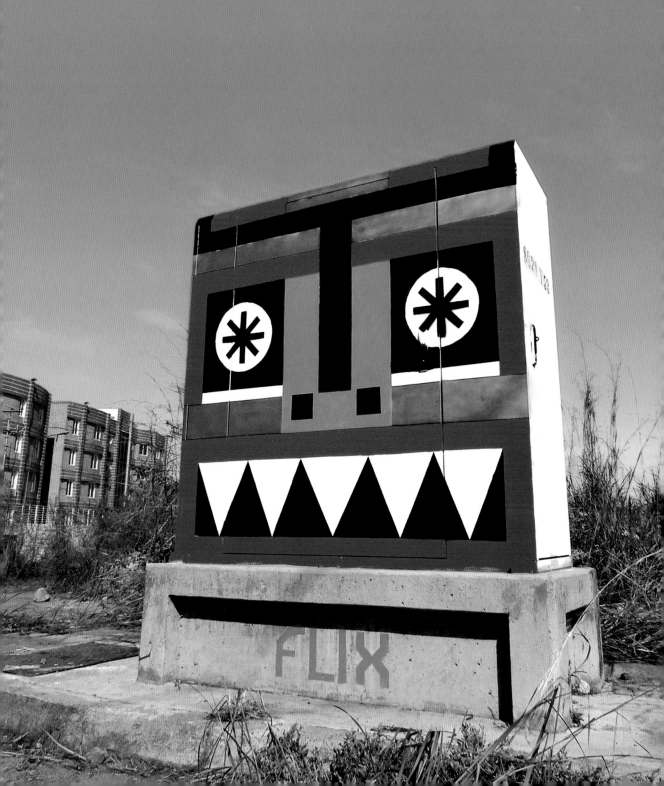

Crew, and individuals such as Inti, Piguan, and Nebs Pereira are still very politically involved. In particular, in 2009, the country organized a Wall of Peace, featuring graffiti running over 3,300 feet (1,000 meters), thanks to the participation of more than five hundred artists from all over the world. On the other side of the Andes Cordillera is Buenos Aires, which has been the hub of street art in Argentina since the financial crisis of 2001, a major trigger for popular expression. The city held its first Meetings of Styles in 2011 and 2012. **All South American and Central American countries have their own street art stars.** There are the traditional artists such as Bastardilla, Zokos, and Stinkfish in Columbia, Miss Hask and Flix in Venezuela, whereas other, more numerous muralists spread the government's anti-American ideas officially. The first Meetings of Styles in Bolivia and Ecuador were held at the end of 2012, and in Peru the local scene has grown hugely: the Afuera festival, created in 2012 by Lima's street artists in a former mining city on the Andean plains, is proof of this.

All of the smaller countries of South America greet street art with open eyes, a thirst for unlimited discovery, and a huge will to create ambitious projects with limited means.

RIGHT
The Wall of Peace is an initiative by three young artists from the Siembra Arte cultural center in Peñanolén, Santiago. It faces one of the city's poorest districts.

PAGES 146–47
"Ushuaia: end of the world, beginning of everything," is the city's motto. Jef Aérosol left his mark there with stencils in 2013.

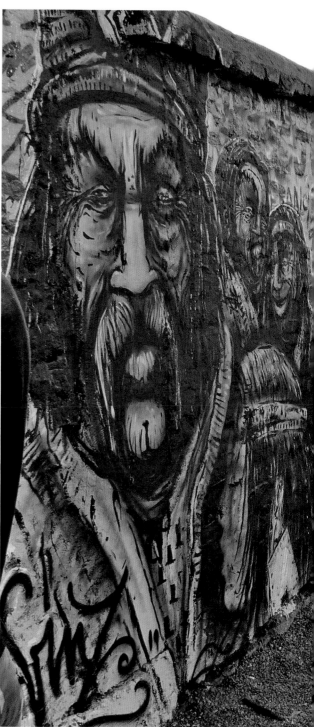

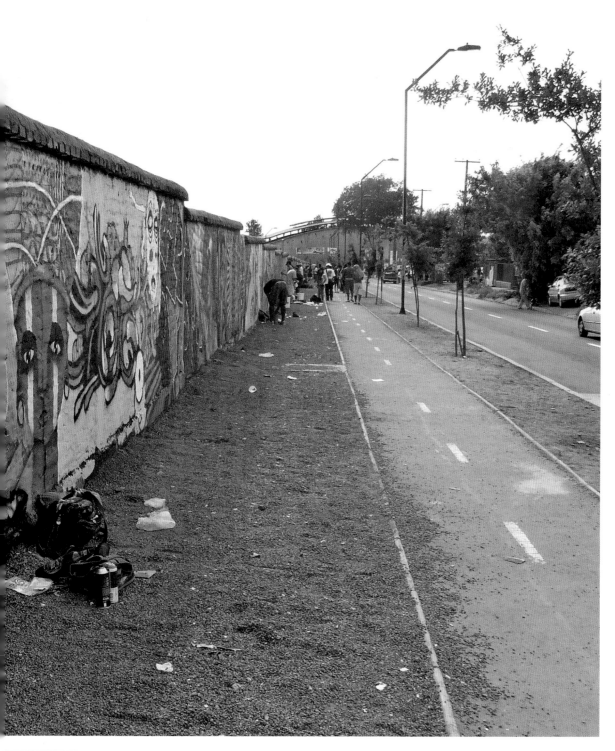

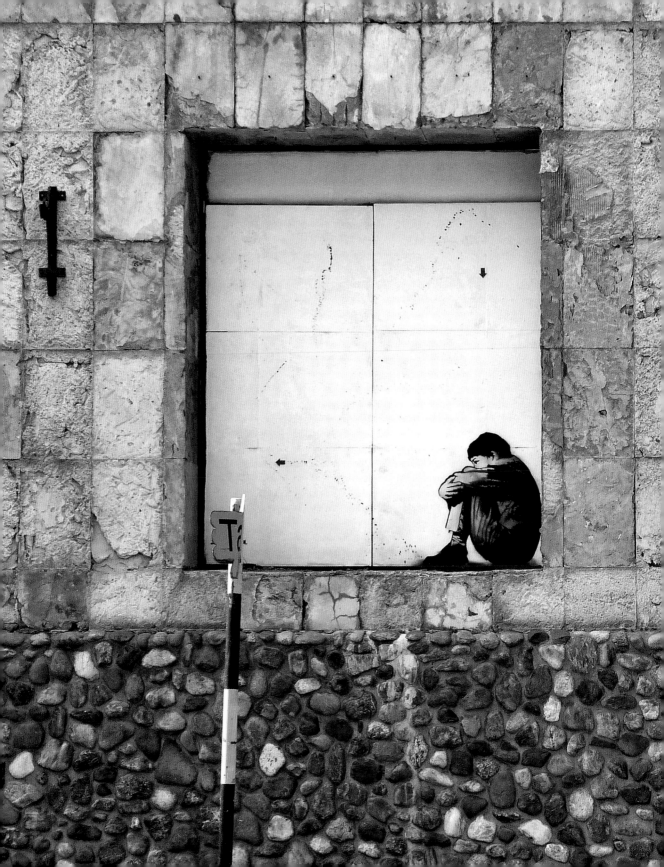

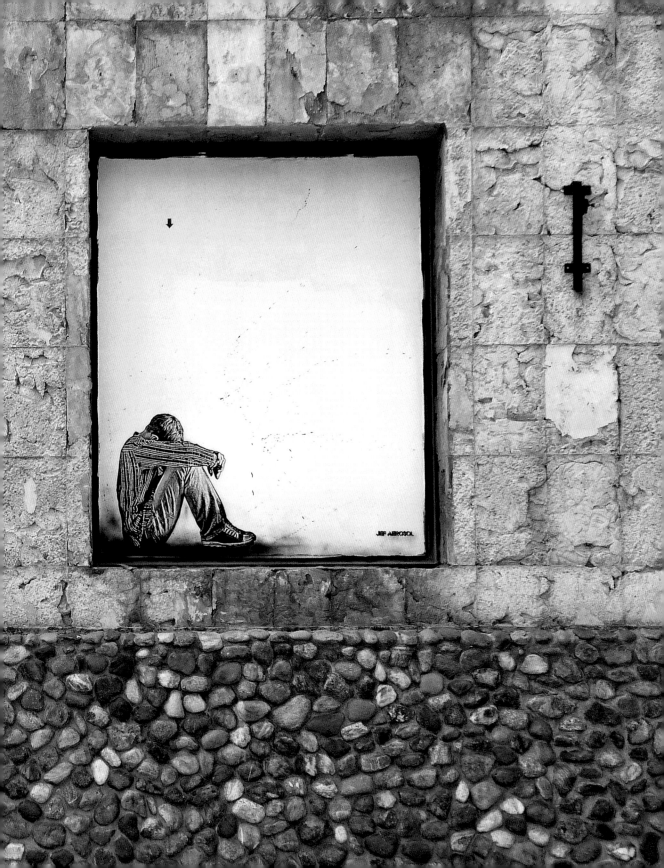

STREET ART & CO.

STREET ART
AND CONTEMPORARY ART

Can street art ever belong in the world of contemporary art? The question could be asked a different way: can the contemporary art market make space for street art? The answer is yes. Jean-Michel Basquiat, who began making graffiti on the walls of Brooklyn, and whose canvases today fetch record prices, is a case in point. What better way to become established than to hold an exhibition in an internationally recognized art gallery?

The photographer JR and Kaws, the parodist of posters and slogans, were not able to resist the temptation of solo shows in the Perrotin Galerie in Paris and Hong Kong. As for Kenny Scharf, he is represented by the Tony Shafrazi Gallery in New York, and Retna by Michael Kohn in Los Angeles. With its eleven branches across the world, the Opera Gallery threw itself into street art. It scoured the field and now shows the works of Seen, Speedy Graphito, Swoon, The London Police, Vhils, Ron English, and many others. Another textbook case is the Magda Danysz Gallery (Paris and Beijing), which started showing the best street art very early on, including works by artists such as Shepard Fairey and Miss Van. This type of gallery, like Jeffrey Deitch's gallery in New York before it closed in 2009, has had a major impact. **It is now possible to find works by street artists in the most prestigious contemporary art fairs, in response to the growing demand. Certain pieces, moreover, can fetch seven-figure sums.** Banksy's works are very sought after; walls weighing several tons were taken down in the U.K. and Palestine, to be presented at the Art Basel Miami fair in 2012, to the great dismay of the artist, who rails against this kind

of practice. He stresses that his works find all their meaning in their original context, and that they are aimed at those who live in the places where they were made. But nothing can stop this inflationist trend, and institutions dedicated to contemporary art have broadened their scope. In 2008 Tate Modern in London invited six artists to express themselves on its monumental façade—the first invitation of its kind from an official institution in England—including the Italian artist Blu, the Brazilians Nunca and Os Gêmeos, the American collective Faile from New York, JR from Paris, and Sixeart from Barcelona.

In 2009 Banksy took over Bristol Museum just before the tenth Lyon Biennale of Contemporary Art asked the American graffiti artist Barry McGee to demonstrate his talents in a huge room, in addition to his TWIST tag on the building's exterior. This idea was taken up by the Berkeley Art Museum in California, which held a retrospective exhibition of the artist in the fall of 2012. **MOCA in Los Angeles in turn organized Art in the Streets, the biggest exhibition of street art ever held, devoting a space of 11,500 square feet (3,000 square meters) to the artists and history of the movement.**

Furthermore, the work of certain contemporary artists is firmly anchored in the city, such as the Chinese artist Liu Bolin, also known as "the invisible man" because he paints himself in order to melt into the background to the point of disappearance. Many visual artists did not wait for the advent of street art to occupy the streets; this is particulary the case with artists who marked the 1970s, such as the German Wolf Vostell of the Fluxus movement and his concrete car sculptures, or George Maciunas, whose experiments left their mark in New York's SoHo district. We should also mention the outdoor *Wall Drawings* by the great minimalist artist Sol LeWitt. More recently, Tania Mouraud painted incredibly sculptural letters on an entire building, whereas Daniel Buren placed vertical bands around the city, inciting passersby to notice visible (place, function, etc.) and

invisible (ideological, political, social, economical, etc.) parameters that define the environment surrounding each work. Also worthy of mention are the spectacular anamorphic compositions by Felice Varini, who paints his geometrical figures in urban spaces by continuing his lines from one building to the next. The form is visible in its entirety only from a single point of view. The works of Christo and Jeanne-Claude are also very important in this context: spectacular creations such as the wrapping of the Pont Neuf in Paris and the Reichstag in Berlin.

But today, as we have seen, many street artists have become artists in their own right. The term "urban contemporary art" is beginning to take hold. *Graffiti Art Magazine*'s globalized approach places this movement within the perspective of art history, and shows the aim of some artists to bring street art and contemporary art together, so that the former becomes a branch of the latter.

HOW CAN YOU SLEEP? Tania Mouraud asks the question on a 50 × 100 ft. (15 × 30 m) wall. Metz, 2005.

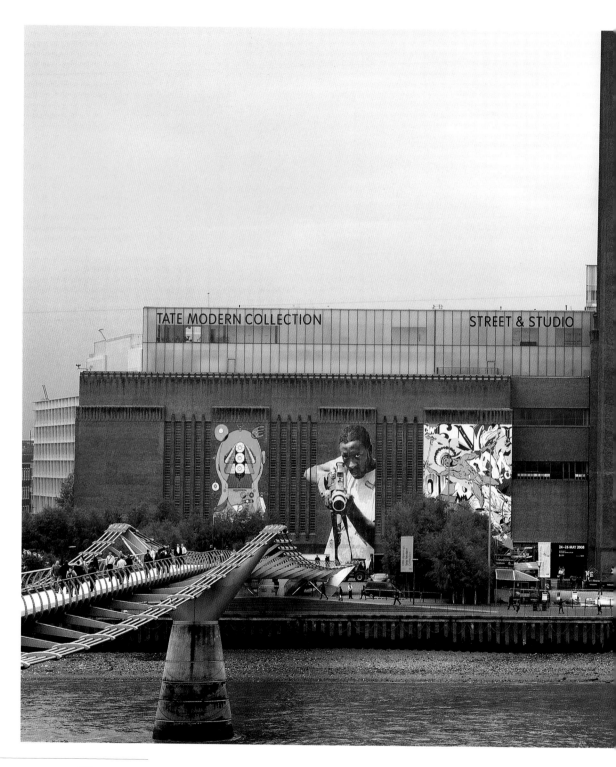

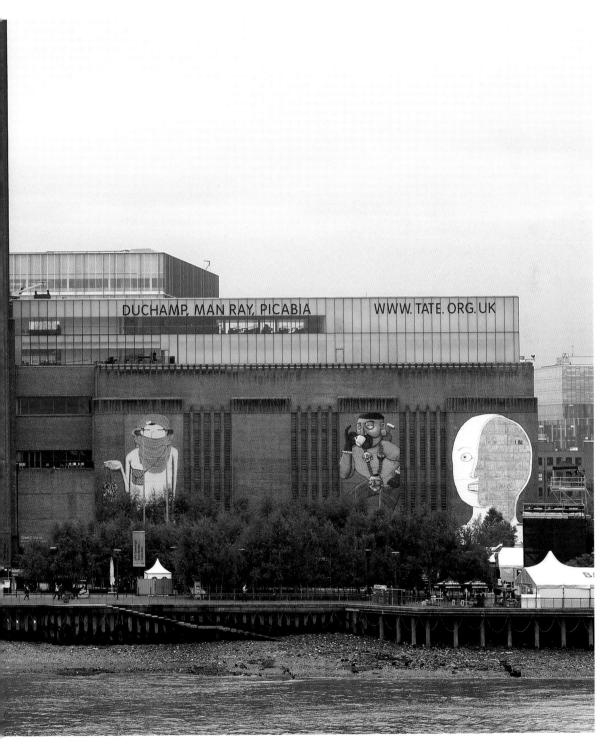

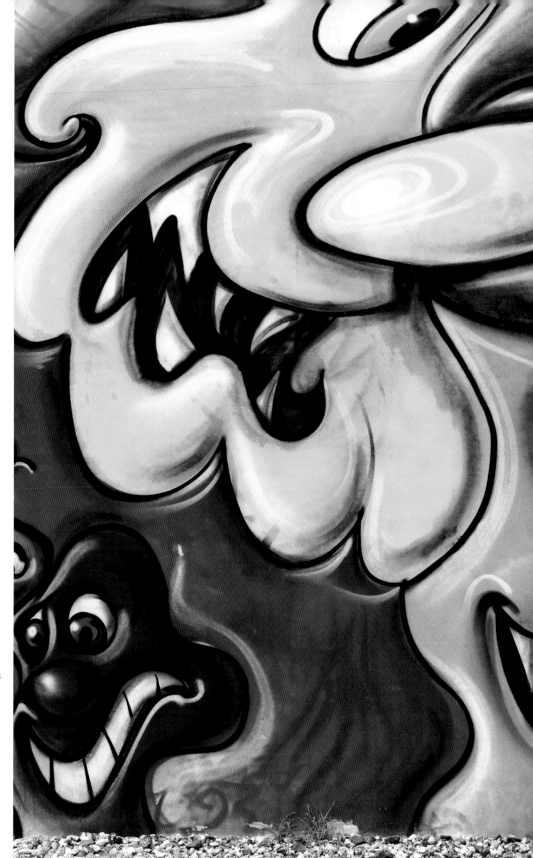

Liu Bolin in front
of Kenny Scharf's
fresco: the
meeting of
contemporary
art and street
art on the
Bowery in
New York
in 2011.

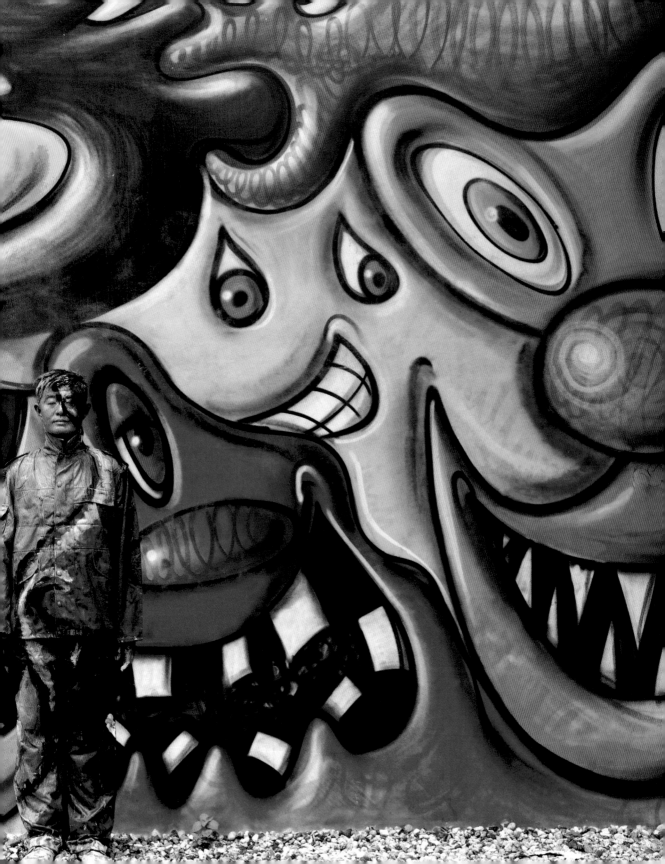

STREET ART
AND LOWBROW ART

There are many links between street art and lowbrow art. The two movements are closely related and share the same spirit. Lowbrow art is a prolific movement that combines the iconographic codes of comics, advertising, cartoons, graffiti, tattoos, and even seventeenth-century drawings and oil paintings. It is "no-holds-barred" for this international community of experts in mass culture.

At the very beginning of graffiti and tagging in New York, Stay High 149 used the logo of the television series *The Saint* for his signature. In the same way, other early graffiti writers dipped blithely into the imagery of popular culture, combining it with their graffiti. At the beginning of the 1980s, characters from Walt Disney or alternative comic strips of the time could be found on subway cars. With the development of street art, some artists who formerly used only spray paint began working with brushes and were soon mastering the most complicated pictorial techniques.

By choosing to work in the city, Ron English, with his billboard parodies, or Jeff Soto, with his fluffy characters, made the link with the universe of lowbrow art, which mingles icons of popular culture and displays a taste for polished surfaces. This kind of intervention occurs only in authorized places, on account of the time required to create such meticulous images—unless it resembles the work of Ron English, who, during illegal interventions, rapidly sticks up paintings on paper made in the studio. The use of digital files means that certain pieces are easily reproduced. It is very probable that we will see more and more works of this kind in urban spaces.

PAGE 158
Jeff Soto made this fresco with the help of a robot installed in a car.

PAGE 159
Ron English takes on junk food, but with a painting technique that rivals Dali's.

FACING PAGE
By appropriating the iconography of the TV series *The Saint*, Stay High 149 created one of the first encounters between street art and popular culture. The artist's nickname came from his regular consumption of cannabis when he first began painting graffiti, just as the Saint also flies high.

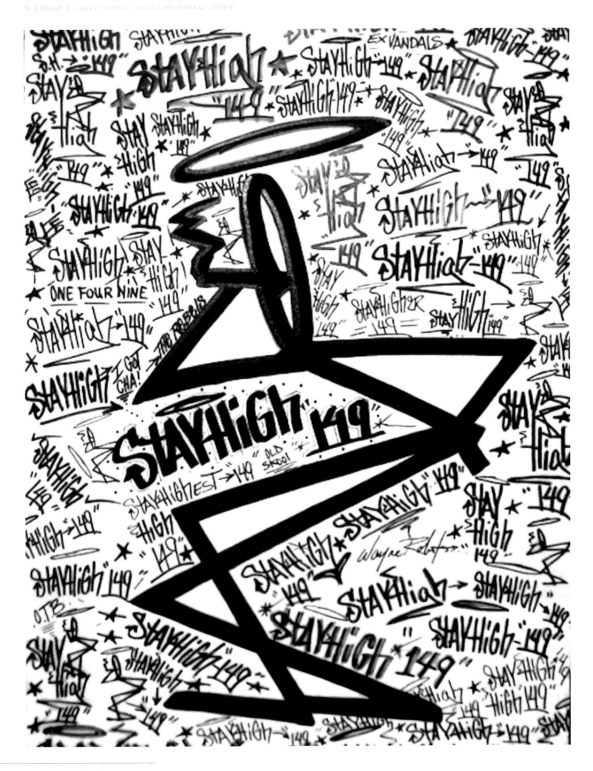

STREET ART, MUSIC, AND SPORT

Graffiti and tags were the first graphic mediums of the hip-hop movement. Born in the South Bronx area of New York at the beginning of the 1970s, this music scene quickly spread to the rest of the world and popularized graffiti thanks to album covers, posters, and stage designs, often created live with spray paint. It is interesting that graffiti, the king of street art disciplines, should be the visual expression of an international movement. The West saw a simular trend in the 1960s, with the hippie movement and the psychedelic aesthetic, but perhaps no other cultural phenomenon has been as complete, associating graphic arts, music, dance, sport, and fashion.

It took less than five years for hip-hop to became established. Everything began in 1973, in New York, with the first DJs, such as Grandmaster Flash, and the pioneer of mixing several discs at once, Kool Herc.

This technique meant that he could create long, rhythmic pieces for the breakdancers at the first block parties where writers such as Futura, Phase 2, and Dondi were often present. Breakdance appeared with its B-boys and B-girls, and more related to hip-hop as a complete discipline, combining both music and dance. It spread around the world with groups such as Grandmaster Flash and the Furious Five, or the legendary Afrika Bambaataa and the Soulsonic Force, who took inspiration from the visionary artist of the New York scene, Rammellzee, and his extravagant stage attire. Skateboarding was the main sport associated with street art, accompanied by the baggy fashion of XXL clothes that signaled the end of the fluorescent colors of the "fun" years, and, from the 1990s, the famous hooded sweatshirt.

Another musical trend that was important for street art was punk. Born at the time of the first tags, this alternative style of music, produced by groups such as The Ramones from New York and the Sex Pistols and The Clash from London, brought an entirely new energy that was compatible with hip-hop. Punks were also in the street and quickly took up stencil art. Stencils became one of their weapons, and the sleeves of cult albums or revolutionary slogans were reproduced on walls and the protagonists' jackets. This musical movement greatly influenced many of the second generation of street artists, including Shepard Fairey, WK Interact, and Banksy.

The artist Rammellzee, who passed away in 2010, contributed greatly to creating links between hip-hop music and street art from early on. One of his futuristic, gothic costumes for his live interventions is pictured here.

STREET ART AND TOY ART

The statue of *The Companion*, the emblematic figure by Kaws, measuring over sixteen feet (five meters) high, was shown in Paris in the courtyard of the Galerie Perrotin, but also in Hong Kong and at the Aldrich Contemporary Art Museum in Connecticut. Before attempting three-dimensional monumental sculpture, street artists first familiarized themselves with the world of toy art. Taking advantage of an enthusiasm for collectible toys, many of them then began to create toys of their own.

One of the first toys, made in 1999, based on Shepard Fairey's work. Series of 284 copies.

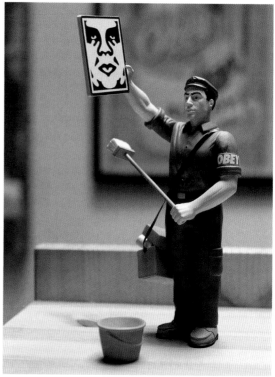

Among them, Futura, Mist, Shepard Fairey, Ron English, and Os Gêmeos took part in this three-dimensional adventure. This new means of expression had many followers, and it is now common to see 3-D creations appear in artists' solo shows.

Toy art was popularized and made accessible partly thanks to production chains based in China. In this field, there is a race for innovation. In France, some small companies produce limited editions with high-quality materials: K.Olin, for example, who produces beautiful limited-edition pieces in Limoges porcelain. Editions are also commonly made in metal, wood, resin, and, more traditionally, in molded plastic.

FACING PAGE
The American graffiti artist Risk created this sculpture for the show *Letters from America* in Los Angeles. An XXL prototype for a future toy?

It is not surprising that many street artists today feel they have a sculptor's soul. The limited edition has also made an unexpected appearance in relation to graffiti: big makers of spray paint collaborate with artists who lend their signature to spray cans, which are then produced in limited series.

5

THEY DID IT FIRST

The Birth of Street Art

Before a certain Taki 183 left his mark on New York's five boroughs and thereby promoted the tag movement in the United States, Julio 204 was already striving to do the same thing. Taki, influenced by Julio, took up his idea and gained recognition thanks to the wide distribution of his name and an article on his work in the *New York Times* in 1971. So, just for the record, it should be recognized that the tag was born with Julio on 204th Street, North Bronx, NY.

Top-to-Bottom

From floor to ceiling: "top-to-bottom" is an expression that describes a graffiti technique consisting in covering a designated area entirely. The December 1972 exhibition *Floor to Ceiling*, organized by Hugo Martinez at the City College of New York, introduced the tag technique into an official venue for the first time in the United States.

Animals in Street Art

In 2005, during his exhibition *Crude Oils*, in which he reinterpreted great masters such as Van Gogh, Monet, Warhol, and Hopper, Banksy released 164 live rats into the very small gallery in London where his works were on show. Visitors could enter only six at a time, for just three minutes. The skeleton of a museum guard sitting on a chair moved slightly every time a rat wriggled into his clothes. Since then, exhibitions by Banksy and Dran have often included small installations with stuffed animals, or even animals that mechanically come to life.

Silkscreen Printing on Paper and Sticker Art

One of the first works to appear in urban space was a tribute to the Paris Commune, a large-scale occupation of the street. In order to create this piece, Ernest Pignon-Ernest made dozens of life-size silkscreen prints of his drawing *Le Gisant* (The Recumbent Figure), and pasted copies in symbolic places connected with his message. For the centenary of the Commune in 1971, several hundred works were scattered across Paris, from Charonne metro station, to the steps of the Sacré-Coeur, via the Butte-aux-Cailles neighborhood and the area around the Père-Lachaise cemetery,

RIGHT
One of Blek's first rats. Paris, 1981.

FACING PAGE
A reference for street artists: Ernest Pignon-Ernest, Charonne metro station, Paris, 1971.

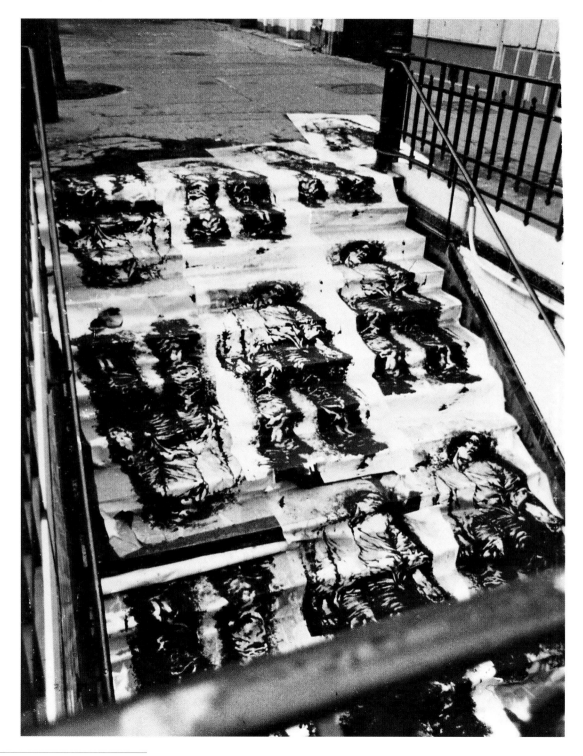

at a time when street art did not yet have a name, and when there were virtually no artworks in the street. Encouraged by this first experience, the French stencil artists Blek le Rat and Goin, as well as the American Swoon, quickly began producing life-size stencils in their own work.

Figures in Frescoes

The first figures in graffiti appeared on trains in 1975. Before then, frescoes were made up only of letters. Artists then began to specialize in figures, but it was not until the arrival of the English street artist Mode 2, at the beginning of the 1980s, that figures began to play an important role in graffiti. Many artists became keen on this practice, including Mist in France, Logan in Spain, and WON Abc and the Ma'clain crew in Germany.

Tagging the Unexpected

Drawing on a live animal: another stroke of genius by Banksy, who painted an elephant with the same wallpaper pattern as the room in which his works were being shown during the exhibition *Barely Legal* in Los Angeles in 2006. The British artist was not the first to do so, but his action went down in history. Before him, Darryl McCray, the father of graffiti in Philadelphia, better known as Cornbread, wrote his name on one of the elephants from the city zoo, and, as if this was not remarkable enough, he took up—and won—the challenge of tagging the side of a private jet belonging to the Jackson 5. Since then, the

French artist Zevs has succeeded in sticking fake license plates onto real police cars, which are regularly tagged in the United States. But animals remain a prime target: Banksy had already painted several cows, sheep, and pigs during his exhibition *Turf War* in 2003, and repeated the performance by transforming an English cow into a billboard reading, "TO ADVERTISE HERE CALL 0800 BANKSY." The WWF put out an advertising campaign to encourage awareness of the environment by tagging—fortunately in a digital but very believable fashion—endangered species such as polar bears, rhinoceros, blue whales, etc.

The Creation of the Street Art Icon: The Rat

The first rats to be stuck on walls appeared in the Parisian urban landscape in 1981. In order to catch the attention of residents and passersby in the 13th and 14th arrondissements, Xavier Prou and his acolyte of the time, known as Blek, invented, without knowing it, the icon of street art: the town rat drawn in realistic poses. Banksy later appropriated this image and made it into his work's mascot, giving the small animal a bit of humanity, all the better to lodge it in our minds.

The Fight against Advertising

Occupying a billboard in order to transform it or corrupt its message demands a quasi-ideological commitment. The complete transformation of the original image, which is generally extremely visible, requires careful preparation in the studio. The practice of covering billboards with graffiti began in the middle of the 1980s in the United States. In 1981, Ron English was one of the first to use the advertising poster as a giant backdrop for the expression of his ideas, and in particular his stance against cigarettes and junk food. Today, this notion of hijacking an image is used by many street artists, including Kaws and Zevs.

FACING PAGE, TOP
A piece on a jet plane by the pioneering French artist Ahéro.

FACING PAGE, BOTTOM
WWF advertising campaign: effective!

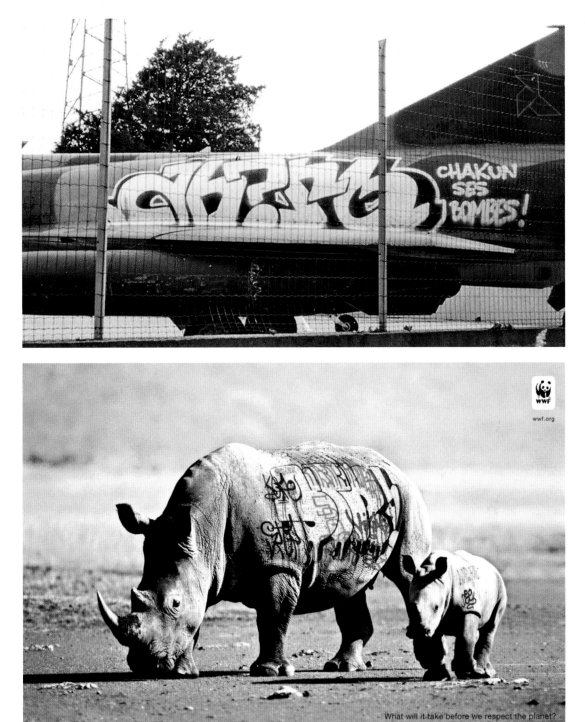

CHAKUN SES BOMBES!

What will it take before we respect the planet?

WWF
wwf.org

Sending a Work into Space

Who other than the artist Invader, with his *Space Invaders* pieces, would think of sending one of his works into space? By propelling his mosaic *Space-One* into the stratosphere, he became the first street artist to send a creation to such heights with the help of only a high-altitude helium balloon. Launched from Miami, *Space-One* was filmed throughout its trip, making the *Art4Space* project that took place on August 20, 2012 into a performance, the first of its kind.

The Street Art Photograph

Bigger than a billboard! Much bigger. The photographer JR was the first street artist to work on a truly monumental scale. In 1984, on a housing estate in the Parisian suburbs, he covered entire apartment blocks with giant images of youths from the area. His aim? To give the residents their confidence and pride back. He repeated the exercise several times, always on a spectacular scale. The size and the message of these images meant that they functioned like visual shocks as much as ideological challenges. A pioneer of illegal interventions on a grand scale, JR opened the way to monumental pieces of street art.

The Hammer and Chisel

Once all the other techniques of intervention in the street had been tested, someone had to find the way back to the origins of sculpture. The Portuguese artist Vhils learned how to use a hammer and chisel to sculpt his material. Of course, instead of quarry stone, bricks, concrete, or plaster are used; the city's walls take the place of blocks of marble . Vhils scrapes and sculpts, smashes and hammers his material until a face emerges—a face he wants to offer to the world, at a specific time and place.

Toward the Infinitely Small

Thanks to photography and the Internet, it is possible to capture and share meticulous, almost invisible works that are anchored in the everyday. This is how the British artist Slinkachu succeeds in showing his work to the whole world. His tiny figurines, positioned in unexpected places, are very difficult to find in situ and show that it is possible to make art in the tiniest of the city's cracks.

The First Animated Film

Who would have believed it? Animated films as a new street art technique! Thanks to the imagination and talent of the Italian artist Blu, this has become a reality. In order to create his surprising project and produce his short film, in 2007 the artist succeeded in animating designs (using the technique of stop-motion animation) that he had painted on the walls of a small room ten feet (three meters) wide. *Walking* shows the constant loop of human evolution. Although rarely used by other artists, this new means of expression demonstrates the vitality of modern street art.

An Extinguisher to Fuel the Fire

By filling his first fire extinguisher with paint, the American artist Katsu invented a giant spray can. Since 2007, thanks to this original and surprising technique, huge tags have begun to appear all over the world. This weapon of mass destruction has been taken to another level by the tagger Kidult, who uses it against brands, deploying graffiti to disrupt their commercial message. The German contemporary artist Anselm Reyle also used this particular kind of spray can for the decor of his exhibition at the Centre National d'Art Contemporain in Grenoble in 2013.

FACING PAGE, TOP
SpaceOne by Invader, the highest work ever thanks to a high-altitude balloon.

FACING PAGE, BOTTOM
Fantastic Voyage, a Slinkachu miniature, in London's Acton district in 2011.

Setting New York Alight for One Month

When Banksy does something, it's usually on a big scale. To inject some energy into the global capital of street art, the golden child of the discipline announced that he would be intervening in New York every day for an entire month. What a comeback! Every work that was discovered led to a frenzy, on the Internet and on site. Scattered throughout the five boroughs, as well as on the web, his pieces mixed stencil art, graffiti, installation, and video. They were a hit with the fans while simultaneously angering the city's mayor. October 2013 was the month of street art—or maybe it was the month of Banksy!

Keeping Warm in the City

In 2005, the American artist Magda Sayeg decided to occupy the city in the most unusual of ways: through knitting. With her collective, Knitta Please, she made huge woolen socks for different objects in the urban environment: trees, street furniture, statues, etc. Her knits found themselves everywhere and earned her a global following.

6

KEY DATES

1940s
Kilroy Was Here

It was the first recurring tag, originally associated with American GIs. It can be found just about everywhere in the world. Even if its origins are not clear, the "Kilroy was here" phrase accompanied by a little drawing, spread during World War II, and may have paved the way for the rise of the tag thirty years later.

1949
The Americans Have the (Aerosol) Bomb!

Edward Seymour created the first aerosol paint spray can. His products were available in stores at the beginning of the 1950s, patiently awaiting the advent of graffiti.

1960
When Graffiti Becomes Art

As a free and non-referential form of expression, graffiti is difficult to situate historically. Brassaï, a Hungarian photographer, studied its most spontaneous manifestations, well before the appearance of spray paint and street art, recording inscriptions and drawings on the walls of Paris over many years. His work spanning three decades was published in the book *Graffiti* in 1960 and praised by Picasso himself. For the first time, this popular practice was considered as art.

1968–69
The Youth Revolutions

On a global scale, the young and the working class began to speak out. Their fight for freedom and the right to expression took the form of demonstrations that broke out in many countries, including France, West Germany, Czechoslovakia, Italy, Yugoslavia, Portugal, Spain, Algeria, Senegal, Canada, the United States, Mexico, Brazil, Uruguay, Bolivia, Argentina, Japan, and China. The street became a place of exchange, and numerous slogans and other mottos flourished on walls.

1972
The First Graffiti Exhibition

Hugo Martinez founded the United Graffiti Artists (UGA) in 1971, at a time when graffiti did not yet have a name; only the practice of tagging had been identified. A visionary (and an astute sociologist), he put together the first exhibition and sale dedicated to the movement at the Razor Gallery in New York in 1972. The issue of market value was suddenly raised for a group of young people who never imagined for one second that they would one day be considered as artists.

1974
Attacking the Museums

Tony Shafrazi was the first to use spray paint in a museum. If you have to write on something, it may as well be a stylish artwork. And so it was on Picasso's famous *Guernica*, then on view at MoMA, that on February 28, 1974 the now renowned New York gallery owner inscribed, "Kill Lies All," written in the same way as the sentence "Kill Them All." This was a spontaneous reaction to the lifting of sanctions against the person responsible for one

of the worst massacres committed during the Vietnam War. Tony Shafrazi gave himself up immediately and, according to the authorities, defined himself as an artist. The paint was wiped off without any damage to the masterpiece, which was protected by varnish.

1980
The Times Square Show

In June 1980, the Colab (Collaborative Projects, Inc.) group of artists and activists organized an exhibition in an abandoned building near Times Square. Artists from the New York underground and graffiti movements, feminists, performance artists, but also politically committed artists all gathered here. Over one hundred participants disrupted an American art scene that was overwhelmed by abstract expressionism, which had dominated painting since World War II. Jeffrey Deitch, then a journalist for *Art in America*, defined the exhibition as the beginning of recognition for postmodernism, marking the end of theoretical dictates.

Poster produced by the Boijmans Van Beuningen Museum in Rotterdam for the *Graffiti* exhibition in 1983.

1983
Wild Style and Style Wars (Cinema, TV, and VHS)

Charlie Ahearn, one of the Colab artists, fell under the spell of graffiti to the point of making an eighty-two-minute film on the subject. *Wild Style* (the title comes from the eponymous graffiti style) was released in cinemas in March 1983. The same year, the seventy-minute documentary film *Style Wars*, made by Tony Silver in collaboration with the photographer Henry Chalfant, appeared on American television screens and met with great success. It was the start of hip-hop culture and graffiti's crazy spread across the United States and around the world.

First Graffiti Exhibition in a Museum

The Boijmans Van Beuningen Museum in Rotterdam, the Netherlands, held the first graffiti exhibition to take place in an official establishment, thanks to Yaki Kornblit. He organized the event in collaboration with Willem Speerstra, as they both had a good knowledge of what was going on in New York.

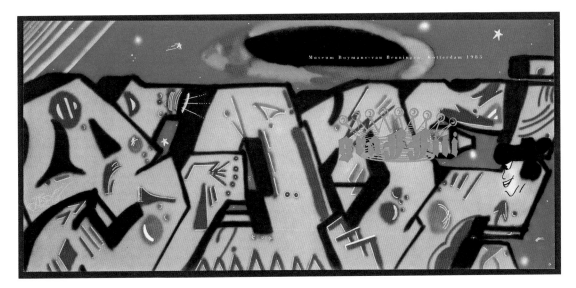

European Solo Show

Dondi White, with his unique style combining letters and figures, had a strong influence on the world's graffiti scene. He was the first American graffiti artist to have a solo show in Europe, at the famous Yaki Kornblit Gallery in Amsterdam. At the same time, he took part in exhibitions on graffiti in Dutch museums, and some of his pieces entered into permanent collections. His show opened up enormous possibilities for American artists in Europe.

1984

First Marketing Campaign

The RATP (the Paris public transport network), commissioned the American artist Futura 2000 to spray-paint multiple posters that it had produced for an advertising campaign entitled "Graffiticket". It was the first time that graffiti had been used as a means of communication, moreover by one of the companies most affected by the phenomenon.

A Declaration of War

The Metropolitan Transportation Agency (MTA) officially declared war on tags and graffiti. It was a time when all the local authorities in the United States became aware of the phenomenon's scale, thanks in particular to the experience of New York City. Street art was now illegal, and graffiti artists risked time in jail.

1990

The Home Studio

With Apple and its easy-to-use computers, as well as personal printers and scanners, the offices of the first geeks were transformed into small research studios. New digital material, allowing for an unprecedented level of interaction, contributed to the enrichment of artistic creativity.

1998–2000

World Wide Web

Thanks to the new search engine Google, it became possible to find, reference, and unite this as yet scattered community. Street artists knew they were many, but they did not realize the scale of the movement. Google gave a huge boost to the street art scene. The first websites, such as Art Crimes, were created in 1994, but it wasn't until 1998 that websites dedicated to street art began to grow, thanks to easy-to-use software. Then came the blogs and social networks.

2005

The Artists Commit

Based on an idea by the British artist Banksy, the wall separating Israel from Palestine became the symbol of an "oppressor" wall. Artists were invited to occupy, at their own risk, this surface that was receiving an incredible amount of media attention. Only a few of them had the courage to take part in the project, but its strong intellectual and political stance showed the potential of a deeply committed art form to a new generation of artists.

2006
The Banksy Effect

For the first time, at a Sotheby's auction in London, a work by Banksy sold for over fifty thousand pounds. Since then, everything has moved very fast, and prices continue to rise. Street art is starting to be considered as a speculative art form by the market.

2008
The Street Art President

Shepard Fairey spontaneously created a work in order to participate in Barack Obama's first presidential campaign. Thanks to the power of his portrait, it soon became the official campaign poster. Aside from shining a huge spotlight on the artist's work, this represented an as yet unparalleled level of recognition for the world of street art. With record youth participation in the elections, communication specialists wondered at the real impact of Shepard Fairey's work. It is probably still underestimated.

2008–9
Recognition

Through the six artists who worked on the façade of Tate Modern in London in 2008, Banksy's exhibition at Bristol Museum, and the Born in the Streets exhibition at the Fondation Cartier in Paris 2009, street art officially entered the world of art institutions, reserved until now for internationally recognized contemporary artists.

2011
The Biggest Street Art Project in the World

JR received the TED Prize for his project Inside Out, by far the biggest street art project to have seen the light of day. It was imagined on the basis of collective participation. Volunteers were invited to post their photo or those of people they would like to see posted around the city to the artist's website. A few weeks later, they received by post large-format prints with which to decorate the walls of their choice. With no fewer than 120,000 photographs posted in over 9,500 cities from 100 countries across the world in March 2013, the project was a huge success. The first interactive work on a planetary scale had been launched.

Art in the Streets

The Art in the Streets exhibition at MOCA in Los Angeles was the explosion the whole street art scene was waiting for. Curated by Jeffrey Deitch, Roger Gastman, and Aaron Rose, three of the top experts in the discipline in the United States, the project took the form of a gigantic group exhibition and grounded the movement formally within the history of art.

2012
A Foundation for Graffiti

The Speerstra Foundation opened its doors in the small town of Apples in Switzerland. It is based around a family collection of over two hundred works from 1979 to 2002, presented permanently in a space of 3,300 square feet (1,000 square meters) spread across two floors. The most important artists from graffiti's beginnings can be found here, with works up to twenty-six feet (eight meters) long and six feet (two meters) high. The space could easily have been called the Graffiti Foundation.

7

KEY WORDS

While some terms, such as "writer," are back in fashion in the graffiti world, expressions taken from contemporary art are starting to be used in the jargon of specialized magazines.

AEROSOL
This is a pressure system that ensures the dispersion of a liquid. It has become the generic term for designating spray cans, as well as the type of paint (generally acrylic) they contain.

ANAMORPHOSIS
A technique consisting of making an image appear only when it is viewed from a specific point; beyond this viewpoint, the image is broken up or illegible.

BATTLES
Battles are organized meetings during which artists confront each other, size each other up, and battle for artistic supremacy, be it in dance (hip-hop), music (scratch, rap), or the artistic field of graffiti and tags. With the live execution of frescoes, battles become a spectacle. On stage, the actors do their best, and everything takes place in a playful mood, to the delight of the audience.

BLACK BOOK
The name of the books in which graffiti artists usually draw their works. They experiment, sketch, and produce miniature versions of their future projects in these books. Considered as almost sacred objects for some, they are similar to traditional art sketchbooks.

BLOCK LETTERS
Big, rectangular, very legible letters, most often painted with a roller.

BUBBLE LETTERS
Letters in rounded, bubble form.

CAPS
These are caps adapted for aerosol cans that serve to vaporize the paint. All sorts of caps exist and produce different results, from very fine to very thick lines (fat caps).

COLLAGE
Originally made with rice- or flour-based glue, collage posters are one of the least damaging forms of street art.

CREW
Individuals from the same collective come together under this name. Synonyms such as "team" or "group" are rarely used in the context of street art.

FRESCO
Generally on a wall, this large-scale intervention, which is not necessarily narrative, is made by one or two experienced artists.

GRAFFITI
While it derives from the Greek word *graphein* ("to write, to draw, to paint"), the word is inspired more by the Italian *sgraffito*, which is an old artistic technique consisting of engraving a design or an inscription in a fine layer of plaster. Its current usage derives from, among others, the photographer Brassaï and the American press, which used it for naming tags and then frescoes on trains at the beginning of the movement in the 1970s.

HALL OF FAME

Or in this case "wall of fame," the term designates the walls or other locations that feature works by recognized artists.

INSTALLATION

In contemporary art, the term designates the production of a work that is adapted to the space it occupies. More and more street artists produce this type of intervention by adapting their art exactly to the surfaces it occupies and by broadening their skills to become sculptors, video artists, or even builders.

MURAL

Large-scale commissioned works, visible most often on urban walls.

NEW SCHOOL

"New generation," "new times," and "new style" can also be employed to describe a beginner.

OLD SCHOOL

Designates the old school represented by the first generation of graffiti artists, as well as the graffiti style associated with it.

POSCA

A brand of marker pens with foam nibs, used for tagging. They are made in a range of widths and colors. Even if other labels exist, the name has become generic in the same way as "Hoover." (These marker pens can also be filled with other inks in order to better withstand weather conditions and cleaning.)

POST-GRAFFITI

Designates work that is no longer made in the street, but on a surface that can be sold. Imagined in 1983 by Dolores Neumann as the title for an exhibition she organized in the Sidney Janis Gallery in New York, the term is used almost exclusively in the commercial market.

REVERSE GRAFFITI

Instead of adding material (for example, paint), existing material is taken away (often built-up dirt). It is environmentally friendly graffiti but is still illegal, however, because the surface has to be totally cleaned in order to get rid of it.

STICKER

Made from paper or vinyl with an adhesive surface, it allows the artist to stick small works or messages up very quickly and in the most unexpected places.

TAG

Originally the street artist's signature, often drawn with a Posca. It accompanies a work, or is written on its own to indicate that its author has passed by, and thus becomes a work in its own right.

TOY

In street art, the word designates collectible figurines. As with many objects, they are more or less rare, and can measure up to 3 ½ feet (one meter) in height. Generally produced in molded plastic, toys permitted the creation of the first street art sculptures.

URBAN CONTEMPORARY ART

A new way of naming street art, in order to link the practice with its artistic and market value.

VANDAL

Term used by detractors to denounce taggers and graffiti artists who, above all, seek to destroy or damage. The term "vandalism", by extension, serves to define the final result of the action executed in this manner.

WILD STYLE

Very complex lettering that can be read only by the initiated few. An important graffiti discipline, wild style lent its name to the first film on street art.

WRITERS

Before institutions and the media gave the name "graffiti" to tags and frescoes, the field's actors defined themselves as "writers", producing "writing" during their illegal excursions.

8

30 ARTISTS

A1ONE

Who is he?

Karan Reshad was born in Tehran in 1981 at a time when graffiti was establishing itself all over the world. His street name can be understood in several ways: "A1one" can mean "the first" because, when he began in 2003, he was really the first artist to produce graffiti and street art in Iran; the name can also be read as "Alone" by replacing the number 1 with the letter l. Thrown out of art school at the end of his final year following an argument with the director on religious matters, A1one decided to express himself directly in the street. He also began translating international articles on street art into Farsi in order to educate a new generation of Iranian artists, and he encouraged the thirty or so artists following his blog to use their own language in their work. It was not until 2008 that A1one was able to travel for the first time, when he was invited to Australia to represent Asia during the Melbourne Stencil Festival. In 2012, his social activism through his work in the street (although it lacked direct messages of protest), his refusal to organize exhibitions for the regime, and his activity on the Internet led to his arrest in the street, in broad daylight, by plainclothes policemen. Ten days of detention were to follow in an individual cell for political prisoners, in the most sordid and secret of Iranian prisons. Iran's leading street artist has become an exile: strongly encouraged by the police, he left his country in May 2012, two months after his arrest. He knows that, if he goes back, he will immediately be put in prison. Since then, A1one has been living in Germany and has picked up a life dedicated to art in a more favorable environment.

His work

As a pioneer of urban art, A1one has experimented with all the techniques and is skilled in many, from stencils to graffiti, from tags to Arabic calligraphy via the creation of stickers. He also has a good knowledge of art history and enjoys using black humor. If his imposing frescoes are illegible (to "uncreative" minds), the message is there all the same, tangled up inside the work, but accessible for those who wish to find it. The pioneering spirit of the discipline in Iran can be found in his stencils. Growing up just after the 1979 revolution, A1one was influenced by the portrait stencils honoring soldiers who died for the country that blossomed on the walls of his city. Once he had discovered the work and tortured lives of Francis Bacon, Van Gogh, and Nietzsche, notions of suffocation or of social and economic pressure on the people flowed through his work. His abundant works and frescoes in Farsi suddenly take on another meaning. The words "love" or "truth," the subject of many pieces, seem to unleash an amazing energy, but also to consume themselves from within. When he speaks of his paintings, he often calls them "pain-things" in English. And like any good expressionist artist, he works quickly, in an attempt to capture an emotional intensity. The resulting drips of paint are due to this urgent need to create in the moment, with no attempt at stylistic effect. He is inspired by the great Iranian poets and mystical poetry, from which he draws reassurance and inspiration, giving his work a fragile strength that arouses a sense of wonder.

He said:

"What is street art for me? It is more about social activism than about making something beautiful and emptying spray cans."

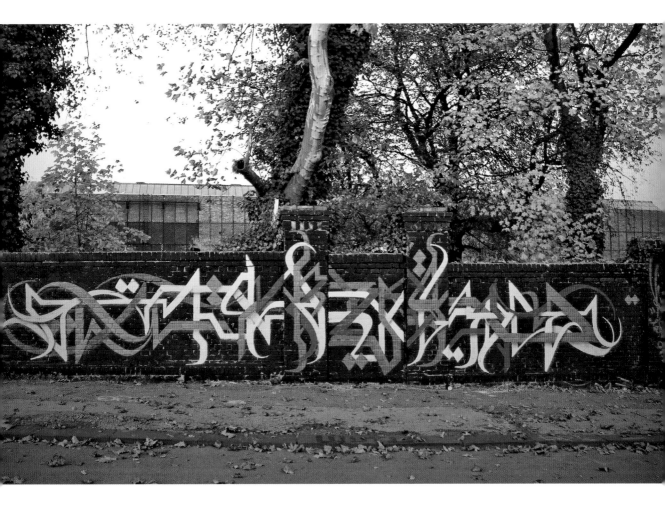

Haghighat (Truth), 2012. Spray paint on wall. Essen, Germany.

ARYZ

Who is he?

Born in 1988 in Barcelona, Aryz grew up in an artistic environment and studied art himself. Influenced by his family circle and close friends, he began expressing himself through graffiti, and yet, dissatisfied with his work, he eventually moved toward painting figures. Far from associating himself with this scene, which he nonetheless respects, he is at ease with his particular style, leaving its definition to others. Street art? Graffiti? Neither appeals to him. He describes himself as an artist painting in public space. He judges his fellows, and wishes only to be judged, by the final result, without taking into account the artist's age, name, or history: the work must stand up for itself. He also avoids any personal representation in the media. As the Internet and mobile phones have begun to disseminate works across social networks, Aryz also bemoans the loss of the element of surprise in discovering a work around a street corner. He regularly fights against photographers' lack of respect for the frescoes they photograph and the way they modify the colors before posting them on the web, thereby transforming the original work.

His work

In 2005 Aryz began to occupy, in large format, the walls of abandoned factories in Spain, before being invited to international gatherings. Whether in Poland, Denmark, Italy, Porto Rico, or in the United States, his works and his style are instantly recognizable and unanimously accepted. The same is true of his canvas works, which he began making in 2009 during his first gallery exhibitions. Spray-painted or made with brushes, his "small-format" works have the same energy as his monumental frescoes; he skillfully combines the choice of color with the subject, and carefully creates a feeling of movement in order to transport us to a hazy, bittersweet, and smooth moment.

Aryz is a part of the new generation of mural artists who seem to know no limits as far as the scale of their works is concerned. Whatever the size of the wall on offer, the final result always fills it to the maximum. The design is, of course, thought out before, but the artist always makes sure his subject echoes the everyday life of passersby, and more generally the city in which he intervenes. It is this humble and intelligent approach that makes his work so familiar to the public. With each fresco the artist tries to tell the story, in images, of a side of the city to which he has just been given the key.

In addition to participating in all the street art festivals, he designed the cover of the American magazine *Juxtapoz* at the beginning of 2013 and has started to enjoy real recognition in the art world, both in Europe and the United States.

He said:

"For me, putting theory aside, it's all just about painting and enjoying yourself."

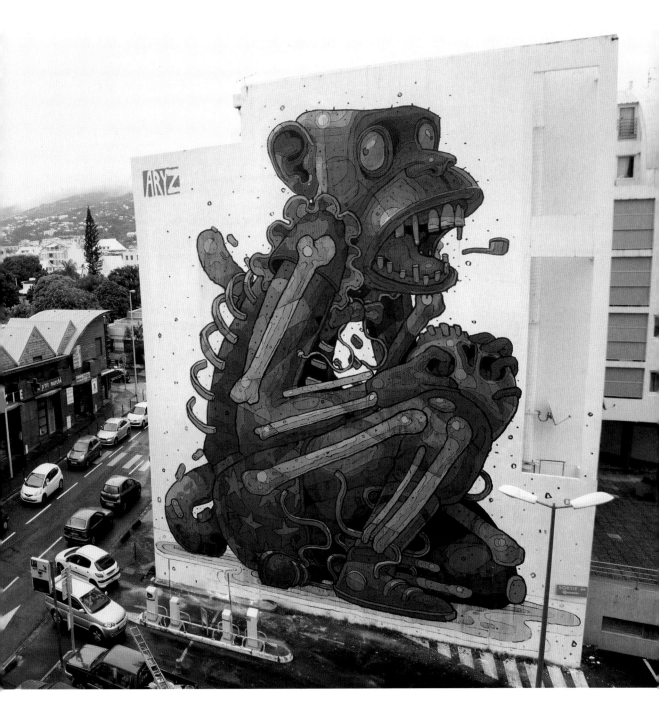

Monkey Business, 2012. Spray and brush paint on wall. Saint-Denis, Réunion.

BLEK LE RAT

Who is he?

Xavier Prou was born in 1951 in Boulogne-Billancourt, one of the well-heeled suburbs of Paris. He discovered tagging at its very beginning, during a trip to New York in 1971, and held onto the memory of this phenomenon that he saw as linked with the May 1968 movement in France. His training at the École des Beaux-Arts in Paris, together with a course in architecture, gave him the necessary technique for his future interventions in urban space. His first piece was made at the end of 1981 in collaboration with a friend, under the pseudonym "Blek," from their childhood comic strip, Blek le Roc. The famous little rats began to multiply. The two companions' interventions became increasingly daring with each new idea and each new challenge, before Xavier decided to go it alone in 1983 and took on the name "Blek le Rat." He started to travel to extend the scope of his research and came to realize the strong impact created by designs positioned in strategic places. In reaction to the growing difficulties encountered during his wall interventions, he began to create works on paper that he pasted in the street at the beginning of the 1990s. Recognized as the father of the icon of street art, the rat, Blek was thrust into the limelight after Banksy recognized his work in 2008.

His work

The work of Blek le Rat is very accessible: his characters express an idea without using words. They bear a message the viewer is free to interpret as he chooses. From his little rats placed along the bottom of Paris's walls to the beggars or rock stars of the 1980s, all of Blek le Rat's stencils are life-size or often larger. By using a format that is slightly bigger than the real size of his subjects, just as Ernest Pignon-Ernest had done, he attempts to create the maximum amount of interaction and projection between the spectator and the work. Since 1991, following his arrest by the police, his illegal and spontaneous works are only ever on paper. Always drawn in black against a white background, his themes pay tribute to wanderers and the forgotten, and are dedicated to the representation of a cult character, or sometimes evoke a painting held in a museum. London, New York, Prague, and Buenos Aires are some of the many destinations chosen by the artist for his collages. History is present in all of his works, whether it be art history in the shape of his faun, or the history of our times, with his soldiers at war, the death of Lady Di, or his support of the journalist Florence Aubenas, captive in Iraq. Today, Blek le Rat's works can also be found in galleries, be they on paper or on canvas.

He said:

"When this art is taken out of the street, in some way it dies."

Andy Warhol, 2012. Stencil on wall. London.

C215

Who is he?

Born in 1973, Christian Guémy currently lives in Vitry, in the Paris suburbs. He has been drawing since childhood, strongly encouraged by his grandparents who brought him up. Toward the end of high school, he started to use spray paint to write in the street. He created neither tags nor graffiti, but poems, already a demonstration of his desire to express himself outdoors. An outstanding student, he showed a great interest in history and art history, and specialized in architecture and seventeenth-century painting, as well as groups of artists such as Der Blaue Reiter (The Blue Rider). Working at first as a historian for the Compagnons du Tour de France (French Tour Guide Company), and speaking four languages, he traveled enormously from 2002 in a series of different jobs as a sales executive in design, before he traded in his suit and tie for the more informal clothes of the street artist. Having adopted a pseudonym, C215, Christian Guémy was reborn in 2005 and became an active militant of urban artistic expression. A series of collective projects followed with an avant-garde feel to them, conceptual and with a strong web presence. Passionate about aesthetics, design, and new technologies, he threw himself into the domain of stencils to become one of its greatest technicians. A street poet without words, he enchants us with his minutely executed works. He represents the new generation of international stencil artists: well traveled, committed, intelligent, and cultivated, he is fully aware of the position of his art within an art history that he is familiar with and masters so well.

His work

Whether in the street or in a gallery, C215's work is immediately recognizable, as if the energy spent making each stencil jumps out at us. At the same time, the delicate draftsmanship and the multitude of details often soften the subject. The passing of time marks most of his works, either through his portraits' wrinkles, his cats ready to pounce, or the representation of a moment in life. His skillful use of color means that C215 easily passes from bright to dark according to his themes and the warm or bright tones that always blend with the subject. Despite his use of the stencil, he rarely produced series and favors small, unobtrusive formats for his outdoor work. If you do not pass them by, you might find yourself touched by these brief moments of poetry. During his travels, C215 met people, exchanged ideas and, in particular, created works that respected others and their environment, moved by the desire to improve urban spaces simply by giving it back its humanity. Recognized by the entire scene, and hailed by galleries and the international press, his work always takes up less space on canvas than on walls, on the web, and in the hearts of his anonymous viewers.

He said:

"I hope I belong to that group of artists who work in the street to improve it, or to give it a bit of the humanity that we all need."

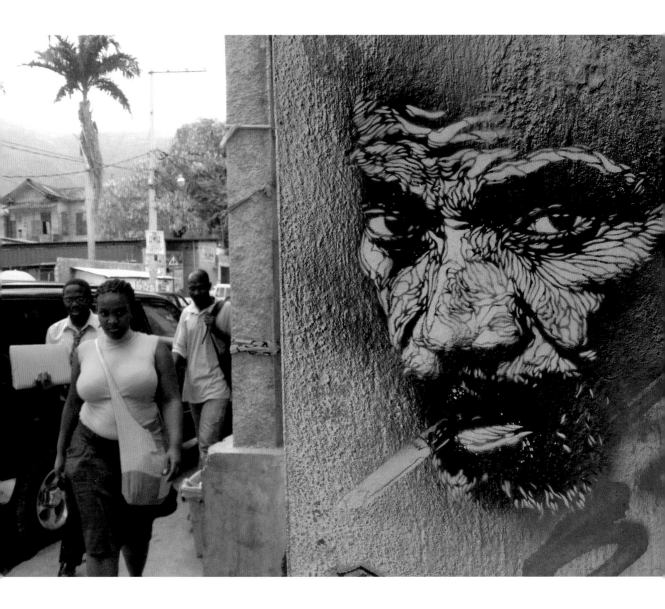

Untitled, 2013. Stencil on wall. Port-au-Prince, Haiti.

CHAZ BOJÓRQUEZ

Who is he?

Born in 1949 in a Latino district of Los Angeles, this young graduate of art and calligraphy became interested in cholo lettering made by the Chicano gangs in South L.A., where he grew up. Adopting and upscaling this style, Chaz made a name for himself, becoming one of the main precursors of graffiti in the U.S. and on the West Coast in particular. His encounter in 1973 with Italian photographer Gusmano Cesaretti did much to highlight the individuality of his output, raising his profile in one of the very earliest books about graffiti, *Street Writers*, which came out in 1975. From 1979 to 1982 he traveled to more than thirty countries, studying both the importance of lettering and graphic styles in different societies and how these reflect the local culture. Showing great respect for his culture and his contemporaries, he decided to leave his cult "Señor Suerte" stencil to posterity, though he could have made a lot of money from it. Increasingly interested in Japanese calligraphy, he has forged a personal style that today can be found in the milieus of tattoo, fashion, and skateboarding. Unflaggingly active, he is a familiar face at major graffiti events.

His work

Calligraphy and stencil work are Chaz's trademarks. The iconic "Señor Suerte" figure, which he stenciled for the first time in 1969 in Los Angeles, quickly became a common tattoo amongst prison inmates. His pieces began springing up on walls in South Los Angeles, "coats of arms" on the border between abstract drawing and Japanese calligraphy, blended with cholo elements. The spray paint was quickly replaced by broad brushes, while glass and paper were attacked with marker pens. Soon Indian ink also made an appearance. Chaz has explained how, since Latino history is marked by oppression, racism, and poverty, it is only natural that his work should address such issues. While from time to time the cross, the skull, and the roses integral to the graphic imagery of the Mexican "Day of the Dead" make an appearance, the artist seeks and attains poetry in vast text compositions, wall paintings, and canvases.

Balance, precision, and perfection are the three adjectives that best define his calligraphic output, often executed in somber, never joyous—but always beautiful—colors. With texts that are incomprehensible to the uninitiated—the mix of Anglo-Mexican slang from the tough neighborhoods of the City of Angels is opaque to most—Bojórquez's work burns with the magic of a sacred text, imposing itself through beauty and the mystery of a hidden meaning.

He said:

"People ask me, 'Ho, you not tagging anymore?' I'm still tagging now, what I'm doing now is I'm tagging inside your brain, I'm tagging inside your skull, so you won't forget my imagery."

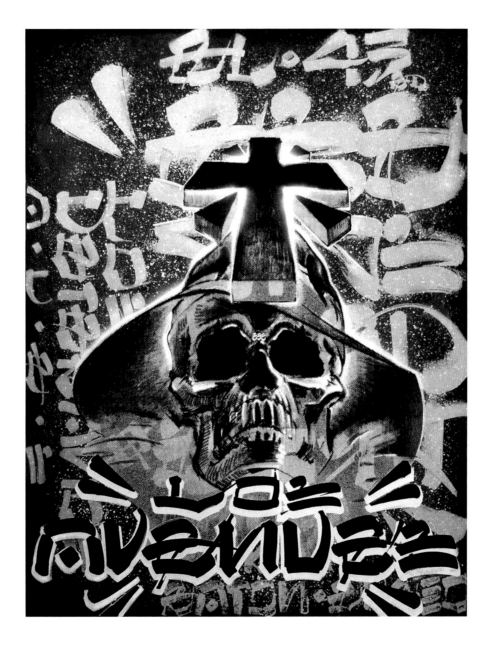

Los Avenues, 1987. Silkscreen print and stencil on paper, 3 ft. 5 in. × 3 ft. 2 in. (104 × 96 cm).

CONOR HARRINGTON

Who is he?

Born in the city of Cork in Ireland in 1980, Harrington has always drawn. He discovered graffiti at the age of fourteen, and it was a revelation: he knew that his life would revolve around this practice and since 1994, he has been leaving his mark in the street. He had a normal school education, before obtaining a fine art degree, and during his university studies he discovered a passion for classical painting. It was impossible for him to choose between these two areas of interest. His trademark? Combining traditional techniques with those of graffiti, handling brushes and spray cans alike. His references? Renaissance painting and mid-twentieth-century abstract expressionism. His frescoes are spectacular and worked on over a long period of time. Whether placed on a wall in Palestine, Norway, Italy, or in his native country, they never go unnoticed. From his first illegal graffiti excursions in Ireland at night, he has kept a taste for risk and traveling—a taste that is satisfied thanks to his global fame.

His work

Harrington's work can be defined as a mixture of street art and fine art. His images are immediately recognizable. His skillfully rendered figures melt into a seemingly unfinished painting, in an explosive encounter between mid-nineteenth-century French painting and the graffiti and tag world. In short, it is as if a vandal had disfigured a museum artwork while preserving its essence. Drips and tags contrast with the classical composition, while bright spray colors highlight the soft tonalities the artist chooses for his figures. Sword-fighting scenes, rodeos, infantry soldiers at Waterloo: the masculine ego is very present in these paintings. It is important to note that Conor works from the photos he takes of elaborate scenarios staged with the help of actors. As for his frescoes, seemingly straight out of a big-budget, epic movie, they have reached monumental sizes since 2010.

He said:

"My paintings are portraits of masculinity, with both its successes and failures."

L'Amour et la Violence (Love and Violence), 2013. Oil and spray paint on canvas, 6 ft. 7 in. × 7 ft. 10 in. (2 × 2.40 m).

CRASH

Who is he?

Born in 1961 into a family of Puerto Rican origin, John Matos is a pure child of the Bronx. Brought up in the northern borough of Manhattan, he still lives and works there today. He started tagging and graffiti at the age of thirteen with his elder brothers. He quickly attracted attention, and Jane Dickson—the wife of Charlie Ahearn, producer of the film *Wild Style*—asked him to participate in the exhibition *Graffiti Art Success for America* at the Fashion Moda gallery in 1980, giving him the possibility of inviting whichever artists he chose. This was enough for the young John Matos, a first-time exhibition curator, to make a successful entry into the official graffiti scene of the time. If his street name, "Crash," comes from an anecdote (he accidentally "crashed" one of the school's computers), the artist employs it in a variety of ways and possible spellings. His keen eye for business means he has collaborated with several brands, such as Fender guitars and the luxury luggage manufacturers Tumi. Generous with his ideas, John Matos is very involved in the fight against AIDS, an illness that killed many of his friends at the beginning of the epidemic. Incapable of considering a work finished, Crash is always looking to improve—and always manages to succeed.

He said:

"My most rewarding achievement is probably getting respect from other artists and dealers. That's the truth!"

His work

Pop art has inspired the artist since childhood. His sources of inspiration are too numerous to be cited, but his work draws from the universe of Marvel Comics and artists such as James Rosenquist, Jasper Johns, and Andy Warhol, whom he frequented and with whom he exhibited at the Mudd Club in New York between 1981 and 1983. He says, "My art is a visual link between street life and established society." In 1984, alongside the artists Keith Haring and Basquiat, among others, he took part in the 5/5 exhibition that brought together French free figuration and American graffiti artists at the Musée d'Art Moderne de la Ville de Paris. His work goes beyond street art. By appropriating pop art codes and associating them with graffiti, Crash connects the two movements. A declared colorist, he is one of the rare links between graffiti and art history. His works are always executed in spray paint and evoke comics, as well as the Ben-Day dot so dear to Roy Lichtenstein. Executed on canvas or on paper, his work is regularly shown on the walls of numerous galleries around the world and is in the permanent collections of big museums such as the Brooklyn Museum of Art and the Groninger Museum in Holland. A retrospective covering three decades of his work was held at the Walsh Art Gallery in Fairfield, Connecticut, in 2010.

Popeye, 2013. Spray paint on wood, 21 × 65 ft. (6.5 × 20 m). Bowery 8 Houston Wall, New York.

DELTA

Who is he?

Born in 1968 in Amsterdam, Delta is one of the precursors of European graffiti. He chose his pseudonym in reference to the letter "d" in Greek: a perfect nickname for a career as an international graffiti writer! He signed his first tags in 1984 and later introduced a new style to the graffiti scene of this period, which immediately positioned him as one of the discipline's leading artists. His work is characterized by futuristic lettering, drawn in perspective and highlighted with 3-D effects that won over the whole community. Thanks to his talent, he quickly joined Europe and America's best graffiti crews. Although he had an engineering degree, he nevertheless chose to live and work on the street for what it gave him: an understanding of chaos, the unpredictable side of things, that no university faculty could ever teach him. This former fan of the very first video games attempts to destruct the simplistic and reductive representations of the world that level, order, and direct our actions, our needs, and our lives. As he grew older, Boris Tellegen (his real name) no longer considered himself a writer, a thing of the past, but he continued to draw from the forms he had invented in order to express himself. His works gained in strength, and yet his favorite canvas is still the wall. In 2010 he decided to forego the pseudonym Delta in favor of his real name and replaced his graffiti with picture-sculptures that still carry an air of his original aesthetic.

His work

Delta began making his first canvases only in the middle of the 1990s, as a way of keeping track of his work. Until then, he had only ever painted his works on wall surfaces in Europe, from England to France, and from Germany to Belgium. He started to use volume, and his compositions gained in density. The paper forms he cuts out are modeled on the letters from his graffiti period, and he superimposes them in order to create kinds of abstract picture-reliefs. His compositions are often dictated by chance. He also creates sculptures in the form of robots, in tribute to the 1980s, and forges Transformers in wood, plastic, or aerated concrete. Working on themes such as the proliferation of objects and the decline of society, his creations move between abundance and minimalism. In line with the first utopians and Russian constructivists, Boris Tellegen shows us what cannot been seen: with his mural installations that he builds himself, he reveals the hidden structures, the sharp edges, the underlying tension of embedded materials. The "upper" part of his works often reveals, through a crack or a fissure, the fragmented accumulation of things "beneath." His approach is built upon an extremely precise relation to form, and color is introduced only later. In order to enlarge the subject, he paints it with a spray can or with a paint roller that then tends to disappear to allow what is "beneath" to emerge once again.

He said:

"Restrictions are, generally speaking, motivating factors and therefore good for creativity."

TOP: *Subduction Zone*, 2011. Mixed media, 23 × 10 × 3 ft. (7 × 3 × 1 m). Muziekgebouw aan't IJ, Amsterdam.

BOTTOM: *Exothermic*, 2010. Mixed media, 59 × 10 × 3 ft. (18 × 3 × 1 m). De Fabriek, Eindhoven, the Netherlands.

DRAN

Virus, 2010. Spray paint and acrylic on canvas, 31 ⅜ × 25 ⅞ in. (80 × 66 cm).

Who is he?

Born in 1979 in Toulouse, Dran is an artist with a caustic sense of humor, close to that of the British artist Banksy, whose work he has been familiar with since its beginnings. He has succeeded in finding a place in world street art thanks to his perfectly controlled drawing technique and, to a larger extent, his touch of black humor and his uncompromising creativity. He began graffiti at a young age, alongside the first generation of graffiti artists from Toulouse. He was drawn to the power of messages on the wall, the illegal aspect of the exercise, the freedom of action, the gratuitousness, and the work's immediate accessibility to the public, and has always sought to follow this path. He appreciates caricature, both literally and figuratively, studying Jean-Marc Reiser, Philippe Vuillemin, Siné, and Georges Wolinski—leading figures of French underground comic strips. Dran says as much as possible with the fewest possible words. While continuing to express himself in the street during his studies, he became familiar with the contemporary art world, combining this influence with his knowledge of comic strips. His encounter with "cardboard" took place in a squat, and it became his favorite material until 2010. The artist gives a good description of himself in this sentence: "I do what I want, and I don't care what people will think. I might have thought it as I made it."

His work

Dran became known through a series of drawings. He retrieves all sorts of cardboard packaging, reworks the original inscriptions, and draws small scenarios over them in pencil to produce perfectly sharp results. In this way, his work reveals our society's flaws through corrosive messages embellished with a few veiled references to his own life. The violence of the message contrasts with the childlike aspect of his drawings, which gives them extra power. For example, the word "FRAGILE" is associated with a scene of domestic violence, "NET WEIGHT 780g" is placed next to a starving African child, and "MADE IN FRANCE" is matched to a series of Asian children sitting in front of a sewing machine. His relatively naïve works were first distributed by small publishers and then by Édition Populaire. Dran's works, therefore, cannot be found on the Internet but in books—small, precious, old-fashioned anthologies—or in the few exhibitions in which he participates. The meticulousness of the artist's pieces is obvious here. He always works from models that he makes either for his friends and family, or for the album covers of the electro group Birdy Nam Nam. In 2007, he developed an advertising campaign for Nissan. This allowed him to invest in the production of his works, to crank up publication a notch , and to organize his first solo show in Toulouse. His work was presented at the Institut d'art Contemporain of Villeurbanne, in the context of the Tenth Contemporary Art Biennale of Lyon; then, after a few group exhibitions, Dran was invited to London at the end of 2010 for Banksy's Christmas exhibition, entitled *Marks 8 Stencils*. He featured as a guest star and gained well-deserved international recognition. Since then, the Toulouse artist has undertaken more complex works on canvas, but always with the same humor and the same style. He moves from drawing to painting, and sometimes tackles more ambitious formats.

He said:

"It's OK to be nasty, when it wakes people up. My drawings photograph the bastards so that we can laugh at them."

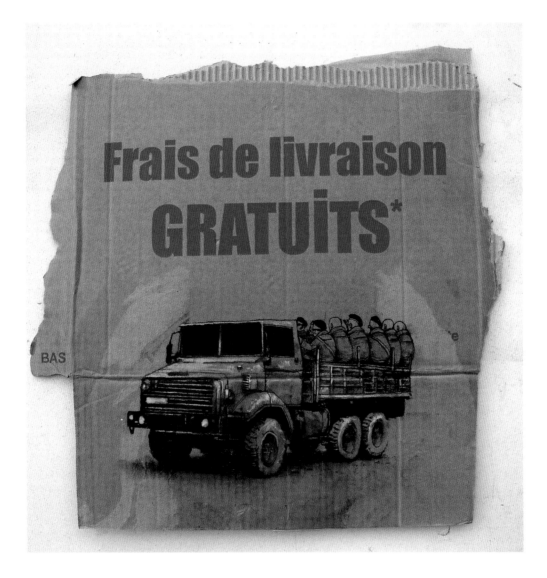

Frais de livraison gratuits (Free Delivery), 2009. Pencil and charcoal on corrugated cardboard, 10 ⅛ × 9 ½ in. (26 × 24 cm).

ERNEST PIGNON-ERNEST

Who is he?

Committed, pioneering, and sensitive are three adjectives that, although insufficient to describe this outstanding artist, best define his place in today's street art scene. Born in 1942 in Nice into a modest family, he began drawing at an early age and discovered Picasso in a popular art magazine at age thirteen. The shock was immediate and triggered his artistic vocation, freeing him once and for all from canvas painting, because, as he says, "After him, I felt that nothing new could ever be produced."

Committed: Upon deciding to become an artist, he rented a small room on the Plateau d'Albion in the Vaucluse region of France, and discovered that French nuclear weapons were hidden only a few miles away, "under the lavender," as he puts it. This paradox became the first theme of his work and made him realize that places are laden with an expressive potential for the artist to see or uncover. Beyond his stance against the atomic bomb, he also fought for abortion and immigration rights in 1975 and emphasized the risks linked to the working conditions of workers in Grenoble the following year. He also tackled apartheid and the eviction of tenants, and, in 2003, paid tribute to Maurice Andin, a martyr of the Algerian independence movement.

Pioneering: Begun on the Plateau d'Albion, his in-situ interventions defined his career and were imitated by many, from Buren to Banksy. His work evolved beyond the drawings and stencils of his first years to explore volume: the 1984 *Les Arborigènes* series, for instance, an invented word that combines the French word for tree ("arbre") with the word "aborigène," or aboriginal. These molds of men and women made in photosynthetic material breathe and live like plants. Scattered around several forests and parks, they call into question man's relationship with nature.

Sensitive: By sticking his works in the street, Ernest Pignon-Ernest understood the importance of the whole in urban space: the size of this immense open-air gallery, but also its restrictions, and the viewpoints it offers passersby. His drawings recognize this fact. Attached to the moments he shares with people, to the memory of the places he has occupied, Ernest Pignon-Ernest uses a language that is accessible to everyone.

His work

Pignon-Ernest began in 1966, with his first stencils made with a roller (spray cans were not yet commonplace) on the roads, blockhouses, and rocks near the sites holding France's nuclear weapons. From 1971, he pasted between four hundred and eight hundred silkscreen paper prints in the locations where he intervened. For each new project, he immerses himself completely in his subject and forges life-size matrix works. Although he handles line perfectly, the fact that he works outdoors means that he has to control his compositions' power: "For a drawing to hold its own in Naples, it needs to be strong!", he says. The process of working on paper and then pasting it is also about freedom: the freedom to perfect his drawing beforehand, of being able to occupy any surface, whether on the floor or on the wall of a church, and of not being bothered by the police. The pasting of his collages remains the artist's "real" work. It is the moment that concludes the work, the hanging that gives meaning, the viewpoint, the light, magnifying the entire poster-building ensemble as an inseparable whole.

He said:

"Working in the street is a poetic act."

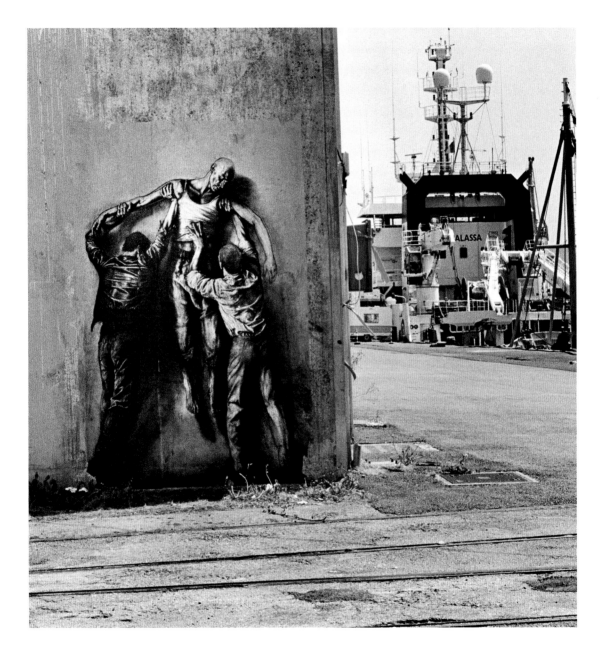

Parcours Jean Genet, 2006. Silkscreen-print collage on paper. Brest, France.

FAILE

Who are they?

The Americans Patrick Miller and Patrick McNeil began placing their work in the street in 1999, but they have been friends since the age of fourteen. They grew up and studied together, and separated only while pursuing art degrees. In 1998 they founded a collective they called A Life, with Aiko Nakagawa. A few years later, A Life became Faile (an anagram), when they discovered a store with the same name a few feet from where they lived. Their work is inspired as much by popular comic strips as by the work of artists such as Roy Lichtenstein, Richard Hamilton, and Mimmo Rotella. They make these influences their own, reappropriating them to better show them in the street, through the collages they paste on the walls. Always attentive to new ideas, they leave the door open to new possibilities. In 2006, Nakagawa left to go it alone as Lady Aiko. One year later, sculpture entered the duo's field of action. And in 2010, Faile collaborated with a master craftsman from Ulan Bator, the capital of Mongolia, to produce a sculpture measuring sixteen feet (five meters) high. Although they recognize their debt to the works of WK Interact, Shepard Fairey, Bast, and Cost & Revs, the duo quickly found its own style and can be counted today among the major figures of international street art.

Their work

Collage. This key word sums up the duo's entire oeuvre. Their works are made from photos, drawings, and comic strips, all remixed into digital compositions. Faile uses and abuses the concept of misappropriation as a writing method, paying tribute to the artists they refer to. As in music, the sample is a founding element of their work and contributes to its subversive character. Typography also plays an important role in most of their creations. Once their compositions are assembled, they are then silkscreen-printed and touched up with color, before ending up on wood, canvas, ceramic, or paper, and usually placed in the street. By no means impressed by the formats on offer, Faile tackled the wall separating Palestine from Israel, the façade of Tate Modern in London, and even created a ruined temple for the 2010 Portugal Arte 10. Their work is similar to Jacques Villeglé's in the torn aspect of many of their compositions, although the street art duo only ever work with their own collages. Without being nostalgic, the two Patricks claim to adhere to the old school, enjoying manual work and the tradition of exhibiting in galleries. Works intended for sale are made in acrylic on canvas and reproduce the torn-paper and collage effect of their outdoor interventions. For some of their installations they use black light, and they collaborated in 2013 with the New York City Ballet. Faile never lacks imagination.

They said:

"Don't worry about money, do what you want and the money will come. Life is too short, just be passionate about what you do, and do it."

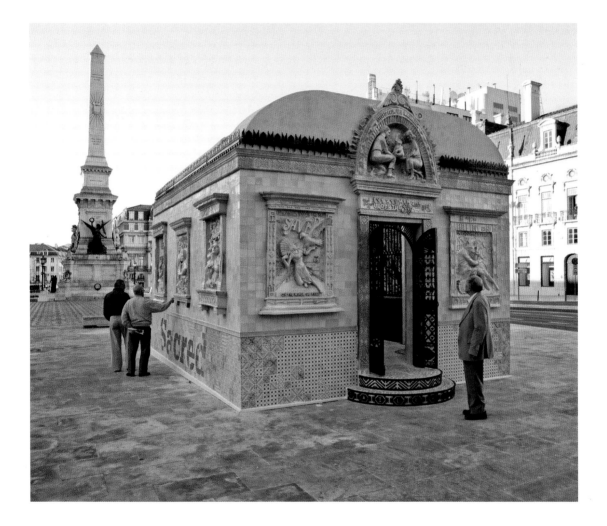

Temple, 2010. Ceramic, marble, bronze, wrought iron, metal, limestone, and mosaic, 16 ft. 4 in. × 29 ft. 6 in. × 13 ft. (5 × 9 × 4 m). Lisbon.

FUTURA

Who is he?

Futura was born Leonard McGurr in 1955 in Brooklyn, to an Irish father and a Franco-American mother—a fact that partially explains the ease with which he travels. He began tagging at the beginning of the 1970s, choosing his pseudonym, Futura 2000, at the age of fifteen. After an accident while spraying graffiti in the New York subway, he undertook a four-year stint in the U.S. Navy, before returning to art in 1979. His return coincided with the first subway frescoes, a trend that Futura took up but in a wholly original, abstract mode that he has developed in magnificent style. Craving new experiences, in 1981 he went on tour with the punk rock group The Clash, painting live at their gigs. The following year he took part in the New York City Rap Tour in Europe, spending much of his time outside the U.S. An unassuming member of the avant-garde, it was not until the early 1990s that he attained full artistic status, abandoning the "2000" from his street name at the approach of the new millennium. Never ceasing to question his own work, Futura has tried his hand at every kind of medium, producing sculpture and exploring as many avenues as possible, from music labels and charity projects to clothing brands.

His work

Futura's art is as unique and as futuristic as his name. Already compared to Kandinsky at the beginning of the 1980s, over the years he has honed his style tirelessly. Handling the spray can like no one else (holding it upside down to draw fine lines), Futura is the father of abstract graffiti. However, this didn't stop him from creating his two figurative characters, Pointman and Nosferatu—veritable toy art icons. His abstractions now appear mainly on canvas or wood, in various formats from medium to very large, and he works flat on the ground, Pollock-style. It is surely Futura's output that best justified the links drawn between postwar American abstract expressionism and graffiti, at a time when alternatives such as pop art, op art, and postmodernism were also jostling for position. Acclaimed as visionary, Lenny McGurr produces work that is undoubtedly the most modern in the entire street art movement.

He said:

"Always resist being one-dimensional and look for other means of creative outlet. The dilemma seems to be that once you've established yourself, you're locked into creating the work that people are familiar with. References to your own past by duplication. Eventually, that's insane."

Eleventh Hour, 2011. Spray paint on canvas, 5 × 4 ft (1.52 × 1.21 m).

HERAKUT

Who are they?

Hera and Akut met in Spain during the Urban Arts Festival of Seville in 2004. Both German, they knew of each other's work through magazines and blogs, and so become street partners. Akut was born in East Germany in 1977 and received the traditional, socialist education of the time. He is patient and a diplomat by nature. Hera was born in 1981, but on the other side of the wall, in Frankfurt, to a Pakistani father and a German mother; her education was totally open to the West. She describes herself as "a dogmatic go-getter." Her street name comes from the most powerful Greek goddess, whose energy she hoped to harness for painting, alone, in the street. The magic took hold, and these two painting partners soon become a couple in real life. Insatiable travelers, they are interested in poetry, literature, and the critical observation of the world. Nothing pleases them more than a fresco that allows them to share an unpredictable situation with strangers, a work that is able to touch its spectators to the core. The pair draw their inspiration from their travels and encounters, and enjoy the fact that they are not totally submerged in street culture thanks to a large number of friends who do not belong to the scene. This has also helped them to keep a certain distance from their work and the urban scene in general, which has changed greatly since their beginnings.

Their work

Their art is determined by their complementary character. In order to paint together, which they have done every day since 2004, they know how to preserve each other's territory, and understand that their differences are their strength. Not content with respecting the other's space, they mutually support each other during their moments of creation, attempting to amplify their work with four hands. Hera, in a rough and intense style, occupies the entire surface, while Akut, in a technique close to photorealism, most often deals with the figures' faces. The duo's paintings are figurative and also narrative: text finds its place, whether just a word or a sentence of several lines. It brings energy and orientates the spectator's viewpoint. It is impossible for Herakut to conceive of their works without it, since, for them, creation is about communication. If both artists like a sentence, they use it and pay tribute to its author in their painting. If not, they find their own themes, subjects, and sentences. The graffiti style of their beginnings has almost entirely disappeared: the energy, the movement, and the lettering of the words they place on the canvas remain. It is to Hera that we owe this very specific typography, a genuine second signature of their works.

They said:

"It's like we are sitting in this boat in a stream and we grab and work with whatever happens to be floating close to us."

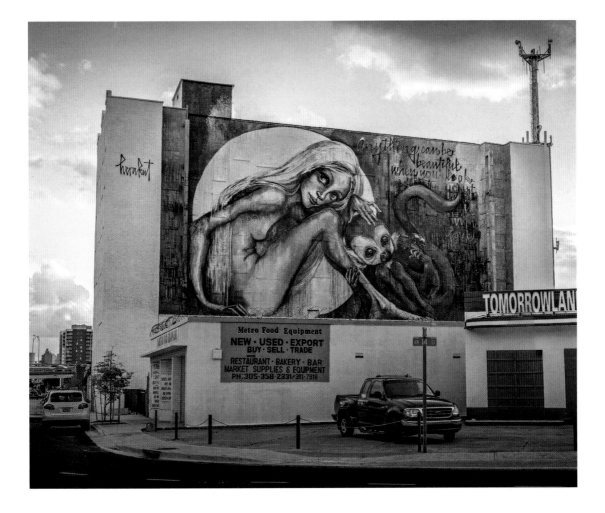

Anything Can Be Beautiful When You Look at It with Love, 2012. Spray paint on wall. Miami.

HOVV & NOSM

VVho are they?

Twin brothers Raoul and Davide Perre were born in 1975 in Spain to a poor and broken family that migrated to Germany. They had to look after each other and started drawing to pass the time, making their first artistic—and illegal—works at the age of thirteen in the shape of graffiti in the suburbs of Dusseldorf. Skateboard at their feet and Posca in hand, they went from paid frescoes, such as painting a storefront or shutter, to illegal interventions on trains at night, something they may still do! In 1997, they grabbed the first opportunity to travel to the United States and quickly became a part of the South Bronx graffiti scene. Hungry for stories, encounters, and contacts, having consumed an impressive number of films (they are admirers of the actor Klaus Kinski as much as of the works of Picasso), How and Nosm stand out. Sometimes they put their past works into perspective and fix new objectives in order to develop their style in a concerted and secret manner, as only twins know how. Having visited over fifty different countries already and worked in legal and illegal conditions, for the biggest brands and for charity, How and Nosm never stop doing graffiti. Of dual nationality, German and American, they admit that the European graffiti scene has the upper hand, and that New York supremacy is well and truly over. Fortunately they can claim to belong to both sides of the Atlantic, and so much the better!

Their vvork

Almost always in large format, the twins' work is multilayered: if, from afar, one glimpses the subject's main form, up close it is a whole different story. Scenes and tiny stories cross over and mix together, capturing the gaze and mind of the viewer. Each work, composed of a rich and detailed narrative thread, representing a seldom joyful world, forms a coherent whole as soon as one steps back. Having used all the spray colors on offer over the course of twenty years of graffiti, How and Nosm chose black, red, and white as their trademarks. Since then they have produced instantly recognizable works, almost entirely made with spray paint. These first representatives of the New York Tats Graffiti Cru in Europe enjoyed immediate recognition, as their work was so unexpected, complete, and innovative. Their works are made on canvas or in the form of sculptures, huge murals, or small format reproductions. They innovate, invent, and push back the limits, with no restrictions, experimenting with volume and design in materials as diverse as wood, glass, and metal.

They said:

"The police just don't leave us alone, day or night."

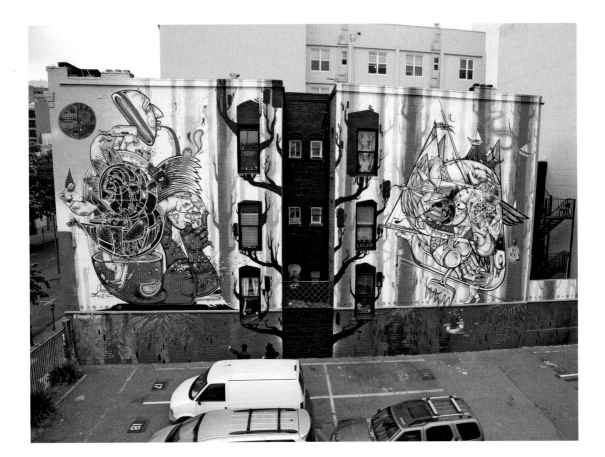

Self Destruction, 2012. Spray paint on wall. San Francisco.

INVADER

Who is he?

This French artist, born in 1969, studied art at university and then at the École des Beaux-Arts in Paris before entering the fray and choosing anonymity. He discovered the graffiti movement while considering how to infiltrate cities with a viral invasion plan, which was fortunately only visual. His artistic approach is as simple as it is beautiful, and the realization of his ideas retains its original power. His work is based upon popular culture and a taste for experimentation. Constantly seeking new ways of representing his pixelated video-game characters, he never lets an opportunity go: from the production of waffles that resemble his icons, to the manufacturing of R-Invader sneakers, via the creation of an automatic ball-throwing device enclosed inside a glass cage, Invader constantly creates and innovates. In his work it is obvious that he is having fun while questioning the contemporary art world. An insatiable traveler, he covers the world, posting his creatures everywhere—often in improbable places—from India to Australia, from Japan to Brazil, from the United States to Bangladesh. Perhaps he travels in a spaceship?

His work

In the beginning, there was ceramic; then came the time of the cube; and now here come his performances. Invader also creates installations, as for the Lyon Biennale in 2001. If the very first Invader dates from the mid-1990s, the true invasion did not begin until 1998. On street corners and under porches, in city after city, the artist sticks up his ceramic figures, drawn directly from the leading video game of the 1980s: Space Invaders. The work is meticulously prepared beforehand: the small ceramic squares are assembled in the studio, ready to be fixed with cement or extra-strong glue in the blink of an eye. Once the city has been chosen, the locations are calculated so that everything makes sense and can be referenced.

In Montpellier, the artist pushed the game further so that the points where he placed his figures joined up on the map to form one of his characters. In a simple but brilliant development, in 2005 his work embraced a new medium compatible with his original idea: the Rubik's Cube. Using only the object's six colors, Invader creates paintings from these tangible pixels that allow him to reinterpret classic masterpieces or other subjects of his choice. Not satisfied with occupying cities, the countryside, and the consenting press (the french newspaper *Libération*, for instance, on June 11, 2011), the artist has also managed to take over the seabed of Cancún Bay in Mexico, in collaboration with the sculptor Jason deCaires Taylor, producing underwater works, and the stratosphere since August 20, 2012. By propelling an artwork over seven miles (twelve kilometers) from the earth's surface, he became the first artist to exhibit in space. When combined with talent, street art can lead to anything!

He said:

"I think that this project's strength lies in the fact that I didn't stop after three years."

Ma Pomme (My Face), 2012. Rubik on Perspex, 3 ft. 5 in. × 2 ft. 8 in. (104 × 82 cm).

JEFF SOTO

Who is he?

Born in 1975, a true Californian brought up in Los Angeles, Jeff Soto admits that the City of Angels' alternative cultures were a great influence: "The fact that I live in South California is an influence on both my work and my vision of the world. Los Angeles is a central place, not only because of Hollywood and the music industry, but also because of its counterculture—skate, surf, punk-rock, latino gangs, tattoos, hot rods (customized old cars), graffiti, 'Kustom Kulture,' fine art." He finally chose the last discipline and obtained a diploma from the Art Center College of Design in Pasadena in 2002. His way of working is inspired by graffiti (which he practiced enormously during his teenage years) and his own personal sensibility, the two combining on the walls that he occupies in the largest possible format. Continually searching for free spaces in which to express himself, particularly during his travels, he considers his urban interventions—and the street credibility they bring—very important. He does not, however, consider himself a graffiti artist, but rather "a muralist with an occasional urge to do some graf."

His work

Through his spectacular compositions, Jeff Soto shares with us his flamboyant visions, deep fears, and the nostalgia of his youth, but also tackles more universal themes such as love, desire, and hope. His very specific palette of colors, subjects, techniques, and the themes he addresses find an echo in an ever-increasing circle of fans. Inspired by toys and the fictional worlds of his childhood, the alternative lifestyles of skateboarding, graffiti, hip-hop, and popular culture as a whole, his representations are both accessible and stimulating. Linking the world of street art to pop surrealism through his use of a brush and the subjects he tackles, Soto builds a bridge between two worlds. He moves, with the same enthusiasm, from rock posters to a daring collaboration with Chevrolet. As an artist-illustrator, he exhibits in museums and is appreciated by the most attentive collectors. For the works that are for sale, Jeff Soto uses only wood as a material, as in his solo show at the Riverside Art Museum, California, in 2008. Jeff Soto takes us into a fantasy in-between world with his colorful compositions, his vanities, and his imaginary bestiary, as if color were the primary source of his figures' energy.

He said:

"Art is a very, very tough profession. It's easy to feel discouraged and down on your luck."

Owl, 2012. Spray paint on wall. Richmond, Virginia.

JR

Who is he?

JR is an alien, ten years ahead of his time. When he started working for the Rossignol skiing brand in 2001, he was already far ahead of everyone else. And few are capable of following him. The idea of the street as a gallery, of "everything for the outdoors, not indoors," was already there. Building-site signage helped forge his signature, which he placed near his street works in the form of a yellow and white ribbon. As a photographer, JR relies on his camera lens to produce a clearer, more precise vision, with a better framework and a viewpoint that is different from everyone else's. And beyond the photographer's vision, there is that of the artist and the discerning citizen. In his gigantic installations, the viewpoint is therefore no longer the only factor. The images involve a long creative process. All of JR's work should be read according to the current political, historical, and economic context in the locations he occupies. The artist invests himself in the site, revealing social tensions or collective action. There is no distance from his subject. Meeting people, risking the incredible, sticking as close to reality as possible have become part of his signature. Each image wears its story on its sleeve (or on its paper). The people he photographs agree to reveal their deepest, most personal feelings for the duration of a portrait. They trust the photographer who, each time, keeps his promise: to show their inner beauty to the outer world.

His work

This French street artist has become a global figure. His work has, in part, finally entered galleries through contemporary art's front door. One has to travel far to find his collages in situ—in China, Liberia or Brazil—or follow his activity during festivals and other European cultural events. His actions have become legal in Western countries but remain illegal in the countries where he finds many of his subjects. JR has managed to bring together a mass of people from the four corners of the world who believe in another means of communication than the one imposed upon us by the media. I stick therefore I am. I become master of the image I send out, which I offer to others. By creating this campaign of encounters with thousands of anonymous individuals, the artist shows most people's desire for peace, even if the press highlights the wars undertaken by a few. It is difficult, therefore, to translate his acts into "artworks." All that remains is the visual testimony of his spectacular photographic installations that the artist creates in situ, as well as the publication of a few lithographs or the creation of collages in different materials. Embedded within a mission of reconciliation, his work shows the reality of the very many people associated with his projects, and gives rise to a valuable awareness. Could an artist dream of anything more beautiful?

He said:

"The street inspires me. I come from street art. JR is my tag name. I like people and I draw from their emotions."

Women are Heroes. Collage on loudspeakers.

MARK JENKINS

Who is he?

Born in 1970 in Virginia, Mark Jenkins studied geology and played the saxophone in a big band. Nothing hinted at a future career as a street artist until he found himself in Rio de Janeiro in 2003, killing time, playing with transparent packing tape. At this point, something triggered in his mind and everything suddenly sprang into focus: his memory of the Spanish sculptor Juan Muñoz's works, the 3-D structure he had just made by molding his own body, and the street beneath his window. These three sources formed a single idea. And so he placed his transparent tape figure outdoors and watched, from afar, the reactions it produced in passersby. He understood that he loved this act, but did not yet call it "street art." Since then, Jenkins has continuously shown his work almost everywhere depending on his commissions and encounters; he has roamed over twenty countries and participated in many workshops. He currently lives in Washington, DC. The writer Albert Camus, the world of the factory worker, and anyone capable of coping, alone, in a hostile environment all feed his inspiration and trigger his anti-establishment character. He also collaborates with Greenpeace on global warming awareness-raising projects.

His work

Jenkins really began working in 2005 with the *Storker Project*, in which he created babies from tape: hundreds of transparent cherubs placed in the most incongruous places in cities across the world, from Bethlehem and São Paulo, to New York and Warsaw! Then came a series of life-size figures in all possible positions, animals (dogs, giraffes, or ducks), and all kinds of objects. Then he had to think of a new direction: something that came to him naturally with the idea of dressing his models. With this simple gesture, Mark Jenkins shifted from poetry to intervention, from the "very visible" to camouflage, opening up an immense field of interpretation. Confusingly real, his figures are placed in dangerous situations—immersed in the middle of a lake, or balanced on the roof of a building—and constantly bring policemen and firemen, journalists and curious onlookers running. But most of them are placed on the ground in positions as improbable as they are funny. Some have their heads stuck in the wall against which they are leaning, making passersby look twice. Jenkins's works can also be found in galleries and, even if this does not bother him, the artist is always wondering what lies ahead: the path he has taken since 2003 astonishes him. There is no lack of surprises on the horizon.

He said:

"What kind of art would you make if you were the only person to walk around in the city to see it? If you can be in tune with that, then I think you're making the right kind of art."

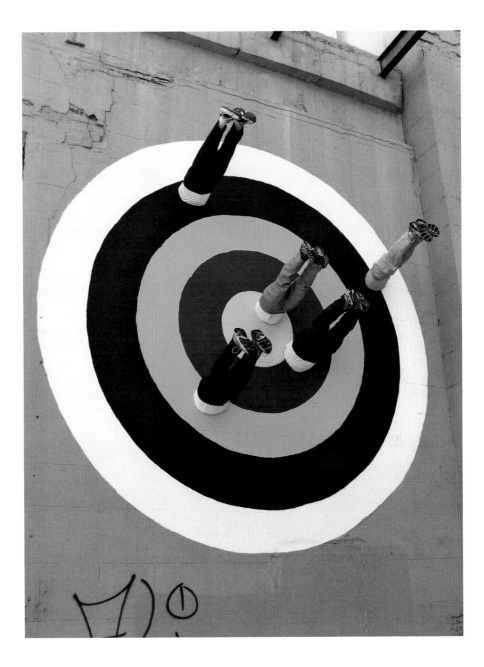

Untitled (Human Darts), 2012. Mixed media and paint on wall. Richmond, Virginia.

MISS.TIC

Who is she?

Born into a modest family fated to tragedy, Miss.Tic took her pseudonym from the world of popular comic strips. Born in 1953 and orphaned at sixteen, she took up traditional theater and then street theater before giving America a try in 1979. Back in Paris three years later, this child of Montmartre combined theater with the applied arts and began to mark her territory with stenciled sentences on the walls. Miss.Tic is one of the few female street artists from the heroic period and one of the best known, whose endurance and dedication can command only respect. A sidewalk poetess, she harangues passersby with words, aphorisms, and false proverbs. She narrates her relation to the male with humor and spirit. Miss.Tic displays her passion for this other that she so resembles in the physical risks she undertakes during her urban interventions, even as she tends to her glamorous image. She asserts her femininity loud and clear, like that of her sisters, with its moods, desires, and wounds, and portrays the battle of the sexes with elegance and spirit. Personal diaries are shamelessly revealed to anonymous passersby through scathing humor; prose comes into direct contact with the depths of our souls. Sometimes raw and brutal, Miss.Tic's works evoke the fragility of existence, the joys and the pain that should be lived to the full.

Her work

Her short, incisive texts, provocative or inquisitive, accompany the image of a sexy, enticing woman that figures in all of Miss.Tic's works. The relation between the words and the image makes the passerby stop and think. Her stencils, in which black and red slightly overlap, create an effect of contrast and depth on concrete or brick. Since 1986, her word/image depictions are regularly transferred onto canvas or other transportable media and sold in galleries. By using materials drawn from the street, such as rusty metal, fragments of wall, wood, or torn posters, Miss.Tic introduces into collectors' homes that part of urbanity that is inseparable from her work. Her depictions also find their place in the world of cinema and music posters, and this great master of Parisian haikus shows her works in Venice and London, Berlin and Singapore. She draws from the memory of the streets, commits herself and takes a stance, persists and signs. She has acquired legitimate recognition, never having stumbled, as if she ever could.

She said (and wrote):

"The obvious makes us blind."

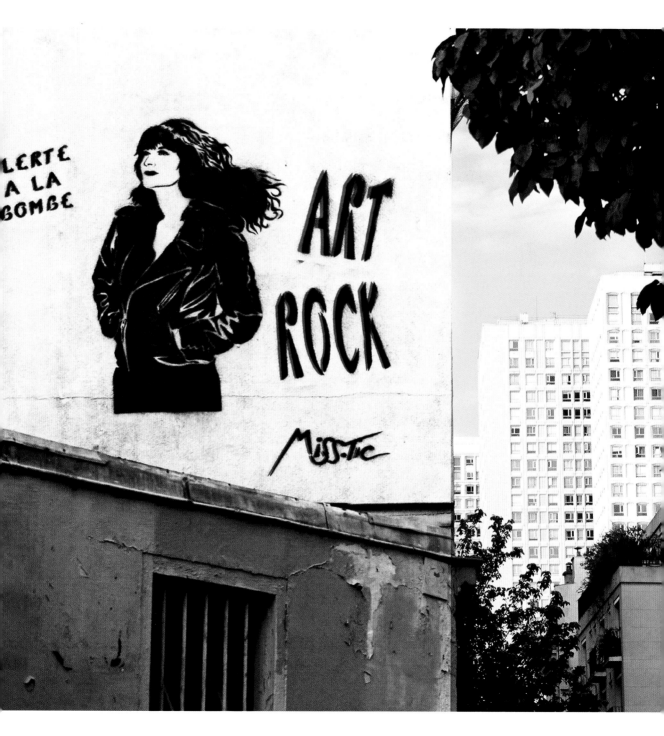

Art Rock, 2011. Stencil on wall. Paris.

MODE 2

VVho is he?

Born in Mauritius in 1967, Mode 2 ended up in South London in 1976. Influenced by the film *Star VVars*, the book *The Lord of the Rings*, and role-playing games, he educated himself through comics and science fiction. At the end of secondary school, he discovered the Covent Garden hip-hop scene and, thanks to his skillful drawing, he painted banners and customized the jackets of his friends. Quick to make a place for himself in the growing world of graffiti, Mode 2 came to use spray cans and markers, and joined one of the first crews before founding the Chrome Angelz with some friends in 1985. A great fan of hip-hop (music and dance), he fed his inspiration by following the artists of this movement, participating graphically in battles and other gatherings across Europe and beyond. Modest and precise, a living encyclopedia of graffiti, Mode 2 cultivates sharing, experience, and work in order to keep evolving, enchanting, and sending out positive waves to those who contemplate his works.

His vvork

This master of figures—which have been present from his very first frescoes—saw his work on the cover of Henry Chalfant's second book, *Spraycan Art*, in 1987. This big spotlight on his inimitable style encouraged him to constantly evolve and progress, which he did by traveling widely until 1989, taking on numerous commissions in order to pay his way. This was an opportunity for him to test new painting techniques. This pioneer of European graffiti admittedly creates less in the street than before, but his grafs, like his emblematic figures, continue to occupy increasingly larger formats in cities and galleries. Loyal to all the writers who preceded and inspired him, Mode 2 creates works that are always in move-ment, some of which are now exhibited in museums. He attempts to transmit the dynamics of taggers' lettering, the dancers, and the hip-hop artists that he claims as his kin. Most often executed on canvas, paper, or cardboard, his works retain the spirit of his beginnings but, for health reasons, the artist uses spray paint less and less. It is a real problem for this traditional aesthete, who, for ethical reasons, prefers original to customized caps. And so, he fell back on pencil, marker pens, and brushes which he wields with unrivaled talent. Many define him as "the graffiti artist who draws women"; this is true, but a closer look reveals that Mode 2 in fact draws the world around us.

He said:

"Ours is a 'hands on' culture by definition, and, up until today, this vvhole spectrum of shape and tone and rhythm still eludes definition by those from outside of it; not that vve vvish to be exclusive, as communication and the act of giving are an essential part of our form of expression.... Those vvho control the established and accepted art media vvill still continue to talk about vvhat they don't understand, using vocabulary vvhich does not fit the form and dynamics of vvhat my predecessors as vvell as some of my contemporaries have given me the capacity to express myself vvith."

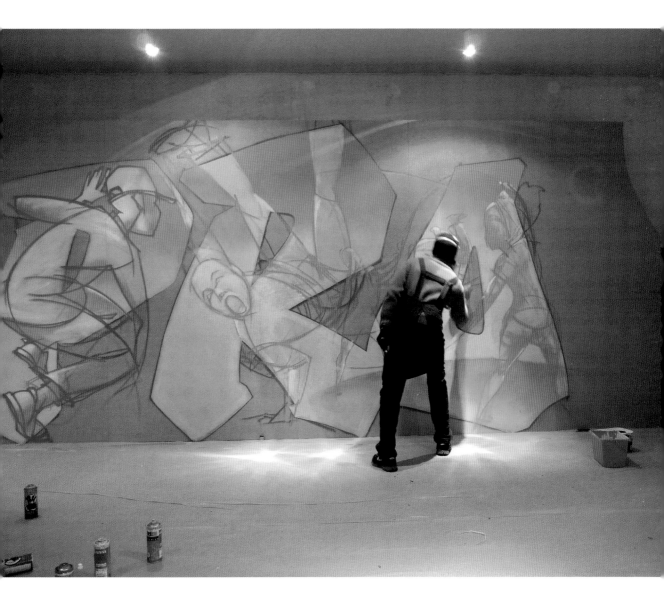

Chelles Battle Pro, 2012. Spray paint and acrylic on wood, 7 ft. 10 in. × 16 ft. 5 in. (2.4 × 5 m).

OS GÊMEOS

Who are they?

The Brazilian identical twins Otavio and Gustavo Pandolfo, born in 1974 in São Paulo, have become the stars of South American graffiti. They started out in hip-hop culture as breakdancers at the end of the 1980s, before getting involved in graffiti, using inexpensive colors and spray paint. Their first step was to emulate the American graffiti style, without really mastering the technique, save what they saw in the book *Subway Art* or the film *Star Wars*. They started to explore techniques themselves and achieved a totally new style, very different from the American model. In 1993, they had a chance meeting with Barry McGee who was in São Paulo for a few months. His techniques and experience were to influence the pair, who began to understand the importance of their own culture. Os Gêmeos ("The Twins" in Portuguese) began to occupy walls with monumental works, in the manner of the *pixadores*, but using graffiti. Their style developed over time and, from 1997, their notoriety spread beyond Brazil. Since then, the artists have been present at all the major festivals, bringing their touch of color and inimitable texture to walls, preferably over thirty feet (ten meters) high!

Their work

Color and Brazil have always gone together; with Os Gêmeos, yellow became a signature, visible from a distance and resonating with light. The walls painted by the twins are too numerous to mention, but the delicacy of their graphic works (even in the case of the large pieces) is as remarkable as it is constant. They execute their subjects together, without verbalizing the ideas that they draw from their Brazilian culture. But their work does not stop at frescoes, as large as they are. The brothers also started occupying museums and art centers in 2005. For example, they created works with Jeffrey Deitch in New York in 2005 and 2008, and at the Museum Het Domein in Holland in 2007, Tate Modern in London in 2008, the Vale Museum in Brazil in 2011, and the Institute of Contemporary Art in Boston in 2012. Their indoor work is radically different from their street work, and they favor installations in the same vein as those of their mentor, Barry McGee. The museum interventions are almost always paired with an outdoor work. The twins' notoriety meant they were able to collaborate with Louis Vuitton on the creation of a scarf in 2013, just like Takashi Murakami.

They said:

[In answer to the question, "You use a lot of yellow and red in your work—why is that?"]
"According to stupid research, these two colors apparently cause chronic anxiety in dumb people."

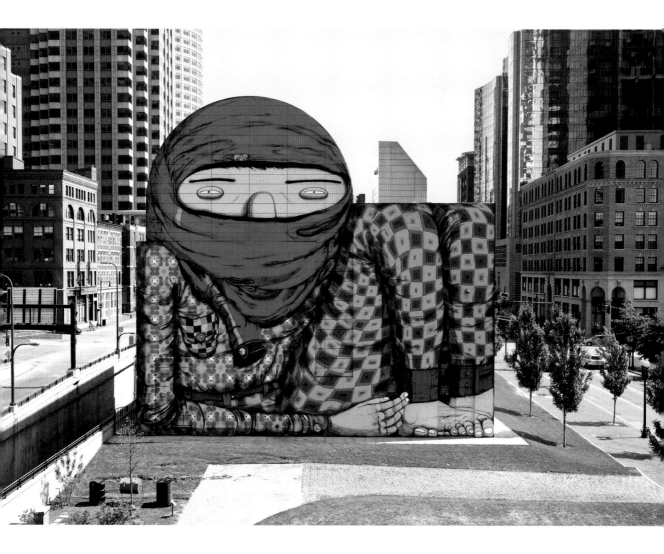

The Giant of Boston, 2012. Spray paint on wall, 75 × 75 ft. (23 × 23 m). Boston.

ROA

Who is he?

Born in 1975 in a small Belgian town, Roa is part of the second generation of artists to express themselves in the street. He began his career painting graffiti with his friends on the walls of his native city at the age of thirteen. Passionate about animals, he depicts living and dead creatures in his own particular style, pretty much across the world. Fascinated early on by species unknown to man, he has undertaken a serious amount of research on the subject. He bases his work around the idea that the animal he depicts can be found near the place it is painted. You therefore have to go to Australia in order to see his opossums, or to Berlin to admire his hogs. Working prodigiously, Roa focuses on learning the morphology of animals and uses this knowledge to call into question humans' true nature and our destructive instinct. Based on an almost mystical search, the artist's work is as conceptual as it is sociological. It tells us that we too belong to the mammal family, and that we must respect nature that, in one way or another, will end up reminding us of its presence. A word to the wise.

His work

Darwin's *The Origin of Species*, which he keeps on his bedside table, is an obvious subject for Roa. Although he began with graffiti, the artist took a kind of backwards step and resumed pencil drawing, as if trying to understand life by going back in time. His monumental compositions in black and white often evoke death, or at least the passing of time. The artist believes that the animals he represents have been at the city's gates for a long time, already a part of the local landscape, waiting for someone to reveal them. His works assume their full meaning in large formats, on the brick or concrete walls of working-class districts and derelict buildings, his subjects seemingly magnified. In gallery works he re-creates his calm but disturbing bestiary, placid or ready to pounce. Often he offers us an amazing view of one of a creature's skeleton, as if seeing the inside is sacred. Painting his works on assembled pieces of wood or, even better, on any surface with a door, Roa enjoys creating a double view: with an open door, the animal is alive; with a closed door it becomes an anatomical drawing. It is up to the spectator to choose the vision he wants.

He said:

"Graffiti is one of the most free art expressions in the world; you don't do it for money nor for an institution, it's free expression and it liberates you creatively from a lot of restrictions."

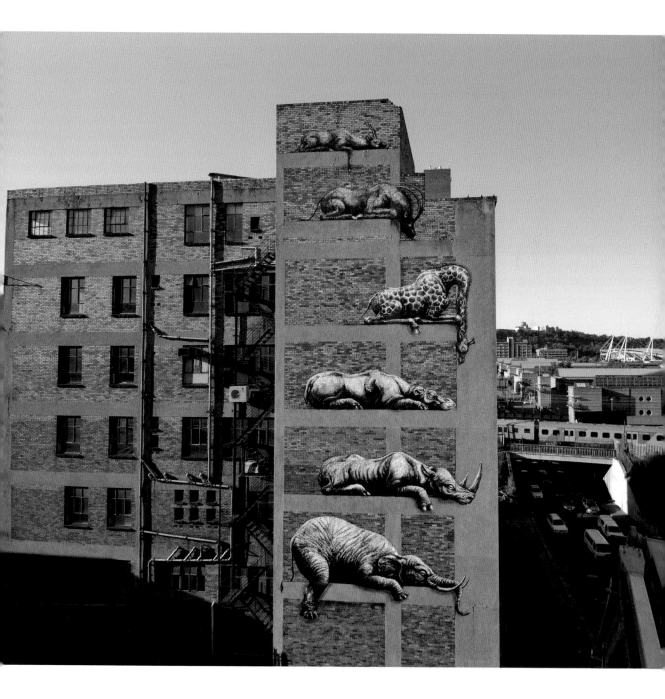

Johannesburg Still Life, 2012. Spray paint on wall. Johannesburg.

RON ENGLISH

Who is he?

Born in 1959 into a modest family in Illinois, Ron English studied photography and art history in Texas before taking up oil painting. To help the masses reclaim the public arena, in the mid-1980s he started taking over billboards. Set on promoting a highly critical stance on the excesses of national advertising campaigns, he wasn't concerned about getting arrested: it was all part of the game. Arriving in New York in 1988, he began working as a "ghost painter" (an artistic ghostwriter), delighted to be perfecting his technique and getting paid for it. However, he dreamed of creating work of his own and hanging it in museums, and he soon gave up this first job to paint pictures in his own right. Committed, spontaneous, and interested in important issues, English has tackled subjects such as fast food, the tobacco and sugar lobbies, and the political class. Highly gifted—perhaps exceptionally so—and hungry to learn, he is a workaholic who paints for fifteen hours a day. After a fantastically interesting, joyous, and rapid rise to success, today he has attained his goal and his works can be seen in many museums.

His work

First appearing in 1981 on the billboards of Dallas, English's works were initially in black and white. He then moved on to color, so as to imitate as closely as possible the ad campaigns that he spoofs. His work quickly gained in intensity, and he took up painting on canvas. A masterful technician, he is endowed with a photographer's eye, and his works give the impression of being in 3-D. Dealing with a range of subjects, he defines his style in one word: Popaganda! (or propaganda meets pop culture). He has also revisited the works of many masters, from Cézanne to Picasso, and from Monet to Munch. However, many of his images still feature an obese Ronald McDonald, a Charlie Brown with a deathly sneer, a dinosaur, or a cow pin-up. Over the last ten years or so, his children have also provided inspiration for his compositions, both for conventional painting and for wall pieces. The artist has explored every medium: oil on canvas, Warhol-type screen printing, mass-produced and limited-edition toys, sculpture, installation, etc.

Today English employs an assistant, who helps him with the backgrounds, among other things, allowing him to produce a substantial output every year. This also gives him the time to participate in outdoor events, in addition to an unrelenting culture-jamming campaign that, in thirty years, has appeared on more than a thousand billboards throughout the U.S.

He said:

"I damn sure didn't make the rules, I damn sure won't live by them."

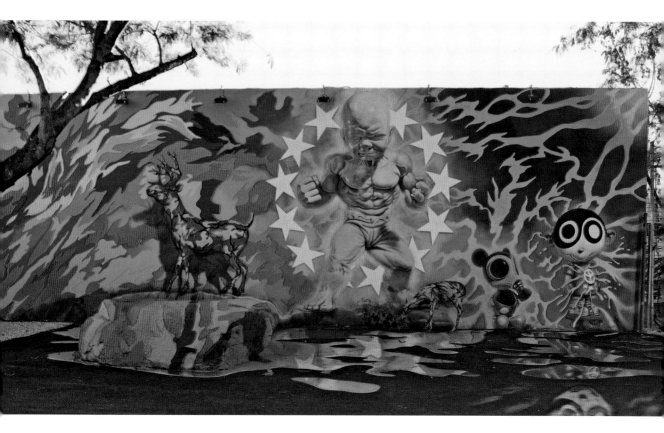

Hulkboy, 2010. Mixed media. Wynwood, Miami.

SHEPARD FAIREY

Who is he?

Shepard Fairey was born in 1970 in Charleston, South Carolina, on the East Coast of the United States. Born into a wealthy family, he grew up with skateboarding and punk-rock music. After graduating from Rhode Island University, north of New York, he moved to the city and opened a small silkscreen print workshop to finance his artistic work. Very quickly, however, Fairey realized the power of urban intervention, and wrote a manifesto on the sticker in 1990. Highly selective in his messages, the causes he supports, and the demonstrations he takes part in, he generally translates his commitment into a poster, the proceeds of which are donated to the specific cause. His fly-posting campaigns always use his iconic figure of André The Giant, taken by chance from one of his first stickers. They began to flourish in 1992, first in the United States, and then all across the world. Inspired by the film *They Live* by John Carpenter, in 1995 Fairey added the slogan "OBEY"—a word implicit throughout the film—beneath his icon's face, and the message became clearer. In 1998, Shepard hit the media, and his fame increased until reaching a peak in 2008, when Barack Obama's team chose the artist's portrait for the presidential campaign. Hardworking, surrounded by a trustworthy team, Fairey is faithful to his humanist ideas and continues to make his prints available at affordable prices so that his work remains accessible to everyone.

His work

Solely dedicated to the techniques of silkscreen printing and stenciling, Fairey questions our society and our values. "The medium is the message": Shepard Fairey uses the philosopher Marshall McLuhan's theory of communication and combines it with the notion of repetition, specific to the tag, in order to adapt it to his project. After a long period devoted to the creation and collage of stickers between 1989 and 1994, the artist began to tackle posters. Pasted everywhere on very visible structures such as bridges, freeways, and other highly frequented places, his character André The Giant attracted the attention of his peers. Beyond his work based on this iconic figure, Fairey executed a small series of posters at the beginning of the 1990s. In 1996, his images were printed in editions of 100, before reaching 300 in 2002, then 450 in 2008. Sold at a low price, they considerably increased his fan base. In addition to his widely circulated works, Shepard Fairey produces micro-series of two to ten copies, always made by hand on paper, wood, or aluminum, to the joy of collectors. Since 2006, he has exhibited widely in prestigious venues and museums, his monumental murals flourish in several big cities around the world, and his work embraces more and more political subjects for the causes he believes it is important to support.

He said:

"If being original is throwing paint in front of a jet engine to spray on a canvas that's fifty feet away, let's just not be original."

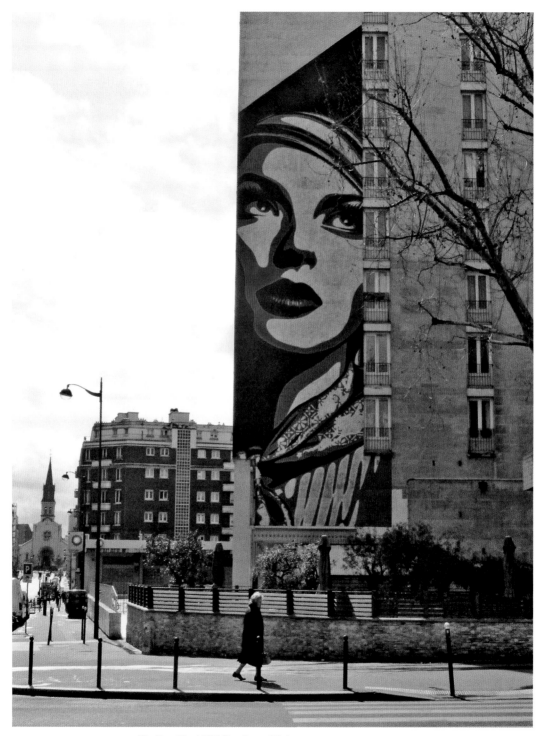

Rise Above Mural, 2012. Stencil on wall. Paris.

SLINKACHU

Who is he?

The British artist Slinkachu was born in 1979 and has been living in London since 2003. After graduating with a degree in art and design, he specialized as an arts director in advertising. To keep his creative work going, he produced miniature figures in his own time. His pseudonym allowed him to stay out of the public eye, so that his work can be judged on its own merits, without a face attached to it. The romantic idea of the anonymous artist is something that appeals to him. His work also allows him to see the city in a new way, to recognize the meager interaction we have with it, and its inhabitants.

The discovery of the stories that formed in the minds of his spectators made him aware of the importance of his work. Fascinated by history and archaeology, he particularly appreciates the work of Charles Simonds, Kris Kuksi, Tessa Farmer, and Jake and Dinos Chapman with their *Hell* series. Like them, Slinkachu embodies many roles in his attempts to tell a story: sculptor, scriptwriter, journalist, and photographer. By encouraging people to look around them, he hopes to create links where there are few, and let poetry invade our cities and our lives.

His work

The smallness of Slinkachu's work is naturally associated with a certain gracefulness and poetry. The intensity of the relationship between the spectator and the work increases with the improbability of the encounter. The size and delicacy of his installations are two major aspects of his work's beauty. They remind us of the world's fragility, the child we once were, and the power of our dreams. Even in photographs, the artist's creations remain touching in their simplicity and authenticity; a few small figures no more than half an inch high, painted and confronted with our world, exert a magical power over our imagination. The subject is often prepared beforehand; Slink, as his oldest friends call him, knows ahead of time what he will leave, and how, but the question is where. If someone happens upon his tiny scenes, they will never forget the encounter. The artist abandons his subjects once they have been photographed, regardless of what will become of them. The humorous aspect of his compositions relies upon somewhat black themes, and the questions they raise return like watchwords: ecology, solitude, or the sense of being lost. In search of an emotional response from the spectator, Slinkachu creates scenarios like a film director, aware of the slightest detail that will give them a new meaning.

He said:

"I aim to encourage city-dwellers to be more aware of their surroundings"

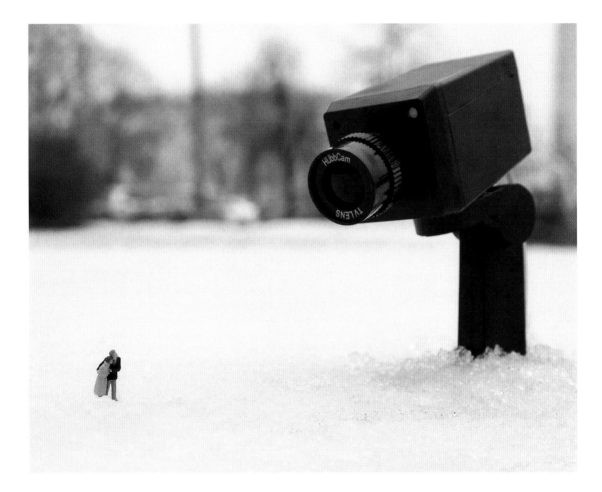

All Alone, 2012. Mixed media. VDNKh area, Moscow.

SVVOON

VVho is she?

Born in Connecticut in 1977, Swoon grew up in Florida before moving to New York at the age of nineteen. She began painting in the street in 1999 while studying art at the Pratt Institute in Brooklyn, New York. Passionate and committed, she defends the causes she supports with a crazy energy. Her creativity takes her work into different fields, often far removed from art, such as helping the post-earthquake victims in Haiti with the Konbit Shelter Project, or the creation of learning and guidance workshops with the Transformazium collective. While she cites Egon Schiele, Gustav Klimt, and Gordon Matta-Clark as influences, the dynamic aspect of her large-format works also refers to art nouveau. She also draws inspiration from Indonesian paper dolls and their slightly transparent texture, which can be found in the works that Swoon puts up for sale. Caledonia Dance Curry, her real name, seeks to understand the beauty that surrounds her by working on subjects that touch her. And when she moves from public to private space, such as the art gallery, the artist's only rule is to be proud of the result. Her work, regularly hailed by art critics, is driven by a powerful creative drive.

Her vvork

Swoon became known for her engraving work printed on recycled paper, cut and then pasted on walls. These fragile, sublime, lace-like compositions are highlighted with natural colors and reflect a fleeting moment caught in the street, or simply a flash of inspiration. She easily spends over a week on her life-size works that she then places in the city districts she passes through. To add variety, she uses different media such as recycled paper, Kevlar fiber, tracing paper, or Mylar (a very solid, transparent plastic film), then creates her installations in situ according to the material she has chosen. Swoon produces all her linoleum engravings, which constitutes the most physical part of her work. In order to concentrate entirely upon the creation of her original designs, the artist shuts herself away before producing editions, each of which are then made unique through the different ways in which they are cut and colored. As Swoon nevertheless enjoys collective work, she can often be found in her Brooklyn studio with one or two assistants helping her to enhance works already printed on paper, according to her vision. Flirting with the contemporary art vvorld, her vvorks have entered the permanent collections of museums such as MoMA in New York or the Brooklyn Museum of Art, and also take the form of installations, as with *The Ice Queen* at the Museum of Contemporary Art in Los Angeles, produced for the *Art in the Streets* exhibition.

She said:

"The dedicated act of looking takes all kinds of love and patience and humility."

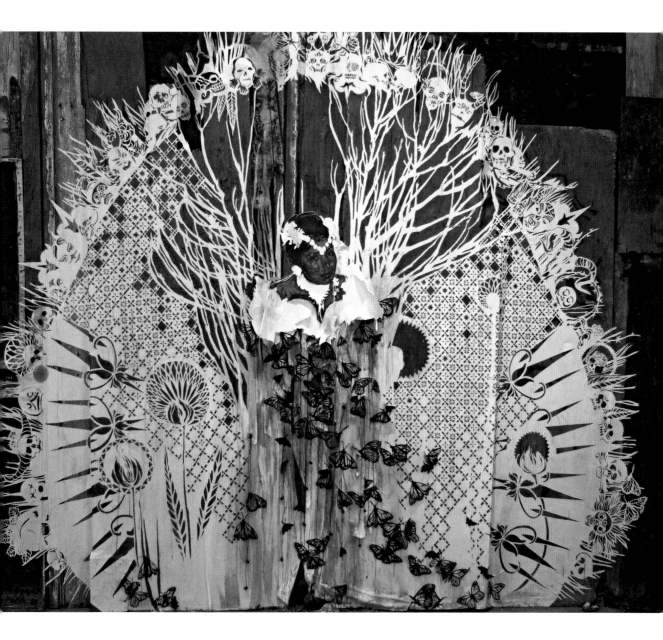

Portrait of Silvia Elena, 2007. Linoleum engraving printed on recycled paper, hand-cut paper, 8 ft. 2 in. × 8 ft. 2 in. (2.50 × 2.50 m). In collaboration with Tennessee Jane Watson, Yerba Buena Center for the Arts, San Francisco.

VHILS

VVho is he?

Vhils—real name Alexandre Farto—is one of the flagbearers for street art in Portugal. Born in 1987, he grew up in Lisbon, mindful of the presence of old utopian political frescoes from the end of the 1970s on the city's walls and the increasing amount of billboards that covered them. A fan of the first Portuguese writers, Vhils began graffiti at the age of thirteen, drawing his influences from everything around him as well as from the international art scene. After a short spell in vandalism with spray paint on trains in Portugal and elsewhere in Europe, he turned to the stencil. Keen to discover new techniques, he traveled with his eyes open, to absorb, encounter, and learn as much as possible. His discovery of Banksy's work marked a decisive turning point in his way of understanding street art. It is by peeling away the layers that his work reveals itself, by creating contrasts that it comes to life, by destroying that it embellishes. Offering humanity to concrete, intimacy to billboards, life to derelict buildings is what drives his creative process. For him, "the process is often more important than the outcome, as it conveys a great part of the message I'm interested in getting across," and he stays away from microphones and cameras. As if there were already too many faces associated with his work, Vhils turns the spotlight on all the anonymous people he has engraved on walls or on posters in the cities he has passed through.

His vvork

Unlike his first paintings on trains and his stencil period, Vhils's works are characterized today by the fact that he takes away from the material he has chosen instead of adding to it. His tools are, then, the hammer and the chisel when he attacks walls, the scalpel when he tackles layers of posters, nitric acid when he works on metal, and, in extreme cases, explosives that produce a spectacular outcome, close to performance. It was during Banksy's Cans Festival in London in 2008 that his work gained public and media recognition, making the cover of *The Times*. Since then, he has created murals from Moscow to New York, via Italy and Germany. During his exhibitions, whether in Lisbon or Shanghai, the artist does not shy away from creating installations, reconstituting his work's original material or building a futuristic city from cubic structures. Among his new techniques, polystyrene allows him to forge anonymous faces with agility and delicacy. As impressive as it is meticulous, his work superimposes cut-out layers of paper and collages to reveal the gaze of strangers in a relief specific to his style. His work depicts the true face of the city, revealing its history and its wrinkles.

He said:

"VVe shouldn't have limits in art, nor the space vvhere vve apply it. No rules should be applied to art."

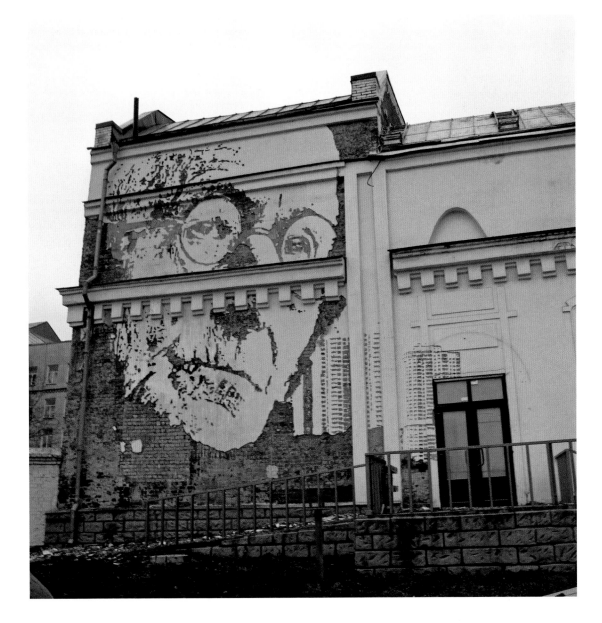

Scratching the Surface Project, 2009. Mixed media, 26 × 16 ft. (8 × 5 m). Moscow.

VVK INTERACT

Who is he?

Passionate about the world of cinema and particularly talented at depicting movement in his designs, this French artist used to work for the film industry, creating storyboards and decor. He stopped everything and moved to New York in 1990. Living in precarious conditions and not speaking any English, he threw himself into the challenge of street art in order to create his own images, dedicated, for the most part, to the art of cinema. Thus, during his exhibition in 2009 in New York, he paid tribute to the film *Twelve Angry Men* (1957) by the director Sidney Lumet. But at the time of his first creations, street art—the evolution of which he has witnessed during more than twenty-five years of interventions—did not have the same aura as today and was seldom recognized, except by a few artists. His first pieces were large murals, before advertising took over any wall measuring over thirty square feet in the Big Apple. Faced with this invasion of commercial billboards, VVK adapted his work and replaced the monumental format with proliferation, intervening on the most tagged walls possible. Always attentive to the existing graffiti, he strove to magnify the work of his predecessors. As a result, he was respected by the local tag and graffiti scene. He prefers working alone, and his art breathes the energy and speed typical of New York. In his name, the word "Interact" is by the far the most important and sums up his approach and the mission he has given himself: to converse with the walls and their history, the location, the city, the people. In short, to interact with the world.

His work

VVK chose to leave France to test the quality and pertinence of his work. A skilled draftsman, he was unable to draw an interesting response from the European public and art scene in 1995. Recognition often has to be sought abroad before one is spotted in one's own country, even more so if it is totally backward-looking and blocked by a particular artistic movement. VVK always draws inspiration from the place where he finds himself, absorbing the energy of the location and spitting it out again in his compositions stuck straight on the walls. He expresses himself mainly outdoors, and only occasionally on canvases destined for art galleries. In these instances VVK attempts to bring indoors what he has felt outdoors. His works on metal or recycled wood seem to come straight from the street. In his canvas works, despite their flatness, he nevertheless manages to make his subject vibrate thanks to his perfect control of movement. The artist hopes that every work will provoke a physical response to his creations. His works are described—with reason—as violent because the power of his expression is neither common nor banal. His compositions are originally inspired by combat positions, martial arts movements, or simply actions he has decided to stage. These are enriched by a multitude of complementary elements that balance the scene and bring a conclusive narrative touch.

He said:

"Street art is and always will be around us. As a street artist, like many others, I am only passing through, leaving a mark, to become part of the street."

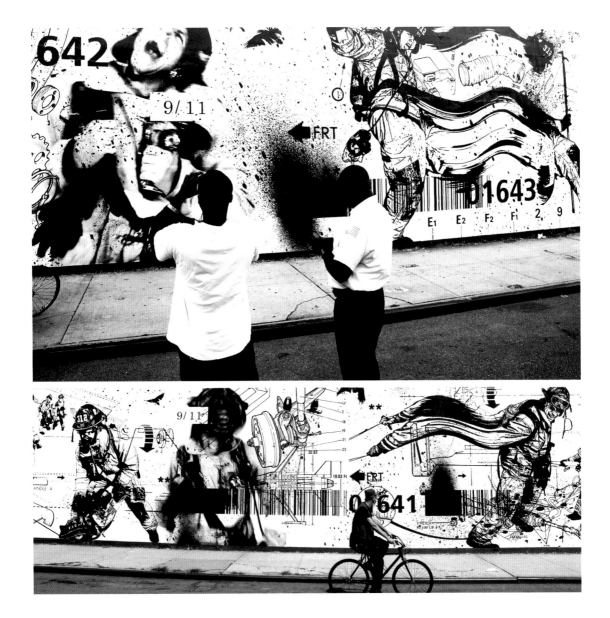

Project Brave, 2011. Wall collage (detail). New York.

ZEVS

Who is he?

This French artist chose the pseudonym Zevs (pronounced "Zeus") in memory of the RER commuter rail train that almost killed him while he was painting graffiti, when he was just fifteen. Aguirre Schwarz got into street art at a very young age. Videos, graffiti, tags, stencils—everything suited this incredibly talented jack-of-all-trades. He lived in in close proximity to his peers, such as Invader, with whom he founded The Anonymous and occupied the city of Montpellier, and André, with whom he tackled an old Parisian townhouse. As time passed, he moved away from traditional graffiti and the narcissistic aspect of tagging. He describes himself as a painter and aims to question our everyday lives, to interact with our environment. On the lookout for the Achilles heel of multinational companies in order to subvert their logos, he travels around the world, from Berlin to Hong Kong, from Copenhagen to New York. He has had a whole string of exhibitions since 2000 and takes advantage of international invitations to create works abroad. A committed urban artist, he shoulders the risks of the job even if it means spending a few weeks in prison in Hong Kong. In 2011, he decided to reveal himself under his real name. A step closer to international artistic recognition?

His work

Zevs was clearly a part of street art from early on, creating tags, graffiti, and urban interventions of all kinds. Working first on the ground, outlining the shadows of objects or urban furniture as if marking a crime scene, he then moved to vertical surfaces to tackle the world of advertising. He appropriated public billboards on which he painted, for example, a night sky full of lightning flashes on the occasion of his collaboration with the skateboarding label Mekanism; and graphically and illegally killed advertisement characters with a bullet in the head (a black spray-hole in the middle of the forehead and red blood running down the face); or kidnapped the image of a Lavazza fashion icon in Berlin. Today his style, on the border between contemporary art and street art, brings a kind of visual correction to billboards, trademarks, and signs of overconsumption of all kinds. Traveling around the world, he aims to show the impermanent side of brand names that have managed to infiltrate everything, even our minds. He liquefies the biggest names: Chanel, McDonalds, Disney, or Google; using great dabs of acrylic paint, he makes the logos drip, as if they have been freshly poured over with too much paint. This matter dripping from ubiquitous advertisements shows that it is still possible to empty them of their substance, meaning, and lifeblood.

He said:

"By pouring paint over it, the logo dissolves in front of the viewer's eyes, drawing attention to and visually disturbing the recognizable and omnipresent trademark. By doing so, I try to investigate the logo's visual power. It's a simple gesture, just as in Aikido when you reverse the power and change the flow of energy."

La Grande Odalisque oragée (The Great Stormy Odalisque), 2012. Oil paint and Liquitex on canvas, 6 ft × 10 ft 9 in. (1.83 × 3.27 m).

BANKSY

Who is he?

Born in Bristol, England, Banksy began creating graffiti works in 1992 as a part of the DBZ crew in his native city. Concealing his true identity, this friend of Shepard Fairey explains his motives and detachment from his immense notoriety in occasional interviews on the Net. Banksy is the most eloquent spokesperson for British street art, with its wry sense of humor. He is also its most popular and most mysterious practitioner. In addition to wall pieces and works placed in unexpected places, he promotes street art in its purest form. He has mounted some incredible spontaneous exhibitions from scratch and discreetly helps truly committed artists, raising money following the arrest of the members of the Russian activist group Voina, for instance.

A recommendation from him is worth its weight in gold: when he has a good word to say about another artist, their prices soar instantly. And with his projects becoming ever more daring, it is clear that he doesn't keep his identity secret for nothing.

If one had to define Banksy, he could be seen as a kind of hybrid of punk icon Johnny Rotten and Monty Python's Terry Gilliam, who spent his childhood under the iron rod of an authoritarian museum-director father and a hysterical, house-proud mother, before making his getaway and swearing he'd be back to wreak revenge.

His work

A multifaceted artist today, Banksy started out working with the stencil, a medium that he found more expressive than freehand. Often bringing an anti-consumerist or anti-establishment message—and an immense dose of humor—he made multiple interventions in the streets of London before moving on, chiefly to the U.S. and other countries. Primarily using stencil key in street work, since 2005 he has produced in-situ installations, pieces in museums and in Disneyland (featuring mechanically animated sculptures), and films, such as *Exit Through the Gift Shop* (2010), as well as a subversive version of the opening credits to *The Simpsons*.

In 2009, he invaded the Bristol Museum and Art Gallery with a superb exhibition that showed his irreverence for the institution and for art history—a punk magic trick performed within the hallowed portals of high art that knocked it off its pedestal. Banksy also plays the role of an independent and brilliant exhibition curator, inviting artists to take part in shows organized in the greatest secrecy—as secret as his still fiercely protected identity—which in itself is one of his greatest works.

He said:

"When I was a kid I used to pray every night for a new bicycle. Then I realized God doesn't work that way, so I stole one and prayed for forgiveness."

BLU

VVho is he?

Born in 1981 in Buenos Aires, Blu is Italian, and became involved in street art in 1999. He moved quickly from graffiti to roller painting in order to satisfy his desire for monumental formats. A great traveler, he roamed around the world to paint, meet people, and learn. His favorite subjects had a political character and often criticized society. In 2005, he chose to visit Central America for its tradition of mural painting. This trip marked the beginning of an exploration, lasting five years, of almost all the countries situated south of the United States. Constantly on the lookout for good walls for his works, Blu tracked down the most improbable places and huge platforms upon which he expressed himself with the same ease as a draftsman fills a page of his sketchbook. A very discreet artist, Blu does not seek notoriety: above all, he is an explorer of extra-large formats and the most diverse techniques. His animation films, which he was the first to introduce successfully into the domain of street art, demonstrate the scope of his talent.

His vvork

Blu's art is characterized by its gigantic scale and is often in black against a white background, highlighted with one or two colors. Man (with a capital M) is generally a prisoner of the human condition, subject to society's restrictions. Blu's very detailed frescoes, asidefrom their monumentality, combine a sense of power with the art of drawing. He does not hesitate to share or collaborate with his peers, such as the Italian artist Ericailcane, who has followed him since his beginnings, or, depending on which proposals come up, with the French artist JR, the Brazilians Os Gêmeos, or Nunca. His work also comes in the smallest of formats, in the form of drawings on paper in black pencil, sketches of potential mural works. Blu makes animated films from his drawings, which he creates on any old surface. Recognizing no limit in size or subject, he passes easily from one side of the camera to the other. His creativity seems boundless, and his capacity to work in every medium gives him the makings of a great artist. In 2007 and 2008, he made the film *Muto* in Argentina, his first "animated wall," which received several prizes and has already been viewed more than eleven million times on YouTube.

He said:

"I try to keep avvay as much as possible from everything to do vvith commissions for labels or advertising, it is something I don't really like. I am not rich, economically speaking, but I am a millionaire in terms of happiness."

APPENDIXES

WHERE TO SEE STREET ART

THE MAJOR ANNUAL EVENTS

(The year of the festival's inaugural event is given in brackets.)

Australia
Melbourne, *Sweet Streets* (2004)

Austria
Bregenz, *Freakwave Festival* (2008)

Belgium
Hasselt, *Street Art Festival* (2011)

Canada
Montreal, *Under Pressure* (1995)

Croatia
Split, *Xstatic Festival* (2011)

France
Bagnolet, *Kosmopolite Art Tour* (2002)
Strasbourg, *Festival Contre-Temps* (2004)

Germany
Dresden, *Urban Syndromes* (1998)
Munich, *ISART* (1999)
Berlin, *Yard 5 Summer Jam* (2008)
Ingolstadt, *La Grande Schmierâge* (2009)

Ireland
Drogheda, *Bridge Jam* (1994)
Dublin, *All City Tivoli Jam* (2008)
Cork, *LiveStyles Fest* (2011)

Italy
Grottaglie, *Fame Festival* (2008)
Milan, *True Skills* (2008)

Mexico
Mexico City, *All City Canvas* (2012)

The Netherlands
The Hague, *I Love HipHop Festival* (2009)
Eindhoven, *Step in the Arena* (2010)

Norway
Stavanger, *Nuart* (2001)

Poland
Lodz, *Meeting of Styles* (2002)
Katowice, *Katowice Street Art Festival* (2010)

Portugal
Covilhã, *Wool* (2004)
Isla de São Miguel, *Walk&Talk* (2011)

Romania
Timisoara, *MOLOTOW* (2011)

Russia
Saint Petersburg, *Art Wall Recycle* (2011)
Perm, *Three Capitals' Battle* (2012)

Singapore
Singapore, *Singapore Street Festival* (2002)

Spain
Huarte, *Cantamañanas* (2004)
Zaragoza, *Festival Asalto* (2006)
Ordes, *Desordes Creativas* (2008)
Gijon, *Most Wanted* (2010)
Barcelona, *Poble Dub Sec* (2011)
Girona, *Milestone Project* (2011)

Switzerland
Orpund, *Royal Arena Festival* (2007)

Turkey
Istanbul, *Meeting of Allstars Graffiti Festival* (2009)

U.K.
Bristol, *Upfest* (2008)
Bristol, *See No Evil* (2012)

U.S.
Philadelphia, *Mural Arts Program* (1984)
San Francisco, *Graffiti Arts Festival* (1997)
Chicago, *Meeting of Styles* (2004)
Oakland, *Estria Battle* (2007)
Honolulu, Hawaii, *POW! WOW!* (2009)
Atlanta, *Living Walls* (2010)

THE MAJOR TOURING EVENTS

Banksy invitationals

In order to remain faithful to a certain idea of street art, Banksy organizes spontaneous events that are kept secret until the last minute, like the three-day *Cans Festival* in London. Information about the events is disseminated only through social networks, giving you just enough to jump on an airplane if you don't live on site.

Just Writing My Name project

Another festival touring a series of destinations in Ukraine, South Africa, Europe, the United States, and Asia, which brings together the leading spray-paint artists.

Kosmopolite Art Tour (www.kosmo-art-tour.com)

France, Morocco, The Netherlands, Belgium, Indonesia, and Brazil: the French festival, born in Bagnolet, makes its way around the world.

Meeting of Styles (www.meetingofstyles.com)

Ecuador, Bolivia, Singapore, Germany, Greece, China, Poland, Bulgaria, U.S., Argentina, Mexico, France, Serbia, Switzerland, Italy, Venezuela, England, Hungary, Malaysia, Peru, and Ireland. At the rate of fifteen or so dates a year, the Meeting of Styles is probably the biggest global organization of street art festivals, with a strong focus on graffiti.

Wall Lords

The first major festival in Asia. Based on a series of qualification rules, each country can compete for the top place on the podium. The final takes place in the winning country the following year.

A work by Jérôme Mesnager, a pioneer in the world of street art. Egypt, 1985.

SELECTED BIBLIOGRAPHY

GENERAL WORKS

Banksy.
Wall and Piece.
London: Century, 2006.

Baugh, Keith, and Sami Montague.
Early New York Subway Graffiti 1973–1975.
Buffalo: Buffalo Arts, 2009.

Ben Yakhlef, Tarek, and Sylvain Doriath.
Paris Tonkar.
Paris: Florent Massot Editions, 1991.

Brassaï.
Graffiti.
Stuttgart/Paris/Paris: Belser Verlag/Editions du Temps/
Flammarion, 1960/1961/2002.

Calogirou, Claire.
Une esthétique urbaine. Graffeurs d'Europe.
Paris: L'oeil d'Horus, 2012.

Cesaretti, Gusmano.
Street Writers: A Guided Tour of Chicano Graffiti.
Los Angeles: Acrobat Books, 1975.

Chalfant, Henry, and James Prigoff.
Spraycan Art.
London: Thames & Hudson, 1987.

Cooper, Martha, and Henry Chalfant.
Subway Art.
London: Thames & Hudson, 1984.

Cubrilo, Duro, Martin Harvey, and Karl Stamer.
*Kings Way: The Beginnings of Australian Graffiti,
Melbourne 1983–93.*
Melbourne: Melbourne University Publishing, 2009.

Deitch, Jeffrey, Roger Gastman, and Aaron Rose.
Art in the Streets.
New York: Skira Rizzoli, 2011.

Fairey, Shepard.
Obey: Supply & Demand.
Berkeley: Gingko Press, 2006.

Ganz, Nicholas, and Tristan Manco.
Graffiti World: Street Art from Five Continents.
New York: Abrams, 2004.

Gastman, Roger, Caleb Neelon, and Anthony Smyrski.
Street World: Urban Art and Culture from Five Continents.
New York: Abrams, 2007.

Klanten, Robert, and Matthias Hübner (eds.)
Urban Interventions: Personal Projects in Public Places.
Berlin: Gestalten Verlag, 2010.

Mailer, Norman, and Jon Naar.
The Faith of Graffiti.
New York: Praeger Publishers/It Books, 1974/2009.

Manco, Tristan.
Stencil Graffiti.
London: Thames & Hudson, 2002.

Manco, Tristan.
Street Logos.
London: Thames & Hudson, 2004.

WEBSITES

Photographers
<photograffcollectif.blogspot.fr>
<wallkandy.net>

Street art news
<arrestedmotion.com>
<graffitiartmagazine.com>
<hifructose.com>
<juxtapoz.com>
<streetartnews.net>
<streetartutopia.com>
<unurth.com>
<urbanartcore.eu>
<woostercollective.com>

European street art
<speerstra.net>

U.S. graffiti
<drunkenfist.com>
<at149st.com> (graffiti in NYC)

World graffiti
<fatcap.org>
<stencilnation.org>

INDEX OF PROPER NAMES

Page numbers in **bold** refer to illustrations

Photographic Credits

© A1one: pp. 133, 188, 189; © Aguirre Schwarz: pp. 62–63; © Ahéro: p. 171 top; © Alban Morlot: p. 69; © Alexandre Orion: p. 82; © Andy Howell: p. 1; © Antonin Giverne – Adagp, Paris 2013: p. 35 top and bottom; © Aram Bartholl: p. 83; © Archives Flammarion: pp. 24, 52; © Aryz: pp. 190, 191; © Backslash Gallery, Paris: p. 248; © Ben Wilson – Gallery For One Week Only: p. 3; © Benjamin Roudet – Adagp, Paris 2013 – Big Addict: pp. 60–61; © Blade: p. 40; © Blek le Rat: p. 38; © Boa Mistura: p. 79; © Boris Tellegen: pp. 200, 201; © C215: pp. 137 top, 194, 195; © Chaz Bojórquez: pp. 25, 197; © Christian Guémy: p. 17 top; © Christina Bojórquez: p. 196; © Courtesy Gallery Magda Danysz: pp. 154–55, 240, 241; © Courtesy of Shepard Fairey/Obeygiant.com: pp. 17 bottom, 94, 126; © Courtesy Reinkingprojekte – Photo: Mrpro: p. 51 top; © Deamze: p. 18; © Delta: p. 7; © Dran: pp. 33, 202, 203; © Ellis Gallagher: p. 65; © Eoghan Brennan: p. 210; © Ernest Pignon-Ernest, Adagp, Paris 2013: pp. 41, 169, 204, 205; © Faile: pp. 97, 206, 207; © Faith47: p. 137 bottom; © Farzad Orsgani: p. 188; © Finé: pp. 126, 227; © Flix: p. 143; © Futura 2000 – Courtesy Galerie Jérôme de Noirmont, Paris: pp. 208, 209; © Geoff Hargadon: p. 229; © Goin: p. 95; © Goin, Demeure du Chaos – www.goinart.net: p. 39; © Gregory Tuzin: p. 73; © Harcourt: p. 224; © Henry Chalfant: pp. 26–27, 37; © Herakut: pp. 212, 213; © Ian Cox: pp. 4, 5, 6, 18–19, 57, 91 top and bottom, 102, 106–7, 108–9, 114, 118–19, 120–21, 128–29, 138–39, 165, 192, 193, 211, 230; © Isaac Cordal: p. 72; © Jana Ebert: p. 245; © Jean-Marie Racon – Adagp, Paris 2013: p. 53; © Jef Aérosol – Adagp, Paris 2013: pp. 54–55, 146–47; © Jeff Soto: pp. 158, 219; © Jeremy Gibbs: p. 194; © Jérome Catz: p. 163; © Joe Iurato: p. 77; © John "Crash" Matos: pp. 198–99; © Joshua Allen Harris: p. 256; © JR: pp. 124–25, 134–35; © Juana Alicia, Miranda Bergman, Edythe Boone, Susan Cervantes, Meera Desai, Yvonne Littleton, and Irene Perez, 1994/All Rights Reserved: p. 105; © Julian Beever: p. 81; © Know Hope: p. 136; © Leonard Bourgois: p. 174; © Mark Jenkins: pp. 21, 70–71, 222, 223; © Martin Andreasen: p. 115; © Michel and Christine Denis-Huot, Matthieu Javelle, and Stéphane Balesi – Ogilvy & Mather France: p. 170 bottom; © Mike Piscitelli: p. 175; © Miss.Tic: p. 225; © Mode 2: p. 227; © Monica Müller: pp. 214, 215; © Museum Boijmans Van Beuningen, Rotterdam: p. 179; © Nick Torgoff: p. 141; © Nicolas Thomas: pp. 144–45; © Olivier Burel: pp. 48–49, 56; © Paris Tonkar, 1991: p. 29 top; © Patrick Lerouge: p. 161; © Patti Astor: p. 34; © Peeta: p. 51 bottom; © Peter Gibson, CARCC, Ottawa 2013: p. 64; © Philippe Bonan: p. 226; © Pierre-Olivier Deschamps/Agence VU': p. 221; © Remo Camerota: p. 122; © Rezine – Adagp, Paris 2013: p. 87; © Roa: pp. 101, 231; © Robbbb: p. 123; © Ron English: pp. 66–67, 96, 159, 232, 233; © Rone: pp. 130, 131; © Rosine Klatzmann: p. 168; © Saile, 2013: p. 142; © SatOne: p. 117 top; © Silvio Magaglio: p. 16; © Slinkachu: p. 173 bottom, 234, 235; © Speedy Graphito: p. 113; © Speerstra Collection: pp. 47, 59; © Sten Lex: p. 75; © Studio Buitenhof, The Hague: p. 179; © Studio Invader: pp. 89, 173 top, 216, 217; © Swoon: p. 239; © Tania Mouraud – Adagp, Paris 2013: p. 151; © Tarek Ben Yakhlef, 1990: pp. 22–23; © Tate, London, 2013: pp. 152–53; © The Keith Haring Foundation: p. 43; © TPP: pp. 76, 237; © Truly Design: p. 80; © Underpressure: p. 111; © Vhils: pp. 84–85; © WallsOfMilano: p. 10; © Will Barras: p. 117 bottom; © VVK Interact: pp. 242, 243; © Yoshi Omori: pp. 2, 29 bottom, 30–31; © Zevs: p. 244; © All Rights Reserved: pp. 28, 58, 86, 92, 93, 127, 157, 178.

Acknowledgments

The author would like to thank Élisabeth Couturier for her trust, her advice, and her unfailing guidance;
Julie Rouart, Marion Doublet, and Mélanie Puchault for their patience and their understanding;
and Valériane Mondot for all her help.
I would also like to thank the Spacejunk team and all my friends and family for their support.

Translated from the French by Anna Hiddleston-Galloni
Design: François Huertas
Copyediting: Marc Feustel
Typesetting: Thierry Renard
Proofreading: Samuel Wythe
Color Separation: Reproscan
Printed in Portugal by Printer Portuguesa

Originally published in French as *Street Art, mode d'emploi*
© Flammarion, S.A., Paris, 2013

English-language edition
© Flammarion, S.A., Paris, 2014